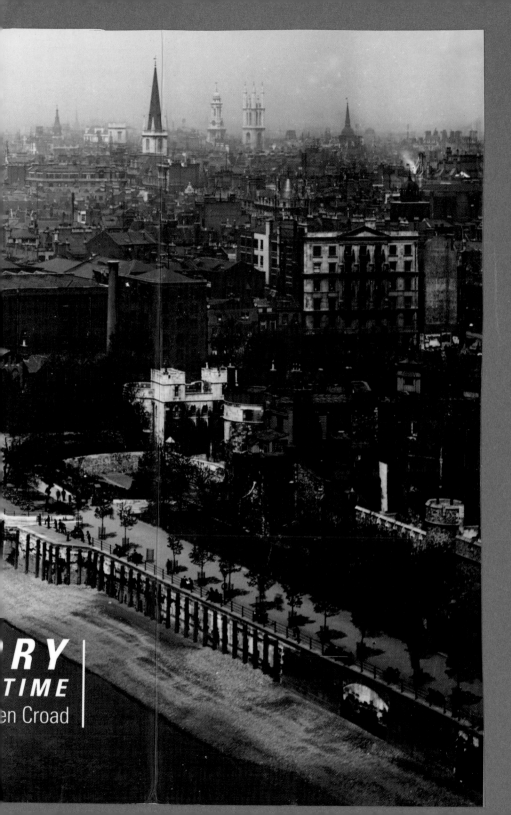

RY

TIME

en Croad

'THE THAMES IS LIQUID HISTORY'

JOHN BURNS, MP FOR BATTERSEA, 1892–1918

NATIONAL MONUMENTS RECORD

The photographs in this book all come from the National Monuments Record, English Heritage's public archive. This is an unparalleled collection of around 10 million photographs and other archive items relating to England's architecture and archaeology. The National Monuments Record has public search rooms in Swindon and London and offers a research service. For more details please write to NMR Enquiry & Research Services, English Heritage, National Monuments Record Centre, Kemble Drive, Swindon SN2 2GZ.

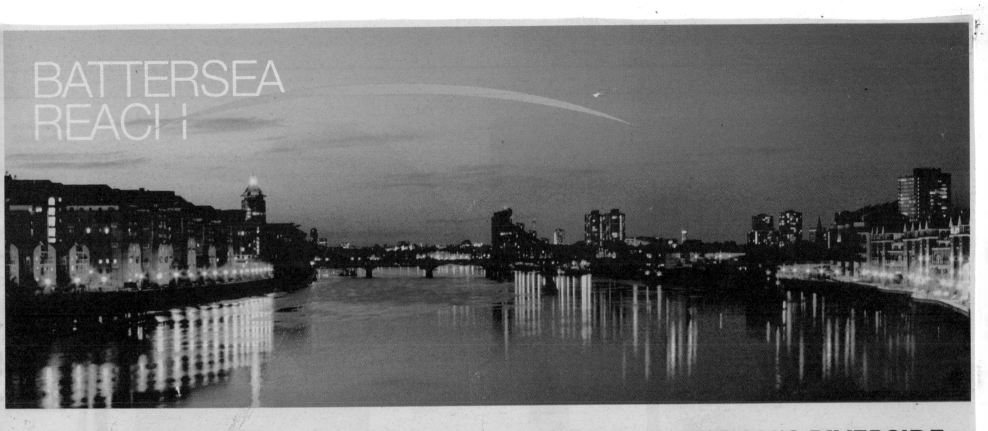

BATTERSEA
REACH

BATTERSEA REACH - A NEW DESTINATION ON LONDON'S RIVERSIDE

LIQUID HISTORY
THE THAMES THROUGH TIME

Stephen Croad

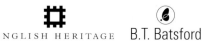

ENGLISH HERITAGE B.T. Batsford

A CIP record for this book is available from the British Library

First published 2003 by B T Batsford
The Chrysalis Building, Bramley Road, London W10 6SP
www.batsford.com
Reprinted 2003

Design Claudia Schenk

© English Heritage 2003

The photographs taken by Sid Barker, Roger Featherstone and Derek Kendall are all © Crown copyright, NMR and reproduced by permission of English Heritage acting under licence from the Controller of Her Majesty's Stationery Office
Damian Grady's photographs are © English Heritage
We are grateful to Paul Barkshire, Nicholas Cooper and the late Bernard Howarth Loomes and the late John Bassham for permission to reproduce photographs from their collections
The remainder are reproduced by permission of English Heritage
Application for the reproduction of images should be made to the National Monuments Record

ISBN 0 7134 8834 4

Printed and bound in Italy

For a copy of the Batsford catalogue or information on special quantity orders of Batsford books please contact us on 020 7314 1400 or sales@chrysalisbooks.co.uk

CONTENTS

INTRODUCTION

FORGET THE SPREADING OF THE HIDEOUS TOWN;

....

AND DREAM OF LONDON, SMALL, AND WHITE, AND CLEAN,

THE CLEAR THAMES BORDERED BY ITS GARDEN GREEN.

William Morris's romantic vision in *The Earthly Paradise* (1896) was a wistful glance back in time at a London that probably had never existed. The Thames was London's reason for existence and since the foundation of the settlement by the Romans the river had been a busy highway and a magnet for trade and industry. In Morris's day London was the capital of an empire that extended over a quarter of the land surface of the globe. The transformation that had occurred in the previous half century and the subsequent century was recorded by photography and this book looks at some of the most significant changes. In a series of telling images it shows the many faces of the Thames within the ancient limits of the jurisdiction of the City of London.

THE NATIONAL MONUMENTS RECORD

The photographs in this book all come from the archive of the National Monuments Record (NMR). This is an unparalleled collection of images, old and new, which has been growing for 60 years. It was set up in 1941 in response to the threat to historic buildings from aerial bombardment at the outbreak of the Second World War. Immediately it began its own recording programme as well as collecting historic negatives and prints. Covering the whole of England, the National Buildings Record – as it was originally known – was an independent body, but in 1963 it came under the auspices of the Royal Commission on the Historical Monuments of England and in 1999 control was transferred to English Heritage. Today the collection comprises more than 10 million photographs and other archive items (including measured drawings and survey reports) relating to England's architecture and archaeology. The majority of the collection is held at the National Monuments Record Centre in Swindon, but London material may be consulted in the NMR's London search room.

THE PHOTOGRAPHS AND THE PHOTOGRAPHERS

The photographs reproduced here illustrate the range of material on the cap-ital, which is particularly well served. Sadly, the names of many of the early photographers are no longer known, but their work remains as an enduring record of long-lost buildings and a past way of life. One photographer whose work features in this book is Henry Taunt (1842–1922). He was born in Oxford and in 1856 became an assistant to a commercial photographer in the city. In 1868 he set up his own business. The *Oxford Times* (1869) wrote appreciatively of his photographs: 'We cannot but speak in terms of unqualified praise of the beauty of the views which were of unusual excellence'. The business flourished and in 1871 Taunt became official photographer to the Oxford Architectural and Historical Society. His love of the river led him to branch out into publishing *A New Map of the River Thames*. This appeared in 1872 and went into six editions spanning 25 years. It was intended for those engaged in boating for pleasure, for 'the Tourist, the Oarsman, and the Angler'. The guide included such useful details as where boats could be hired or moored over night. Distances between locks or inns were valuable for the amateur, so a typical entry reads: 'Chertsey Lock from Laleham Ferry 1 mile 1 furlong 4 yards; to Shepperton Lock, 1 mile 7 furlongs 183 yards: falls from 8 in in high to 3 ft 9 in in low water; average in summer, 3 ft 6 in'. Another piece of essential information was the distance from the nearest railway station. In 1893, Taunt was elected a Fellow of the Royal Geographical Society, principally in recognition of his Thames map and guide. As well as continuing to operate as a commercial photographer, he produced numerous postcards – many of scenes on the river – and published a series of historical handbooks on different stretches of the Thames.

The commercial photographic firm of York & Son was founded when Frederick York (1823–1903) moved to London in about 1861. The company covered much of the country, but sadly only the London negatives have survived. York & Son specialised in architectural and topographical work and their photographs may be seen in a wide range of illustrated books published at the end of the nineteenth century. They also produced stereoscopic cards and lantern slides, which were sold in large numbers. Frederick York died in 1903 and was succeeded by his son William. The company was taken over in 1912 by another well-known photographic firm, Newton & Co., many of whose negatives also are held by the NMR. Newton & Co. continued to use the name York & Son when marketing the earlier material. The surviving part

of the collection was acquired by Peter Jackson, the renowned illustrator and prolific author on the history of London, who since 1974 has been Chairman of the London Topographical Society. Generously, he donated the collection to the NMR in 1995.

An amateur photographer, S. W. Rawlings, who worked for the Port of London Authority from 1921 to 1965 and thus had privileged access to the river, recorded the Thames before and after the Second World War. His photographs show the river still bustling with activity and industry. Stanley Rawlings began his service with the PLA in the Engineer's Department at the West India Docks, and in 1931 he joined the newly formed Public Relations Department. After war service in the Royal Engineers, he returned to the PLA as its Photographer. He was promoted to Chief Clerk in 1959, but continued to contribute photographs of the river to books and magazines.

More recently, Paul Barkshire has photographed the changes from derelict waterfront to commercial regeneration in the 1990s. Two books of his photographs have been published, illustrating the unknown and unexplored corners of the capital. The Royal Commission's staff photographers, so often anonymous, surveyed individual buildings and whole areas under threat from the 1950s until 1999, since when they have continued under the auspices of English Heritage. Derek Kendall, with the Royal Commission for 26 years, is now a senior photographer at English Heritage specialising in the photography of London's architectural landscapes. His publications include *The City of London Churches* (1995), and his most recent exhibition – *Scene Unseen* – documents the hidden spaces of all London's West End theatres. He has lived on boats for the past 22 years and is currently converting an historic Dutch barge moored in South London.

FURTHER READING

The number of books published on London must exceed that on any other world city. It is, therefore, difficult to suggest the most appropriate for all readers. However, of the more recent general histories, *London: A History* (1998) by Francis Sheppard, former general editor of the Survey of London, may be recommended without reservation. *The London Encyclopaedia* (revised 1993), edited by Ben Weinreb and Christopher Hibbert, is a mine of information. *Imperial London* (1995) by M. H. Port covers the development of the capital as a world city and includes much on public works. *The Art and Architecture of London* (1988) by Ann Saunders looks at the capital from an art-historical perspective. Hermione Hobhouse's *Lost London* (1971) covers just that: the important losses in London's historic building stock over the previous 150 years. With a few exceptions, the relevant volumes of the Royal Commission on the Historical Monuments of England and the Survey of London were published early in the twentieth century and, sadly, there is little chance of revised editions being produced.

Some authors have been so taken with the Thames and its history that they have written several volumes of romance and reminiscence. In the 1930s there were notable works by James Jones, A. G. Thompson and Frank Bowen, while much later came L. M. Bates, although he tended to look back to the river's heyday in the 1930s and 1940s. The eminent architectural photographer Eric de Maré (three of whose photographs are reproduced in this book) also wrote on riparian themes, including canals, bridges and the Thames, in the 1950s.

Specifically for architecture, the *Buildings of England* series is without equal. Begun by Sir Nikolaus Pevsner alone in 1952 and covering the whole of the country by 1974, the various volumes on London have been revised several times. The most recent by Bridget Cherry and Simon Bradley are packed with information as well as perceptive comment and observation. It is planned to cover London in six volumes, four of which have appeared so far in the revised and expanded format. However, earlier editions remain invaluable. In addition, in 1998 the Buildings of England Trust published a slim volume on *Docklands* by Elizabeth Williamson, which includes information to the usual impeccable standard on an important part of the area covered by this book. In 1995 the Survey of London published *Docklands in the Making*, derived from its massive two-volume work *Poplar, Blackwall and the Isle of Dogs, the Parish of All Saints, Poplar* (1994). *Dockland*, edited by R. J. M. Carr and published in 1986, is a survey of the industrial archaeology of the whole of the docks' area with a useful gazetteer compiled before the changes of the 1990s. Another very useful and perceptive work on the capital's architecture is the *London* volume (1991) by Elain Harwood and Andrew Saint in the *Exploring England's Heritage* series published for English Heritage. The present author's *London's Bridges* (1983) has information on the bridges of the

tidal Thames, illustrated with many early photographs. *Thames Crossings* (1981) by Geoffrey Phillips includes bridges and tunnels along the whole length of the river. There are of course any number of monographs of varying size and quality on individual buildings and structures, the more useful appearing in the bibliographies of some of the books quoted above. On local areas there are the relevant volumes of the *Britain in Old Photographs* series published by Sutton.

There are many references in this book to working boats on the Thames and again there is a plethora of publications on this subject. The more useful general works include *The Chatham Directory of Inshore Craft* (1997) and Eric McKee's *Working Boats of Britain* (1983). *Shipbuilders of the Thames and Medway* (1971) by Philip Banbury includes information on the boats as well as the industry. Another very informative book is D. G. Wilson's *The Thames: Record of a Working Waterway* (1987), which covers working boats from the earliest times and how they were used, as well as including much about trade on the river. English Heritage published *Ships of the Port of London* in two volumes in 1994 and 1996, which record the many archaeological finds of ship and boat remains in the river and on shore.

ACKNOWLEDGEMENTS

Anna Eavis invited me to put together this collection of photographs in order to bring to a wider public some of the riches of the National Monuments Record archive. I hope that the result may have come somewhere near her original intention and my special thanks go to her for constant support and encouragement. Also a number of friends have been especially helpful and I am much indebted to Alan Aberg, William Chapman, Derek Kendall and Tony Rumsey.

Paul Barkshire and Bernard Howarth Loomes have been very generous in allowing me to use photographs from their collections in the NMR and I am most grateful to them. Many former colleagues in the NMR and staff in other organisations have taken the trouble to help me and I would like to thank particularly the following: Helen Wood (Business Archives Council), Patrick Anderson (City of Westminster Archives Centre), Jane Wilson (Corporation of Trinity House), John Fisher (Guildhall Library), Keith Mackintosh (HMS *Belfast*), Geoff Pick (London Metropolitan Archives), Jenny Hill and Michael Melia (National Maritime Museum), David Birks, Jean Irving, Jonathan Proudman, Ian Savage (National Monuments Record), Mike Seaforth, Robin Taylor, June Warrington (English Heritage), Caroline Johnson (National Motor Museum), David Ashby (Naval Historical Branch MoD), Margot Charlton (Oxford Word & Language Service), Alison Wareham and Jo Hanford (Royal Naval Museum).

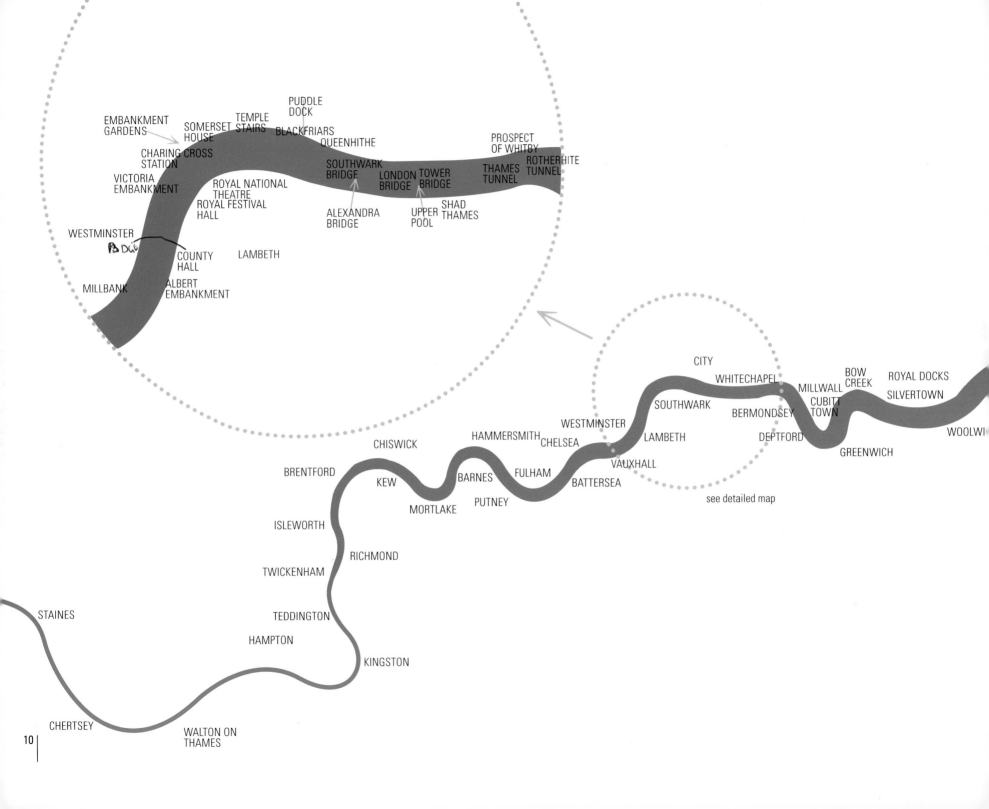

EMBANKMENT
GARDENS
SOMERSET
HOUSE
TEMPLE
STAIRS
PUDDLE
DOCK
BLACKFRIARS
QUEENHITHE
PROSPECT
OF WHITBY
CHARING CROSS
STATION
SOUTHWARK
BRIDGE
LONDON
BRIDGE
TOWER
BRIDGE
THAMES
TUNNEL
ROTHERHITE
TUNNEL
VICTORIA
EMBANKMENT
ROYAL NATIONAL
THEATRE
ROYAL FESTIVAL
HALL
ALEXANDRA
BRIDGE
UPPER
POOL
SHAD
THAMES
WESTMINSTER
BDG
COUNTY
HALL
LAMBETH
MILLBANK
ALBERT
EMBANKMENT

CITY
WHITECHAPEL
BOW
CREEK
ROYAL DOCKS
SILVERTOWN
MILLWALL
CUBITT
TOWN
SOUTHWARK
BERMONDSEY
WESTMINSTER
CHISWICK
HAMMERSMITH
CHELSEA
LAMBETH
DEPTFORD
WOOLWI
BRENTFORD
VAUXHALL
GREENWICH
KEW
BARNES
FULHAM
BATTERSEA
see detailed map
MORTLAKE
PUTNEY
ISLEWORTH
RICHMOND
TWICKENHAM
STAINES
TEDDINGTON
HAMPTON
KINGSTON
CHERTSEY
WALTON ON
THAMES

10

ARKING
REEK DAGENHAM

HAMESMEAD

ERITH

WEST THURROCK

YANTLET CREEK

TILBURY

GREENHITHE

GRAVESEND

THE LONDON STONE, STAINES

12 | H. W. Taunt, c.1883. CC76/238

The London Stone is the ancient boundary marker of the jurisdiction of the City of London. The conservancy of the River Thames had been vested in the Lord Mayor and Corporation of London by long tradition and confirmed by various charters and acts of Parliament. Their jurisdiction extended from Staines in Middlesex in the west to Yantlet in Kent in the east. Prior to the late nineteenth century, the stone stood on an island in the river. The shaft is probably seventeenth century and was set upon its present plinth in 1826. However, the inscription suggests that it is a much more ancient stone, being erected originally in 1285 and raised upon its new pedestal 'exactly on the spot where it formerly stood, ... on the 29th day of July AD 1826'.

In this photograph, swan-uppers from the Dyers' Company pose around the stone for the photographer. Since the Middle Ages, swans had been held to belong to the monarch. The exceptions were certain birds on the Thames, which had been granted to two City livery companies – the Vintners and the Dyers. The ceremony of swan-upping dates from the fifteenth century and takes place each July between Sunbury and Pangbourne. The liveried swan-uppers proceed upstream by boat to inspect the adult birds and mark the year's cygnets for ownership. Those belonging to the Dyers' Company are marked on the beak with one nick and with two nicks for the Vintners. The monarch's swans remain unmarked.

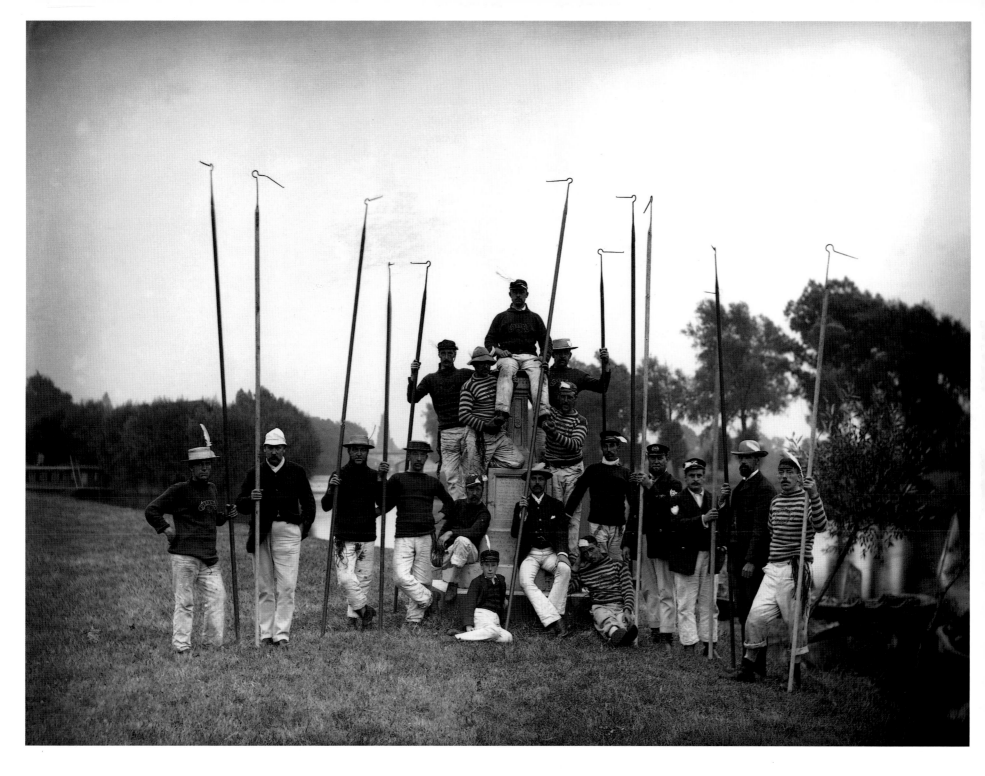

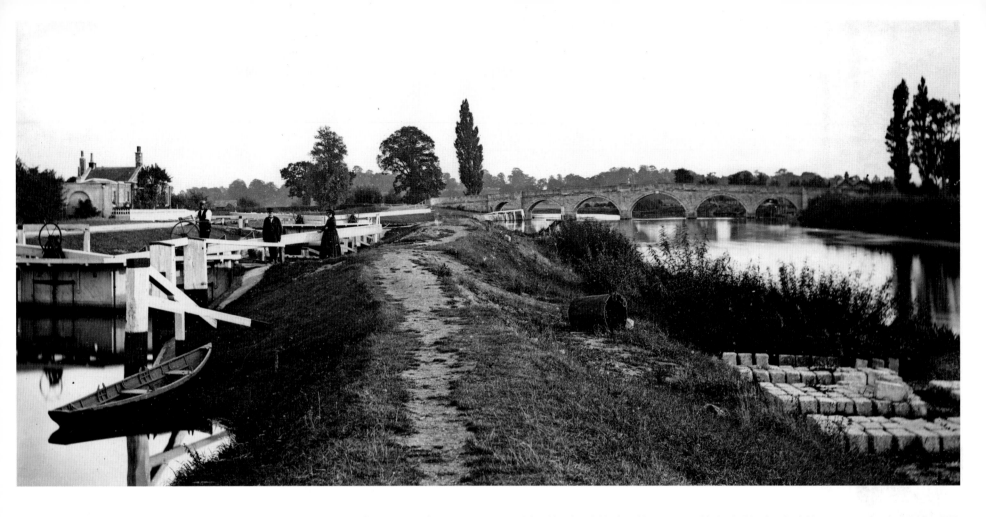

CHERTSEY LOCK AND BRIDGE

H. W. Taunt, c.1875. CC72/509

The Surrey town of Chertsey grew up around the abbey founded in the mid seventh century. A ferry is presumed to have existed here long before the first documented reference at the end of the thirteenth century and its limitations led to the building of a timber bridge soon after 1410. By 1779 and despite numerous repairs, the wooden crossing, also known as Littleton Bridge after the parish on the Middlesex bank, was so dilapidated that a special Commission of Surrey and Middlesex Justices was summoned to decide on its future. One of the members was James Paine, the architect with a successful country-house practice, who was a Justice of the Peace for both Surrey and Middlesex. Together with the county surveyor, Kenton Couse, Paine put forward plans for a new stone bridge. These were accepted and work began in the middle of 1780. Problems arose as a result of confusion over the contract with the builder, but the bridge was completed on 7 May 1785. Chertsey Bridge was damaged severely in 1891, when a barge – the *Sylvie* – broke loose from her moorings and struck one of the piers. There were fears that the whole would have to be rebuilt, but the engineer Sir Benjamin Baker was able to reconstruct the centre arch and the bridge survives to this day. To the left in this photograph is one of the locks constructed as a result of John Rennie's recommendations in 1810. At this point the former county boundary loops inland on the Middlesex shore (left) indicating an earlier meander of the Thames cut through when the lock was built to form the present channel. This tranquil scene is now the site of a double concrete bridge constructed in 1968–71 to enable the M3 motorway to sail over the river just upstream from the lock and weir.

This stretch of the river near Walton was photographed by Henry Taunt before 1875 and shows a truly rural scene, rarely to be found even on the upper reaches controlled by the former Thames Conservancy. Many meanders of the river were breached by locks or new cuts and the banks reinforced to withstand the wash of boats, although strict speed limits have been maintained. As well as being built upon, the flood plains on both banks were favoured for the construction of reservoirs throughout most of the twentieth century. The result is that few water meadows survive. Those that do, such as at Petersham, are carefully controlled. On the Middlesex bank of Syon Reach, in the grounds of Syon House, the seat of the dukes of Northumberland, is a rare example of a preserved tide meadow – flooded twice a day.

WALTON ON THAMES

H. W. Taunt, c.1870. CC72/486

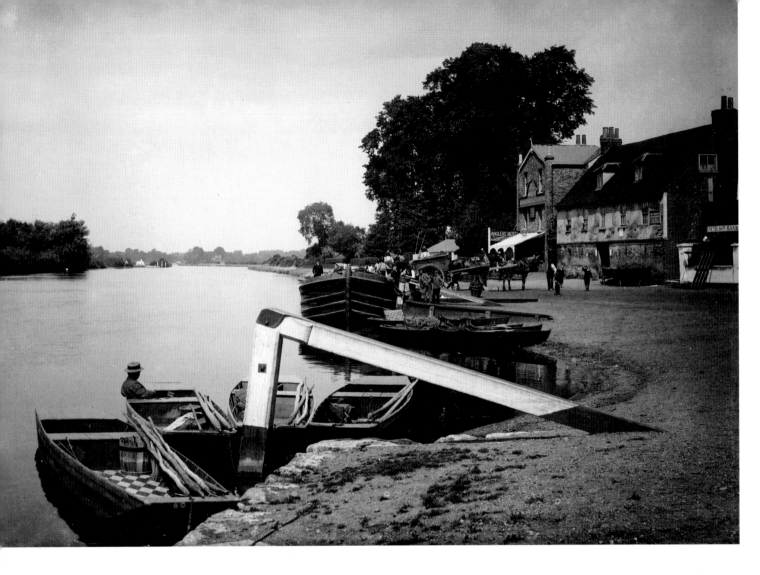

ANGLERS' HOTEL, WALTON

H. W. Taunt, 1880s. CC73/1096

With the coming of the railways, this stretch of the river became enormously popular with anglers on a day's excursion from London. This popularity brought its own problems and resulted in the Thames fishery by-laws, which established a closed season and limited the size and number of fish caught. The Halls in their *Book of the Thames* (1859), which inspired Taunt, and numerous editions of *Kelly's Directory* comment on the famous fishing ground here. Henry Taunt in his guide of 1872 noted that 'Walton is one of the best pitches for bream on the Thames ... and, in places all the way to Sunbury Weir, bream and barbel are to be found. Chub likewise and dace exist along the Middlesex shore, whilst now and then trout make their appearance. Roach fishing, however, is better than any other, and is mostly practised by the fishing visitors'. He went on to recommend the Anglers' Hotel, seen here. Also he noted where boats might be hired – skiffs and punts are to be seen moored in front of the barge unloading alongside the hotel. Taunt was at pains to point out that 'At all the fishing places ... will be found fishermen who make it their business to prepare the ground and supply punt, etc., for the day's fishing; and as far as possible we have taken every care to give a correct list of these men at each place'.

Industries developed on Platt's Ait or Eyot – the usual Thames terms for island – from the mid nineteenth century. Unsurprisingly, boat building was foremost and the others were a waterworks and an electrical works with a charging station to power pleasure launches and electric canoes built on the island. John Isaac Thornycroft, an inventor of high-speed boats, established a yard at Chiswick from the 1860s developing fast naval vessels for carrying torpedoes. Admiralty contracts followed in the 1880s and his success led Thornycroft to transfer to Southampton in 1904. At about this time he set up a small yard on Platt's Ait. In 1916 the Admiralty commissioned a fast launch that would be capable of skimming safely over mined water and carrying a torpedo. These were built by Thornycroft in great secrecy from 1916 on Platt's Ait. Four sheds (confusingly numbered 1, 2, 4 and 5) were specially built on the island by Augustine Alban Hamilton Scott, probably in 1916, although it is claimed that they may date from two or three years earlier. The one illustrated here, Shed No. 5, is much longer and wider than the others and is curved to follow the sluice of the original waterworks excavated in 1888, which survives as a wet dock. All four sheds are remarkable examples of timber construction using Belfast trusses. The Belfast system was developed during the First World War to roof aircraft hangars and other wide structures, but its use for boat sheds is exceedingly rare.

PLATT'S AIT, HAMPTON

Derek Kendall, RCHME, January 1998. BB98/2975

David Garrick, the highly successful actor and manager, first rented a house known as Fuller House at Hampton in 1754. Later the same year he bought the property and employed Robert Adam to remodel the house, henceforth called Garrick's Villa. Like many waterside houses, the villa was separated from its gardens on the riverbank by a public road. Garrick had a tunnel excavated beneath the road with an entrance grotto, possibly designed by 'Capability' Brown. At the time, Brown lived nearby at Hampton Court where he was Master Gardener. In the secluded garden Garrick built a small octagonal temple dedicated to the memory of Shakespeare. It was to house Roubiliac's Shakespeare statue of 1758 (now in the British Museum), and it has been plausibly suggested that Roubiliac himself may have designed the temple. In 1923, Paul Glaize, who had a house-boat moored at Tagg's Island, purchased the Shakespeare Temple and added to it a three-storey house, known as Temple House. This crass addition caused much bad feeling in the area and in 1932 the property was bought by Hampton Urban District Council, which demolished the house and converted the grounds into a public park. A major restoration of the Shakespeare Temple and its landscape setting was completed in April 1999 by the architects Donald Insall Associates. The interior houses an exhibition of the life of Garrick arranged by the Temple Trust, which is dedicated to the preservation of historic garden buildings, and includes a replica of Roubiliac's statue of Shakespeare.

GARRICK'S SHAKESPEARE TEMPLE, HAMPTON

Sid Barker, RCHME, August 1998. BB98/13078 (left)
Eric de Maré, 1949. AA50/1665 (right)

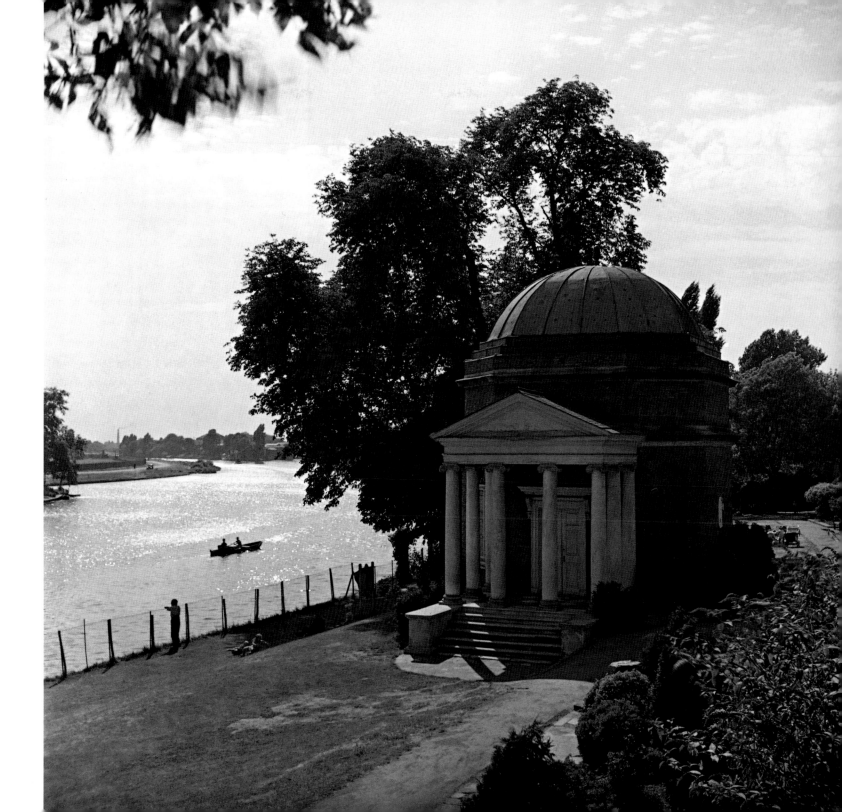

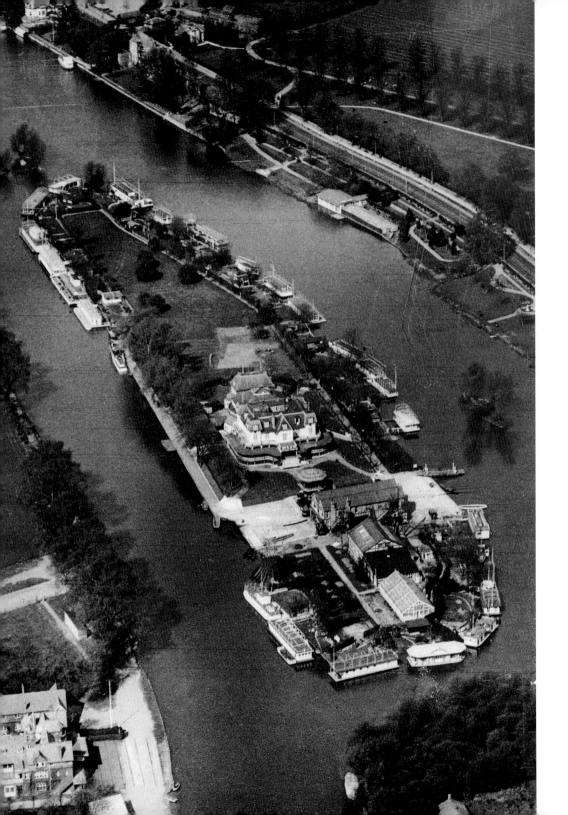

Tagg's Island was named after a boat builder, Thomas George Tagg, who built an hotel on the island in 1873. Formerly it was known as Walnut Tree Ait and was notable for growing osiers used for basket making. Tagg's hotel was taken over by the impresario Fred Karno, who in the early years of the twentieth century toured troupes performing slapstick comedy. Charlie Chaplin and Stan Laurel both started in Karno's shows and made their first visits to America with his companies. The hotel on Tagg's Island was renamed The Karsino when it reopened in 1913 after a lavish conversion. In addition to the hotel, the resort included a concert hall, boathouse and many seasonal attractions, which Karno, never one to undersell himself, boasted was 'the hub of the universe for river people'. As may be seen from this aerial view taken from the south-east, numerous house-boats were moored around the island. Fred Karno's house-boat was one of the most luxurious. Inevitably, the First World War dealt a blow to the entertainment industry and The Karsino's trade declined. It revived briefly after the war and was renamed the Casino Hotel, but never regained its earlier popularity. In 1928 the resort reopened as the Thames Riviera with the added attraction of a vehicle ferry to transport cars to the island. It closed in 1940 and despite attempts to revitalise it or find alternative uses the hotel was eventually demolished in 1971.

TAGG'S ISLAND, HAMPTON

Unknown photographer, 1930s. BB81/7000

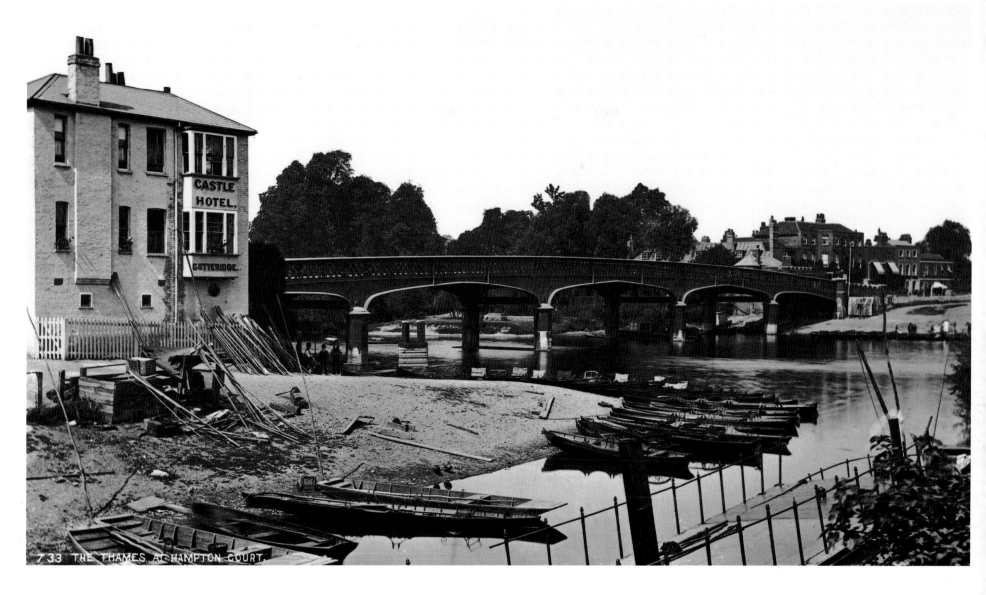

733 THE THAMES AT HAMPTON COURT.

The bridge shown in this photograph was the third on the site. The first wooden bridge, replacing an ancient horse ferry, was opened in 1753, but survived for only 25 years. It was replaced by another wooden structure, which remained in use for nearly 90 years. Thomas Allen, the owner of Hampton Court Bridge, commissioned E. T. Murray to design a new cast-iron bridge, which was begun in May 1864 and opened on 10 April 1865. Its appearance never met with approval: a contemporary described it as 'one of the ugliest bridges in England, and a flagrant eyesore and disfigurement both to the river and to Hampton Court'. With very few exceptions, bridges over the Thames were built by private enterprise and were a great source of wealth to their owners. Allen, for example, earned more than £3000 per year in tolls, until the bridge was acquired for £48,048 by a joint committee of the Hampton and Molesey Local Boards and the Corporation of London to be freed in 1876.

HAMPTON COURT BRIDGE

York & Son, 1890s. CC97/1382

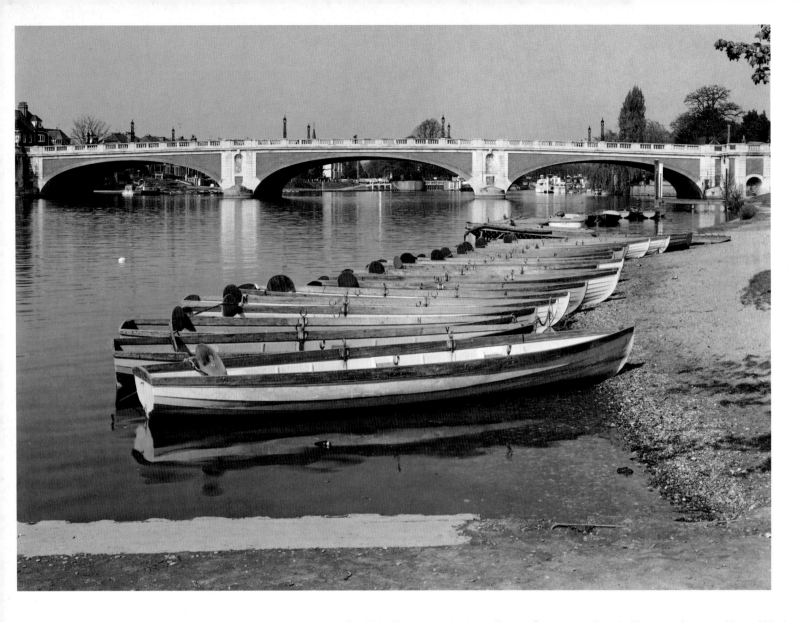

HAMPTON COURT BRIDGE

Paul Barkshire, April 1982. 1694

The third bridge to cross the river at Hampton Court came to the end of its useful life with the increase in motor traffic in the early twentieth century. Permission to build the present bridge was granted by Act of Parliament in 1928. The same Act authorised two other Thames bridges – Twickenham and Chiswick – which were necessary for the construction of the Great Chertsey Road, one of the grand arterial roads planned in the 1920s. The sleek new bridge at Hampton Court was designed by Sir Edwin Lutyens, perhaps the most famous architect of his time, and the Surrey county engineer, W. P. Robinson. It was built slightly downstream from the old bridge in order to avoid any interruption to traffic. Work began in September 1930 and the official opening ceremony was performed on 3 July 1933 by the Prince of Wales, his third such appointment of the day after Chiswick and Twickenham. As may be seen from this view and the photograph of the old bridge, skiffs for hire are still available here.

The resplendent palace on the Middlesex bank of the Thames downstream from the village of Hampton is one of the most celebrated buildings in England. The manor came into the hands of the Church in the early thirteenth century and in 1514 was leased to Thomas Wolsey, Archbishop of York. Wolsey had risen from humble origins to become Cardinal and Lord Chancellor under Henry VIII. He began to build a house to equal his position in magnificence. As the *Buildings of England* (1983) observed: 'Wolsey's Hampton Court was the greatest of all houses built in England at the time'. Wolsey's extravagance incurred the king's displeasure and in the hope of avoiding a fall from favour Wolsey presented the palace to Henry in 1525, but even this failed to save him from disgrace and imprisonment. Henry VIII was very partial to his new acquisition and its situation on the Thames, which had led Wolsey to select the site in the first place, made for ease of communication with London. The general layout of the Tudor palace, seen ranged around the lower two courtyards in this aerial view from the north-west, was established by Wolsey. It was greatly enlarged by the king, who appears to have spent more on Hampton Court than on any other of his palaces, with the possible exception of Greenwich. Little was added by subsequent monarchs until the accession of William III and Queen Mary. William, whose asthma was aggravated by the London air, spent much of his time at Hampton Court and employed Sir Christopher Wren to build up-to-date state apartments. Work began in 1689 and was completed after William's death in the reign of Queen Anne. Wren designed the grand ranges around Fountain Court, to the east (top in this view). The principal south elevation overlooked a formal Privy Garden in the Dutch manner leading down to the river. This has been restored to its former glory since this photograph was taken. The re-creation was made possible as a large amount of documentary evidence survived and this was supplemented by a detailed two-year archaeological investigation. The Privy Garden reopened in July 1995. The Palace has been open to the public since the accession of Queen Victoria in June 1837.

HAMPTON COURT PALACE

Roger Featherstone, RCHME, 1975, NMR 891/244

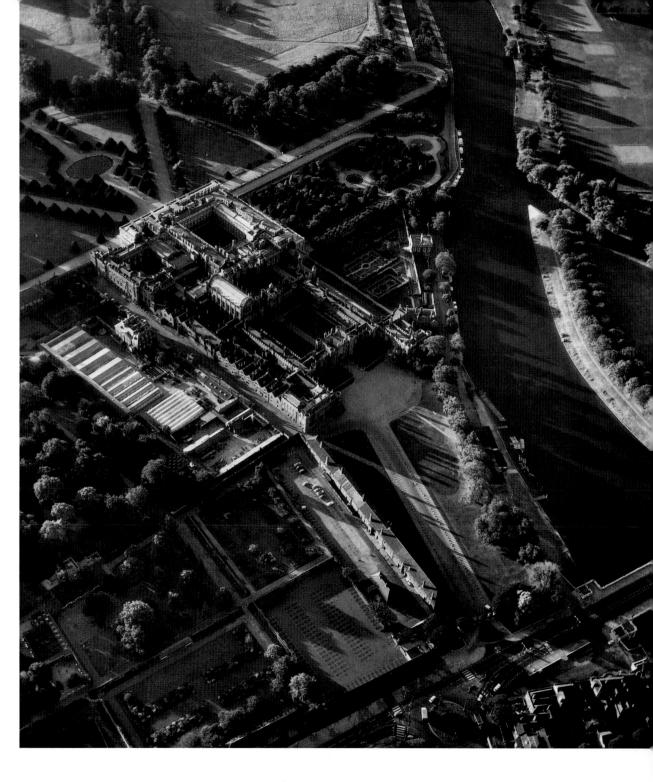

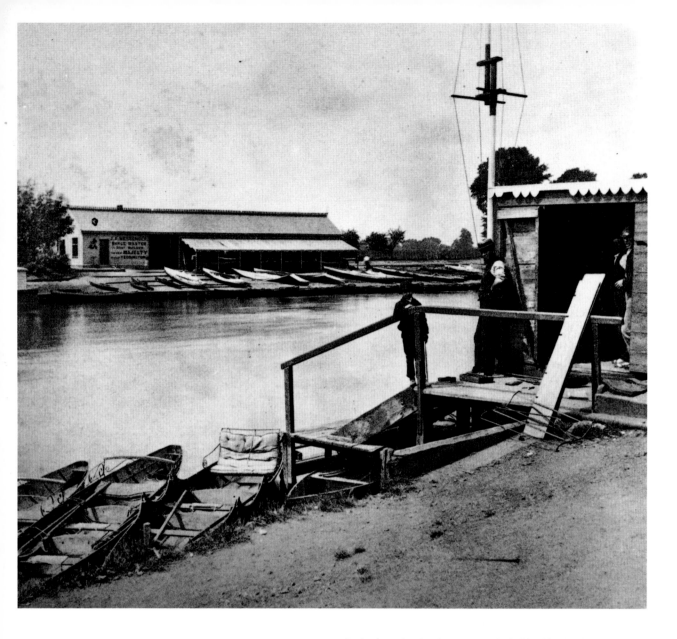

SURBITON FERRY, KINGSTON

Unknown photographer, 1860s.
Howarth Loomes Collection, BB83/3176a

Ferries have played an important part in the life of the river from the earliest times. Apart from the few permanent crossings, the only other means of crossing was to ford the river – rarely possible except during the driest seasons or at the lowest tides. There were at least six ferries between Hampton Court and Kingston on the long loop of the Thames around Hampton Court Park. Some of the sites were of great antiquity, although these may be difficult to trace as both their names and locations changed constantly. This mid-nineteenth-century photograph of the ferry linking Surbiton with the Middlesex bank shows the basic accommodation of ferry-man's hut with its signal mast and across the river the boatyard of James Arthur Messenger – 'Barge Master and Boat Builder to Her Majesty' – of the well-known boat-building dynasty at Teddington. A surprising number of ferries still operate.

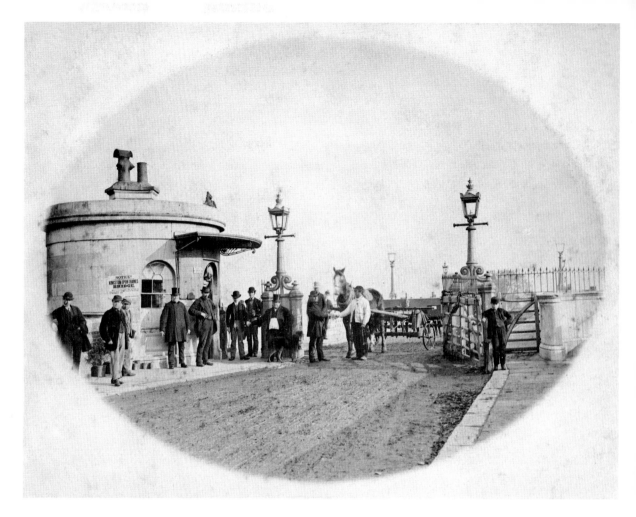

There had been a bridge over the Thames at Kingston since the late twelfth century. During the next 600 years the structure became increasingly dilapidated and a hazard to shipping. In addition, its narrowness was a problem for traffic. Throughout the eighteenth century there was pressure for a complete rebuild, but there was no agreement over responsibility or funding. Eventually in 1813 the courts became involved and two years later ordered Kingston to repair the bridge from its own resources. However, events had overtaken them when a severe frost in January 1814 caused part of the bridge to collapse. The old bridge was repaired, but it was obvious that a replacement was needed. An Act of Parliament was passed in 1825 to empower the town to build a new bridge. Plans were prepared by the Surrey county surveyor Edward Lapidge and work began in November 1825 on a new site upstream from the old. The formal opening took place on 12 July 1828, performed by the Duchess of Clarence, the future Queen Adelaide. Agitation to free the bridge from tolls gathered pace until permission was secured in 1869. The great event was arranged for 12 March 1870. In the photograph of the gates at the Hampton Wick end of the bridge a poster is clearly displayed on the toll-house announcing the freeing of the bridge. Some formality is being enacted in this photograph, but it does not appear to be the ceremony which was performed in front of large crowds accompanied by a guard of honour, military bands, a parade and a huge firework display. The popular celebrations continued for three days. However, the narrow road became a problem as traffic increased and in 1911 the engineers Mott & Hay were engaged to widen the bridge on the downstream side. It was reopened in October 1914.

KINGSTON BRIDGE

Unknown photographer, 1869. BB60/1517

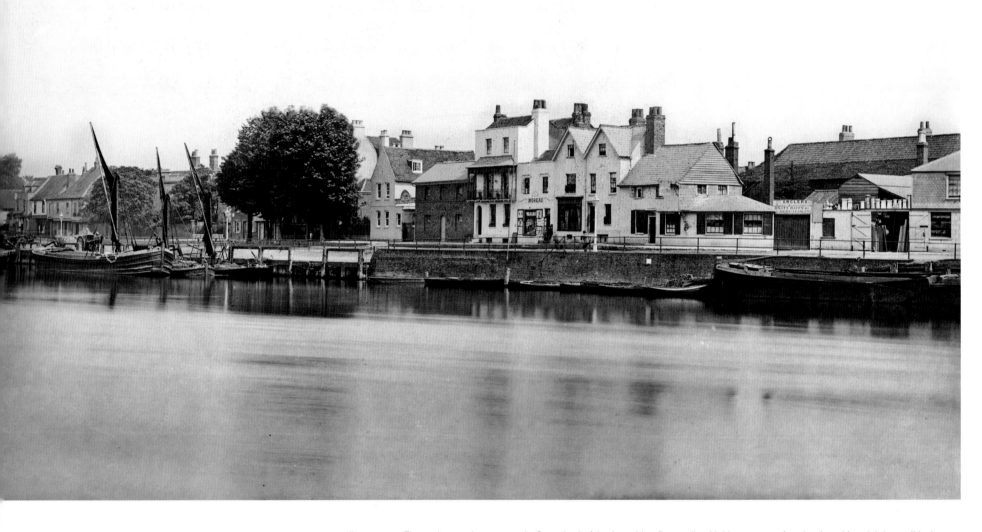

THAMES SIDE, KINGSTON

H. W. Taunt, c.1880. CC72/780

Kingston upon Thames is an ancient town on the Surrey bank of the river with an early crossing. The name is thought to derive from its association with Saxon kings who resided here from at least the seventh century. The stone where they were supposed to have been crowned remains off the High Street. The town's importance grew in the Middle Ages, with the first recorded charter being granted in 1200. There was a bridge here by 1193, the first medieval bridge upstream from London, although it is possible that one existed much earlier. The river here was tidal until the construction of the locks downstream in the early nineteenth century. Thames Side, downstream from the bridge, retained its small scale until relatively recently, when from 1981 Bentall's department store was redeveloped by the architects Ahrends, Burton & Koralek to include terraces down to the river.

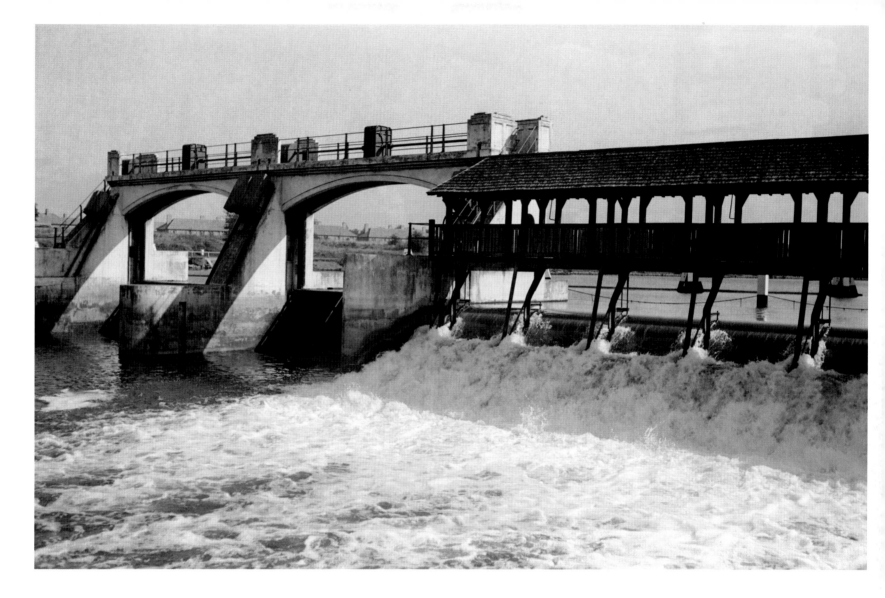

John Rennie, engineer of London Bridge, recommended the construction of several locks and weirs on the river in order to improve navigation. As its jurisdiction ran as far upstream as Staines, the City Corporation was able to build the first pound lock at Teddington. This was opened in 1811 and the weir was completed in the following year, despite fierce opposition from local fishermen and bargemen, who tried to smash the lock. Thereafter, the lock keeper was allowed a 'blunderbuss with bayonet attached thereto' to deter vandals. Below the weir, the Deeps – areas of the river protected in order to facilitate the sport of the angler – became a favoured fishing ground for the amateur rather than the commercial fisherman. The lock still marks the limit of the tidal reach of the Thames and the jurisdiction of the Port of London Authority. Larger locks were built in 1857 and 1904 and again in 1950. By 1904 there were three locks, the largest able to accommodate a tug and six lighters. At the turn of the century the craze for boating was at its height and the locks at Teddington attracted hundreds of pleasure boats at holiday times.

TEDDINGTON WEIR

S. W. Rawlings, 1950s. A515

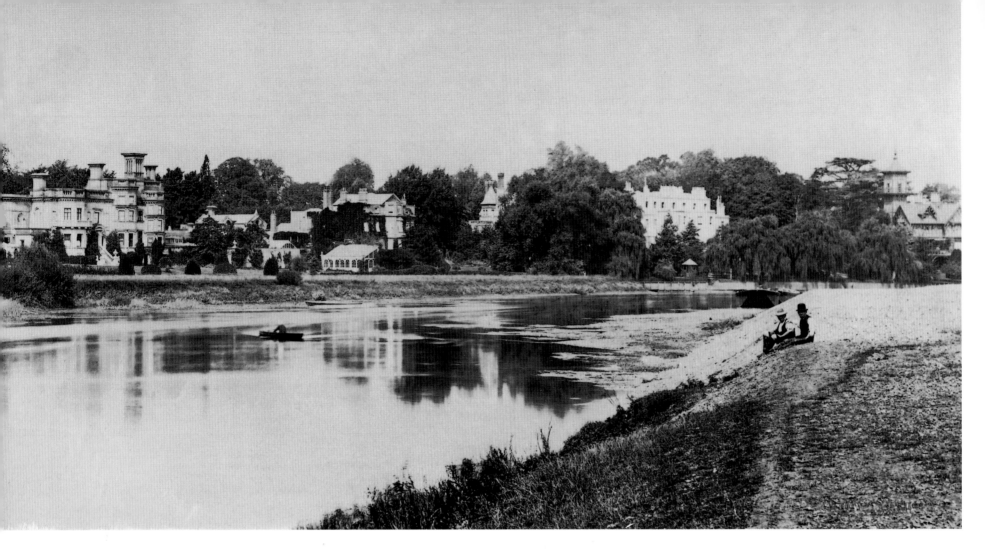

CROSS DEEP

H. W. Taunt, 1880s. BB84/2817

In the early years of the eighteenth century this stretch of river upstream from Twickenham village was home to fishermen, maltsters, bricklayers and other small-scale industries. Then in 1719 the poet Alexander Pope (1688–1744) came to live here and remained until his death. Thereafter, the area attracted the nobility and gentry. Pope's villa stood near the right in this view. Voltaire and Swift were among the famous visitors who came to stay. The house was remodelled in Palladian style by James Gibbs in 1719–20 and Pope was advised by Lord Burlington and William Kent on the layout of his garden. The famous grotto survives and has been restored recently. After Pope's death the villa was enlarged, but demolished in 1807–8. The house (far right) was built in 1842–3 to designs by H. E. Kendall for Thomas Young, a tea merchant, who confusingly called it Pope's Villa. Another famous resident was Horace Walpole, who in 1747 purchased a cottage, which he named Strawberry Hill, and transformed it into the most influential early Gothic-revival house in England. It is now a college and just out of sight upstream (left). The large house on the left was Radnor House. This was occupied from 1722 by John Robartes, fourth Earl of Radnor, until his death in 1757. The house, as seen here, had been remodelled in 1846–7 in Italianate style by William Chillingworth. In 1902 it was purchased by Twickenham Council for use as offices, but on 16 September 1940 it was destroyed by bombing.

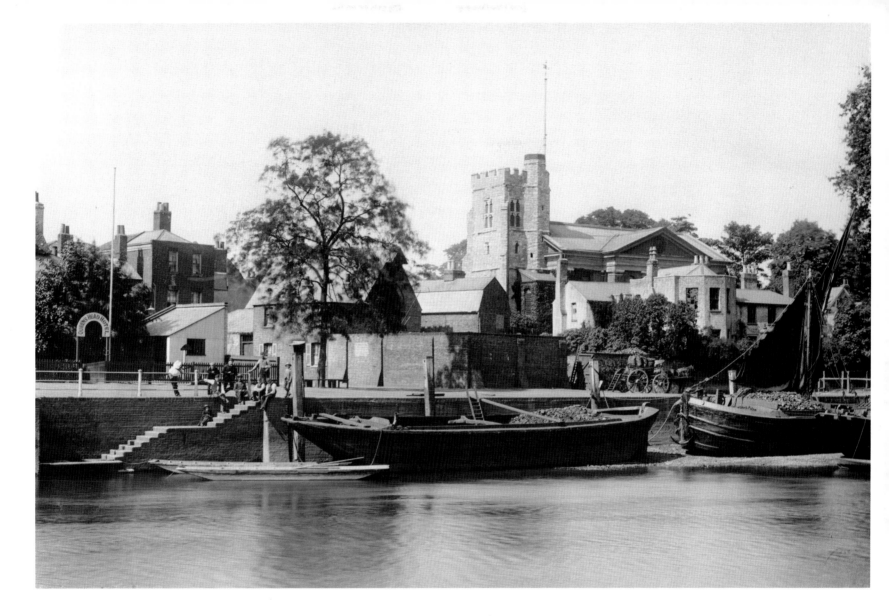

Twickenham is an ancient settlement on the Middlesex bank of a bend in the river. The name first appears in a charter of the eighth century. The old centre around the church is opposite Eel Pie Island – properly Twickenham Ait. St Mary's Church has a late-fourteenth-century tower, but its greater glory is the body of the church, built in 1714–5 to the designs of John James, the original nave having collapsed on the night of 9 April 1713. This photograph shows the vicarage, immediately in front of the church, demol-ished in the early 1890s. In the eighteenth century, Twickenham became increasingly popular with the rich and famous and especially with the literary. Just downstream from the church stood Orleans House by John James, 1710, greatly altered in the nineteenth century and demolished in 1927. However, its most impressive addition, the Octagon designed c.1720 by James Gibbs, survives and in 1962 was bequeathed to the borough as a public art gallery.

TWICKENHAM

Augustin Rischgitz, c.1890. BB99/10002

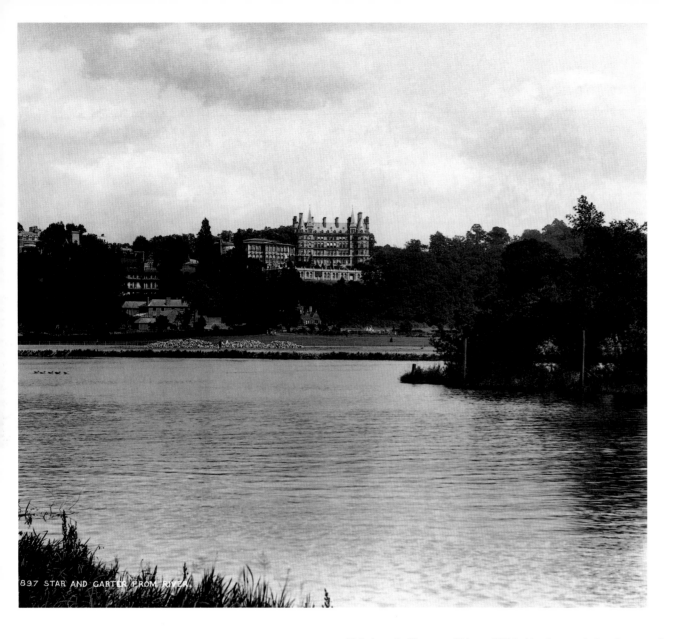

897 STAR AND GARTER FROM RIVER

THE STAR AND GARTER
HOTEL, RICHMOND

York & Son, 1880s. DD97/444

High above the Thames on Richmond Hill, looking down on the broad sweep of Horse Reach, there had been an hotel here since at least 1780. In 1864, Edward Middleton Barry, son of the architect of the Palace of Westminster, designed an imposing new building. The former hotel remained alongside, but in 1870 it burnt down and was rebuilt as a separate ballroom and restaurant by C. J. Phipps. Looking 'more like a stately château on the Loire', the Star and Garter Hotel became a resort for fashionable society who arrived from town by carriage. Later the hotel and its extensive gardens were patronised by day-trippers, particularly members of the newly popular cycling clubs. It fell out of favour and closed before the outbreak of the First World War and was demolished in 1919. The Star and Garter Home for Disabled Soldiers and Sailors, designed by Sir Edwin Cooper, rose on the site and opened in 1924.

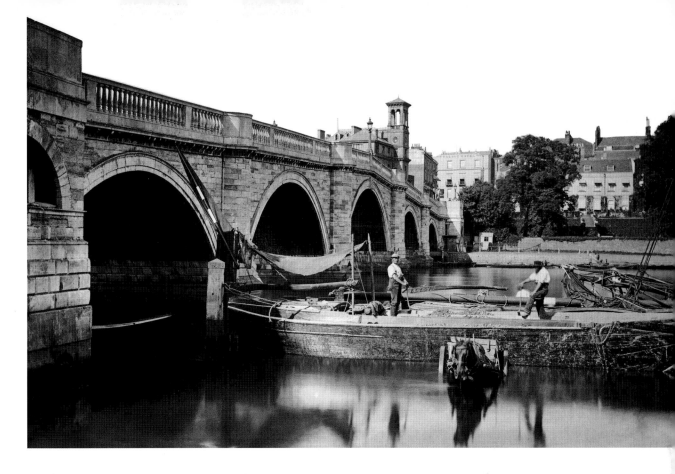

The settlement here grew up around the King's Manor of Shene in the fourteenth century. A ferry is presumed to have come into existence at this time and, as at so many busy river crossings, the inconvenience of a ferry became more apparent as traffic increased and Richmond grew in size and importance. Most early references to the ferry recount accidents or its failure to operate in bad weather. Plans to build a bridge were put forward in the middle years of the eighteenth century and in 1773 an Act was passed to allow its construction. The designers were James Paine and Kenton Couse, their first such collaboration coming a short time before the bridge at Chertsey. Work commenced in 1774 and the bridge was opened to traffic on 12 January 1777, although its completion drifted on for at least another two years. The new bridge was widely praised at the time: 'a simple, yet elegant structure, and, from its happy situation, is … one of the most beautiful ornaments of the river … from whatever point of view the bridge is beheld, it presents the spectator with one of the richest landscapes nature and art ever produced by their joint efforts'. Unusually, finance for the project came from two tontines, one of £20,000 and the other of £5000 in £100 shares. The last survivors of the scheme died in March 1859 and August 1865, aged 86 and 91 respectively. After the death of the last annuitant of the first tontine, the bridge was freed from tolls on 25 March 1859. In the early years of the twentieth century there were proposals to widen the bridge or build another close by, but it was not until 1933 that a scheme was agreed. The Cleveland Bridge and Engineering Company began work in spring 1937 to widen the bridge on the upstream side, but preserving the original facing stones and the elegant appearance that had delighted observers in the 1770s. This photograph shows a barge unloading at the slip that formerly was the site of the ferry and which was covered by the widening of the bridge, completed in summer 1939.

RICHMOND BRIDGE

York & Son, 1870s. DD97/18

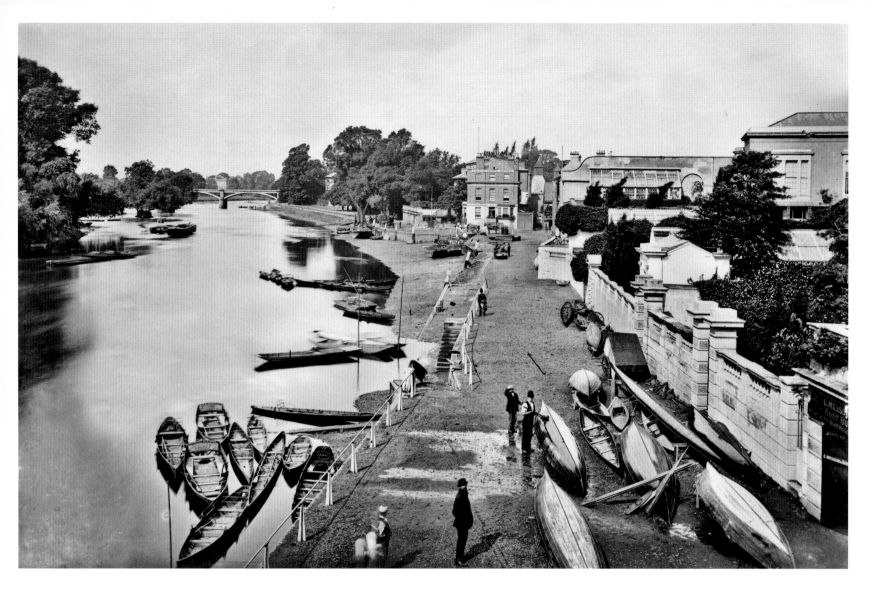

RIVERSIDE, RICHMOND

H. W. Taunt, c.1878. CC74/105 (above)

Paul Barkshire, July 1989. 4608 (right)

Edward III is known to have favoured the royal Manor of Shene or Sheen and died there in 1377. Later monarchs encouraged the development of the palace and the surrounding settlement. The name Richmond appears when Henry VII rebuilt the palace and renamed it after his former earldom of Richmond in Yorkshire. He died here in 1509. The remaining fragment of the Tudor palace is just out of sight in the centre of these views. These two photographs taken looking downstream from Richmond Bridge show a century of change. A wharf remains at Cholmondeley Walk close by the White Cross Hotel (formerly Tavern) and pleasure boats are for hire in the foreground, although no longer repaired and maintained on the walkway. The biggest change is relatively recent. Formerly, to the right were gardens to private houses and the Assembly Rooms, where now there are public terraces. These are part of the complete redevelopment of the waterfront by Quinlan Terry, who employed a mixture of Georgian styles to mask modern office and residential accommodation. This popular and striking development was opened by Her Majesty The Queen in 1988.

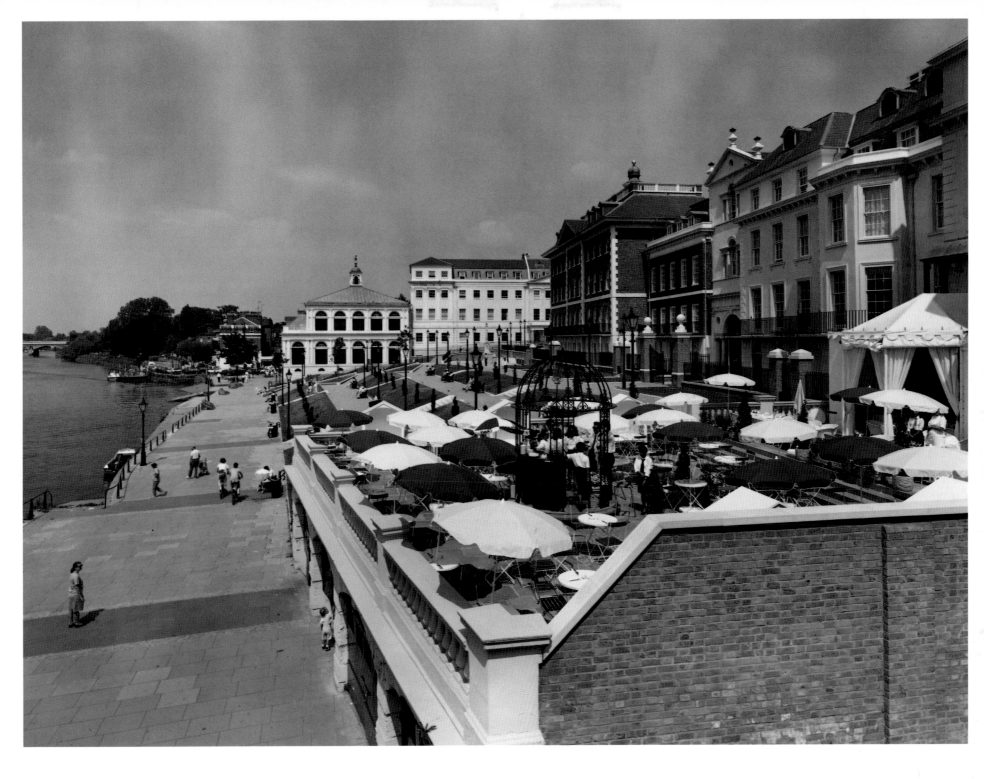

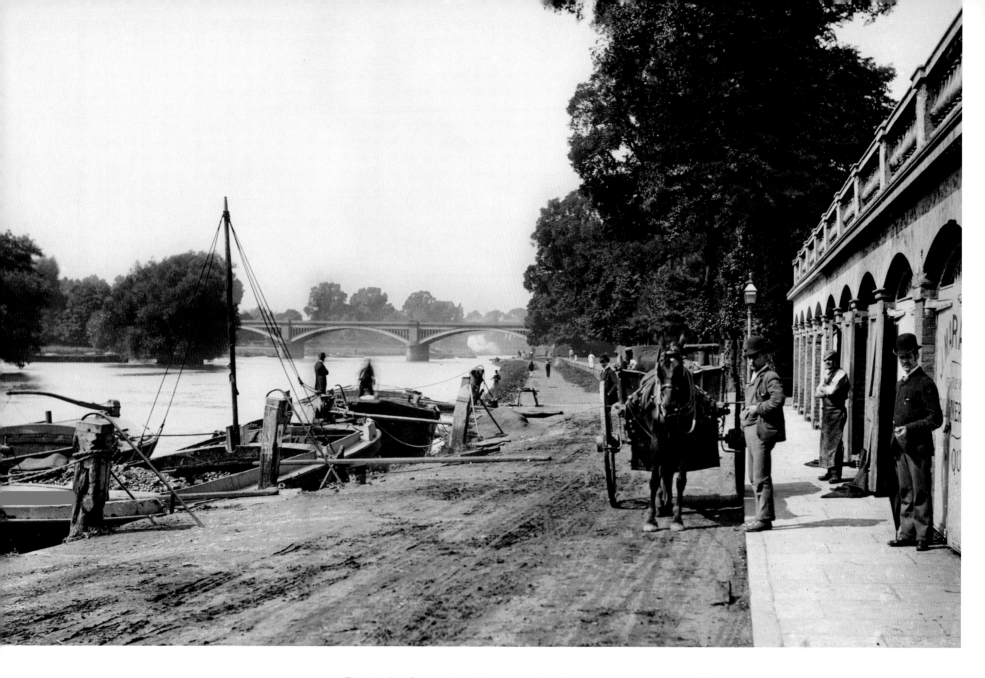

CHOLMONDELEY WALK, RICHMOND

Unknown photographer, July 1890. L.M.S. Collection, CC76/39

This view from Cholmondeley Walk on the south bank shows coal barges being unloaded into the vaults on the right. Formerly, these were boat-houses below the raised gardens of the houses in St Helena Terrace. Later they reverted to their original use. Even at this relatively late date, the photo-grapher with his whole-plate camera attracted the attention of those in the foreground. In the distance there are a good number of walkers on the foot-path leading towards Old Deer Park beyond Richmond Railway Bridge. This is the original 1848 bridge, designed by Joseph Locke, and rebuilt in 1906–8.

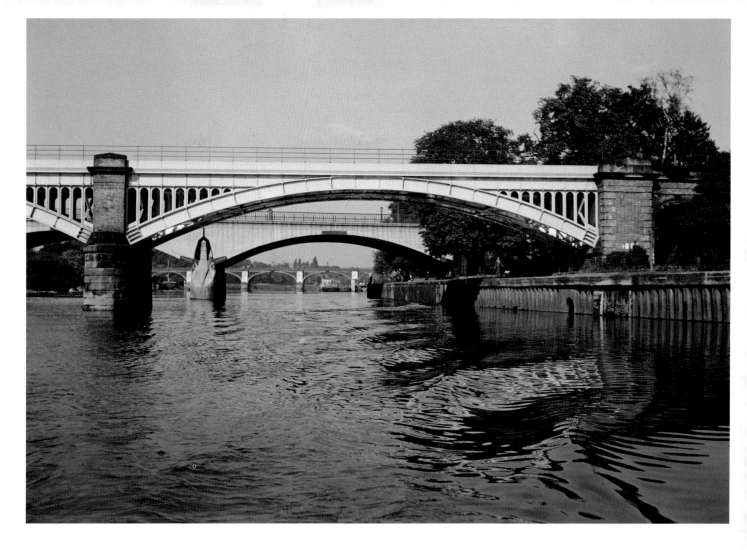

S. W. Rawlings' photograph was taken from a launch travelling upstream towards Richmond and away from a succession of three bridges. In the foreground is Richmond Railway Bridge, then Twickenham Bridge and the footbridge over Richmond lock. This was the last bridge over the tidal Thames to levy a toll. The charge of one penny, suspended for the duration of the Second World War, was never reintroduced. In 1890 permission had been granted to construct a lock and half-tide weir to regulate the river, as the adverse effects of the removal of old London Bridge had been felt this far upstream. The opportunity was taken to include a footbridge as part of the elaborate structure begun in July 1892 under the direction of James More,

engineer to the Thames Conservancy, and F. G. M. Stoney. It was opened by the Duke and Duchess of York (later King George V and Queen Mary) on 19 May 1894. Twickenham Bridge was the second of three bridges opened on the same day, 3 July 1933, by the Prince of Wales. Work had begun in 1931 to the designs of Maxwell Ayrton, architect, and Alfred Dryland, engineer. The bridge in the foreground originally bore the unwieldy title of the Richmond, Windsor and Staines Railway Bridge. Designed by Joseph Locke for the London & South Western Railway, it opened in 1848, two years after the railway had arrived in Richmond. The present bridge is a reconstruction of 1906–8 by J. W. Jacomb-Hood, chief engineer to the London & South Western Railway.

BRIDGES AT RICHMOND

S. W. Rawlings, 1950s. A512

RAILSHEAD FERRY

H. W. Taunt, c.1875. CC72/2178

The figure, obviously posed by the photographer, is waiting for the ferry on the Surrey bank upstream from Isleworth. The river Crane enters the Thames just out of view to the left and the trees on the right are on Isleworth Ait. The ferry was established in the eighteenth century to carry passengers and carriages between St Margarets and Richmond. It ceased to operate during the Second World War. Railshead was an outlying hamlet in the parish of Isleworth in an area once famous for market gardens. The boat house on the opposite bank stands in the grounds of Isleworth House. This was rebuilt about 1832 in lavish Italianate style by Edward Blore for Sir William Cooper, who had been chaplain to George III. Now a convent, it has been renamed Nazareth House.

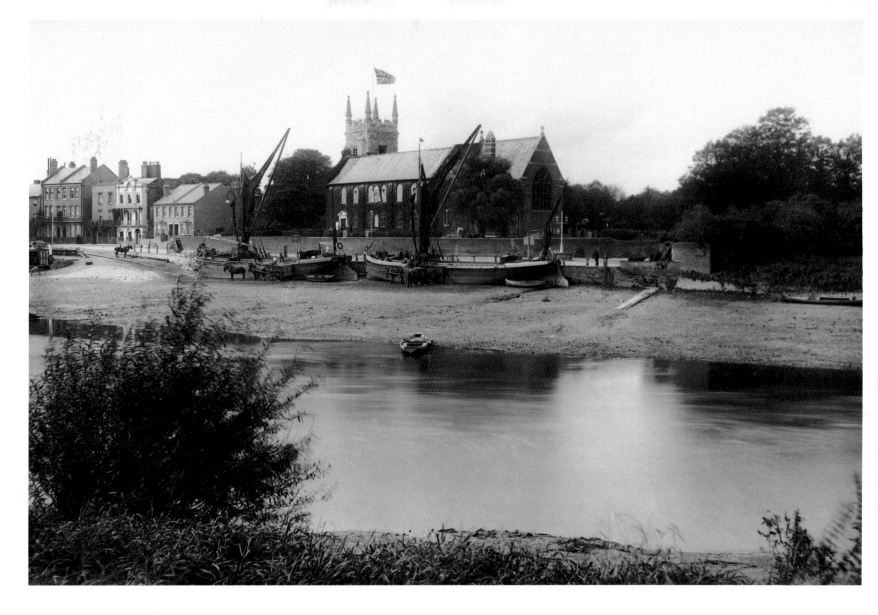

The ancient settlement of Isleworth is centred upon its church, which lies parallel to the river, a feature it shares with a number of Middlesex villages. Immediately downstream is Syon House, originally a medieval nunnery and after the Reformation the seat of the Percys, earls and later dukes of Northumberland. In the 1760s, the first Duke employed Robert Adam to remodel the house. The sumptuously decorated interior included antique columns imported from Italy and delivered directly by boat. The church of All Saints with its late-fifteenth-century tower had a relatively undistinguished nave by John Price, built in 1705–7. The chancel was added in 1866. However, the body of the church was burnt out in 1943, not as a result of enemy action, but by juvenile arson. A new church, incorporating the shell of the nave, was added to the medieval tower in 1967–70 to the designs of Michael Blee. Just upstream is the well-known hostelry, the London Apprentice (see page 38).

ISLEWORTH

Newton & Co., c.1900. CC56/61

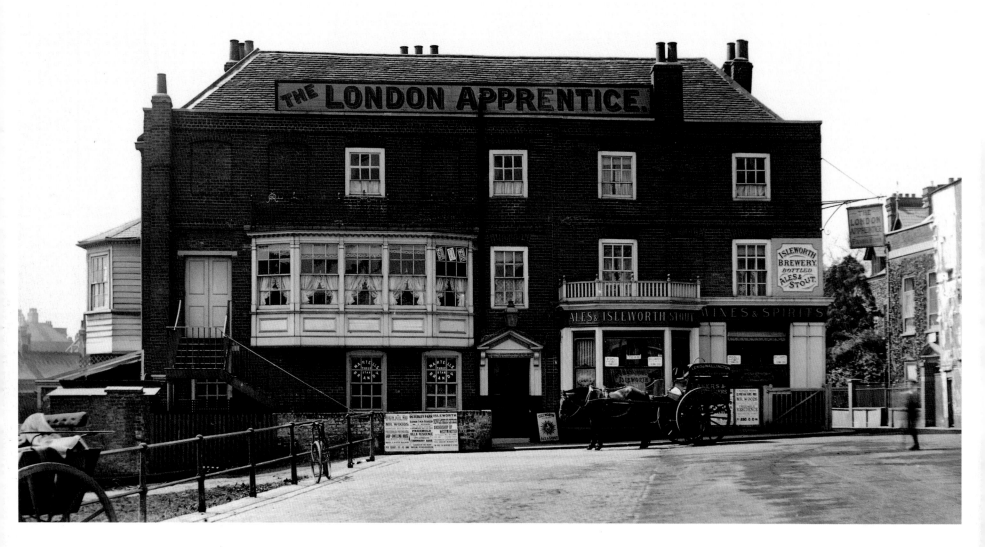

THE LONDON APPRENTICE, ISLEWORTH

Campbell's Press Studio, c.1910. BB73/7081 (above)
Paul Barkshire, June 1982. 1841 (right)

This riverside public house supposedly takes it name from the City apprentices who frequented it when rowing on the river. Said to date from the sixteenth century, the present building standing at right angles to the riverbank is early eighteenth century and the first record of its licence was in 1731. It was largely rebuilt in 1905, when the first-floor bay window was added. As may be seen from the modern photograph, the pub is as popular as ever and in fine weather many of its patrons still arrive by water. Also in this photograph may be seen one of the few remaining working boatyards on the river.

BRENTFORD

Unknown photographer, 1850s. Howarth Loomes Collection,
BB70/1580

Brentford was the nearest Middlesex came to having a county town. It is an ancient settlement where prehistoric and Roman remains have been excavated. The river Brent joins the Thames near the parish church and was the site in early times of the lowest regular ford on the Thames. Hence its name, which was first recorded in 705. The medieval town was strung out along the High Street – the old route from London to the west – running parallel to the river. As a result of its favourable position with good road and river communications, Brentford was a centre for the trans-shipment of goods. This was enhanced further by the opening in 1798 of the Grand Union Canal, which from 1805 ran through to the Midlands. The town's market flourished, industries prospered and inns provided a good living. The associated squalor, however, made Brentford notorious in the eighteenth century. In his guide to the Thames, first published in 1872, Henry Taunt informed his readers of its reputation, but tried at the same time not to be too discouraging to the river traveller. '"Tedious town. For dirty streets and white-legged chickens known" sings one of our poets; like all pushing, busy places … it is untidy sometimes; and its factories in some parts are rather annoying to the olfactory sense; still it is not as bad as we might imagine at first sight'. Some of the numerous industries and wharves ranged along the bank may be seen in this early photograph taken not far upstream from Kew Bridge. The trees on the left were growing on Brentford Ait with the main channel of the river out of view. Even today there are a few working wharves at Brentford, but flats and houses have been built on the sites of many of the warehouses and the main dock has been converted into a marina.

The need for clean water was to exercise the ingenuity of Victorian engineers as water taken directly from the Thames became increasingly polluted. The Grand Junction Waterworks Company moved here near Kew Bridge in 1835–8 from a site in Chelsea, in order to improve the quality of its supply. However, the company continued to draw its water from the river until 1855, when supplies were piped from Hampton and filtered at Kew Bridge. An early filter bed of 1845 survives on the site. The first engine house dates from 1837 and was designed by William Anderson. A second (eastern) engine house was added in 1845 in a more robust Italianate style. This was doubled in size in 1869. The standpipe tower or manometer of 1867 by Alexander Fraser is a notable local landmark. When in 1944 the Metropolitan Water Board began to phase out its older steam engines, a far-sighted decision resulted in the preservation of five engines at Kew Bridge. These included a Boulton & Watt engine of 1820, brought from Chelsea, and a Maudslay engine of 1837, which had pumped water to west London for more than a century. An engine installed by Harvey's of Hayle in 1869 is the largest beam engine in the world still working. Although, even now, water is pumped to the surrounding area from here, the Waterworks at Kew Bridge is open as a museum devoted to the stationary steam engine.

KEW BRIDGE PUMPING STATION

Paul Barkshire, May 1986. 3868

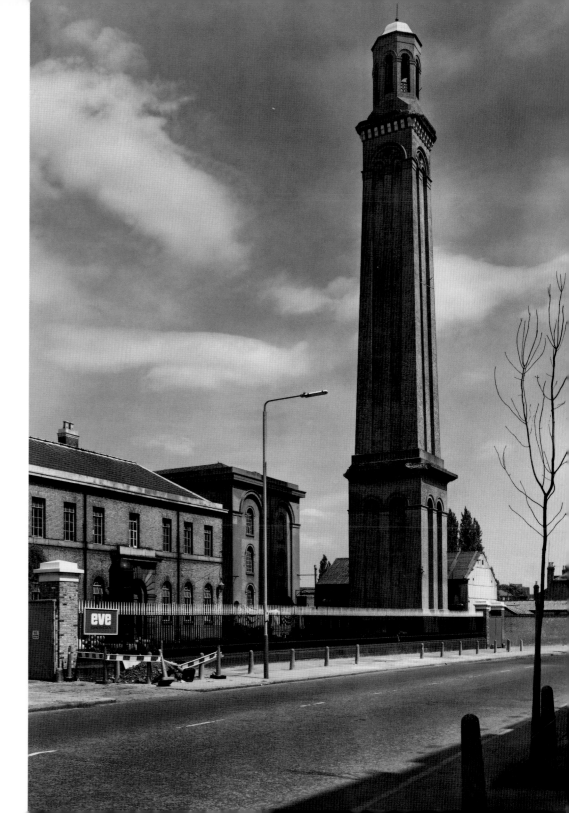

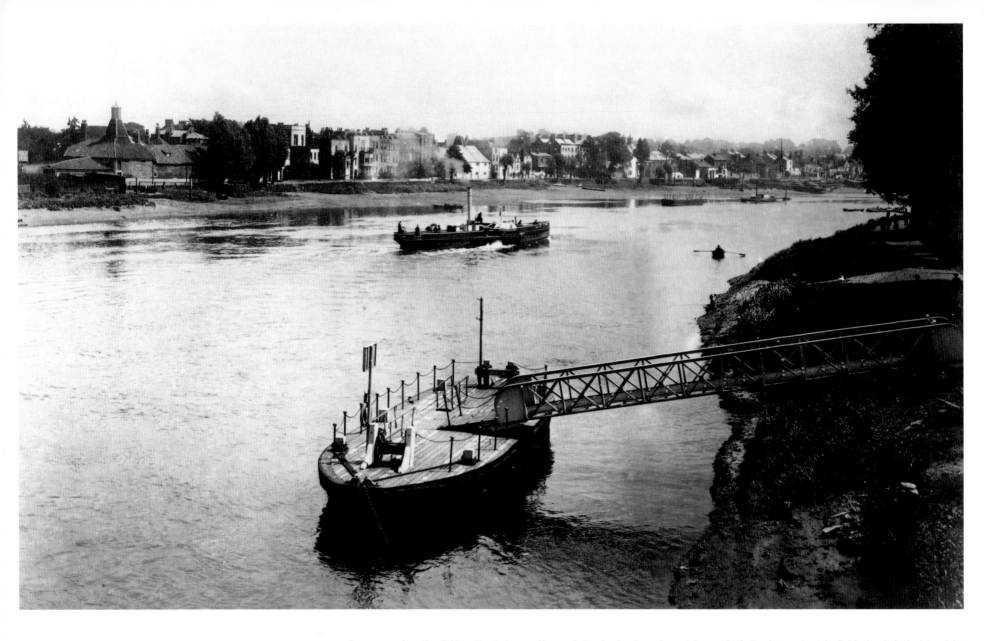

STRAND ON THE GREEN

George Washington Wilson, 1860s. BB99/10003 (above)

Herbert Felton, c.1950. BB99/10004 (right)

Downstream from Kew Bridge, this single row of houses facing the river is a picturesque reminder of eighteenth-century Middlesex. Formerly these were the homes of fishermen, boat repairers and publicans. Malting for the London market took place here from at least the late seventeenth century, although the malthouses seen on the left and just right of centre in the early photograph are nineteenth century. River transport made it easy to bring in the bar-

ley and the coal for fuel and to send out the finished malt. In the later eighteenth century the area became popular with more prosperous residents including the painter Johann Zoffany, who lived here from 1780 until his death in 1810. The more imposing houses may be seen in the later photograph, which was taken at the time of a particularly high tide – perhaps the main drawback of an otherwise idyllic setting.

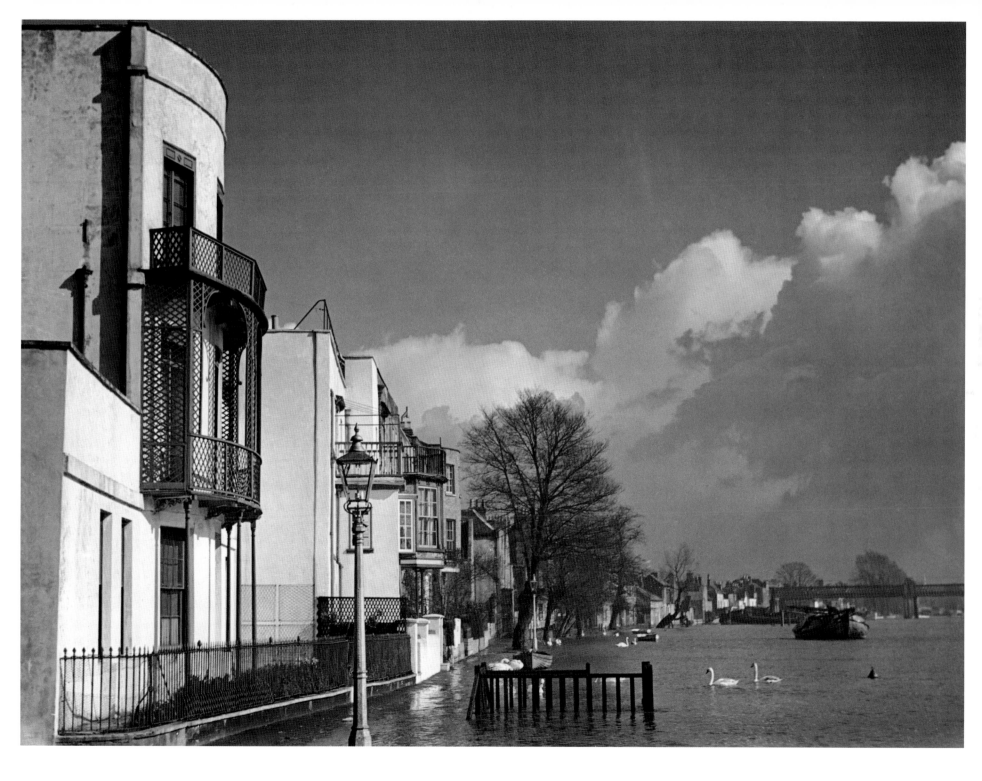

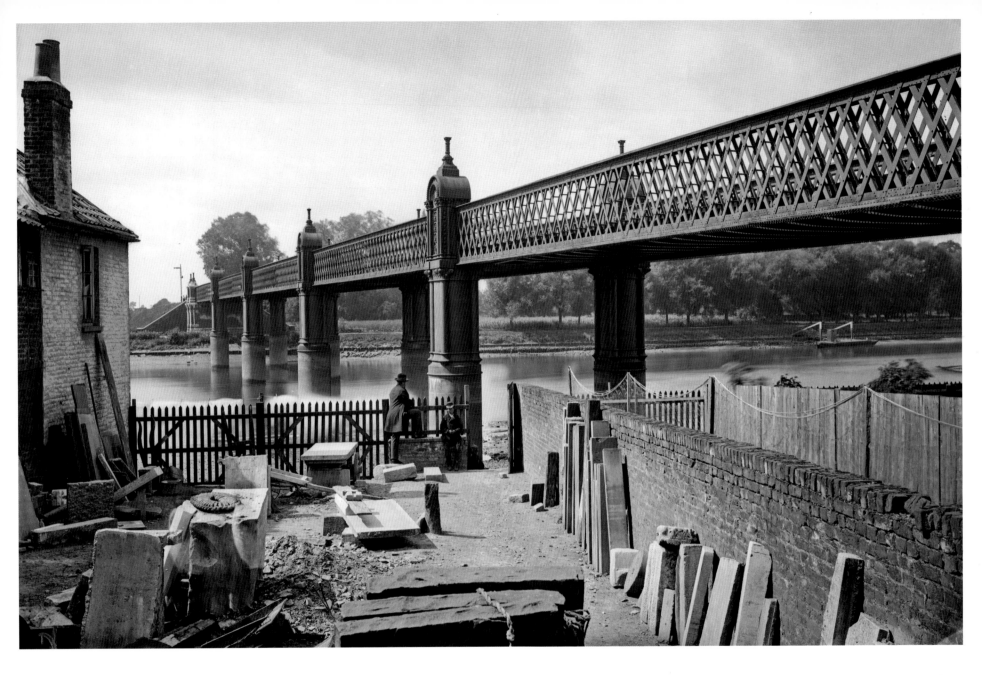

KEW RAILWAY BRIDGE

York & Son, c.1900. CC97/824

In 1864 the London & South Western Railway Company obtained powers to extend their line from South Acton Junction across the river to Richmond. The bridge over-sailing the houses at Strand on the Green to Kew was designed by W. R. Galbraith and built by Brassey & Ogilvie. It opened on 1 January 1869. Today the bridge is used by both mainline and District line trains. In the foreground is a stone-mason's yard at Strand on the Green. The advantages of a riverside location even for small-scale industries for the transport of heavy materials are obvious.

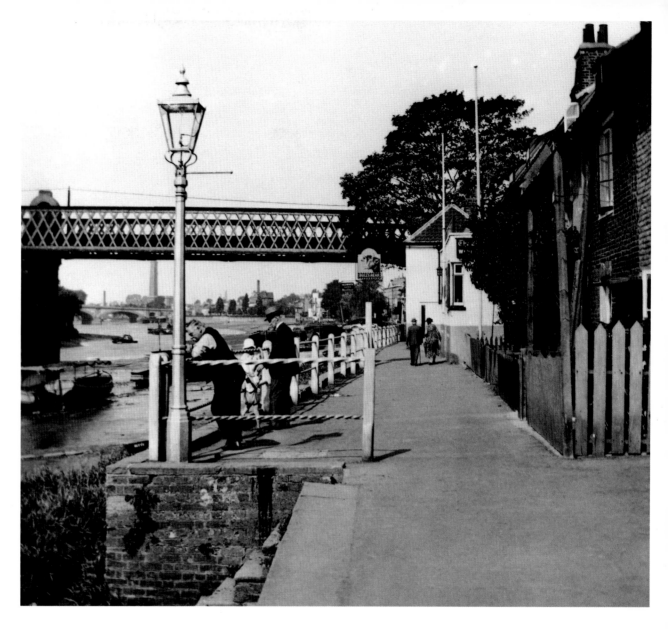

This part of the river became a popular place for barges waiting for trade or carrying out minor repairs. Hence at one time there were large numbers of beer sellers, where crews gathered to arrange cargoes as well as to take a well-earned rest. The Bull's Head and The City Barge are two remaining inns. The latter, originally called the Maypole Inn and first licensed in 1786, was renamed after the state barge, the *Maria Wood*, built in 1816 and used by the Lord Mayor of London for his official journeys until 1859, when it was sold. When not in use it was laid up opposite the pub, which took its new name by association, a process not uncommon on the river. The City Barge was badly damaged by bombing in 1940. The Bull's Head, in the foreground, was first licensed in 1722. Looking upstream beneath the lattice girders of the railway bridge, Kew Bridge and the tower of the pumping station may be seen.

STRAND ON THE GREEN

F. M. Beaumont, 1950s. BB99/10005

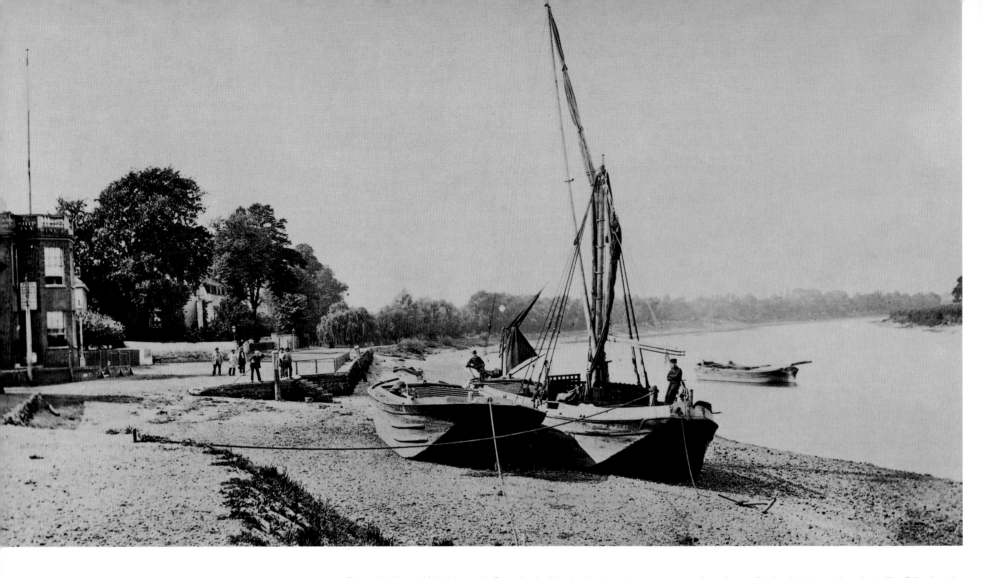

MORTLAKE

H. W. Taunt, c. 1870s. BB99/1567 (above)
H. W. Taunt, c.1897. CC73/472 (right)

The small village of Mortlake on the Surrey bank of the river has been dominated by its brewery since the mid nineteenth century. On the left in these photographs is The Ship inn, which is still a popular riverside venue. The earlier photograph is of particular interest as it shows, drawn up on the foreshore, a swimheaded sailing barge alongside a swimheaded lighter. It has been suggested that this form of barge has a very long lineage, perhaps even perpetuating Roman boat-building traditions. However, firm archaeological evidence for continuity has yet to be discovered. This type of barge originally worked the Thames above London Bridge, when the medieval structure formed an effective barrier to through traffic. Following the removal of the ancient obstruction and the development of the more common spritsail barge, which could navigate both the river and coastal waters, the two types continued to work alongside one another, although no more swimheaded barges were built after 1910. When the first photograph was taken, it was of sufficient interest for everyone to stop work and watch, but by the time Henry Taunt returned some years later photography was no longer such a novelty and the coal heavers carried on with their precarious task of unloading.

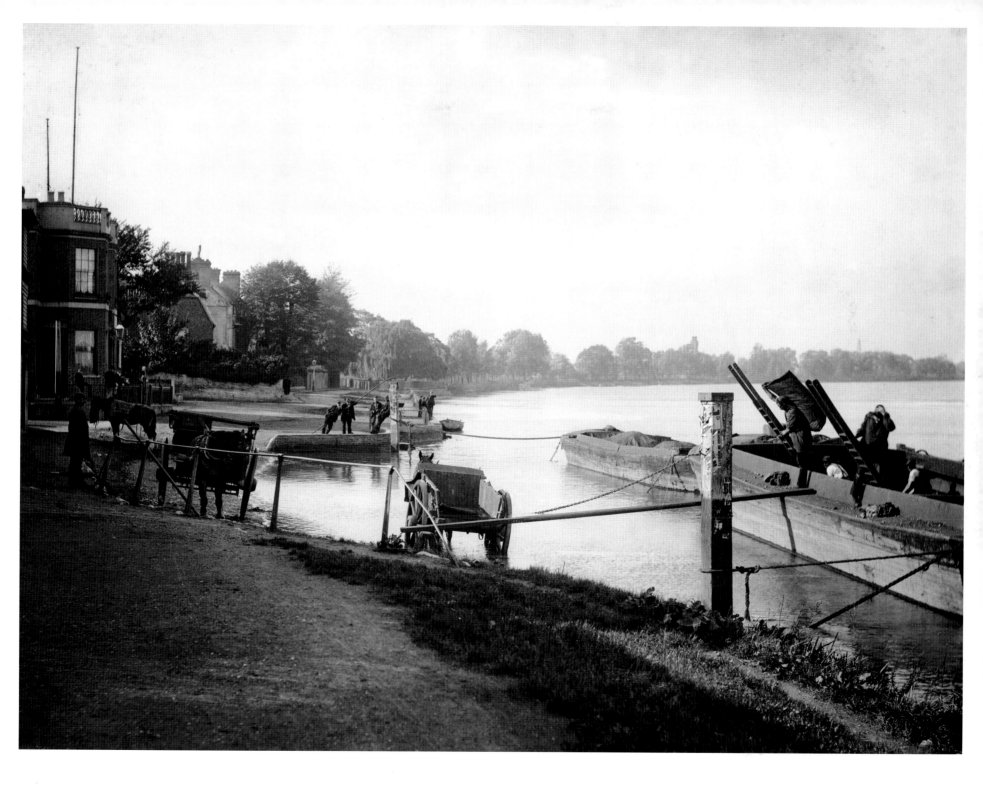

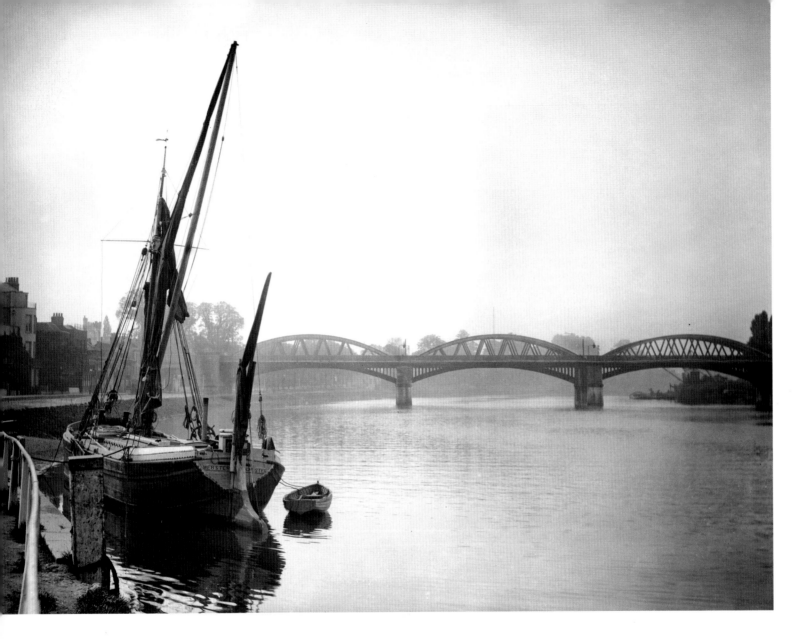

BARNES

H. W. Taunt, c.1895. CC72/669

The settlement on the Surrey bank of the Thames at Barnes, with the High Street leading from the church to the river, dates from at least the twelfth century. Barnes Bridge, shown here, was built to the designs of Joseph Locke and J. E. Errington. It carried the Richmond and Hounslow loop line of the London & South Western Railway and opened on 22 August 1849. In order to accommodate increased traffic and heavier trains, a second bridge was added alongside downstream in 1891–5, when the overhead bow-string girders were included to the design of Edward Andrews. When the new bridge was brought into service the old one was strengthened, but this is now disused. Taunt's view looking upstream shows a barge moored at the town dock at the end of High Street. This barge was registered at Rochester and was built after about 1885 as it has wheel steering.

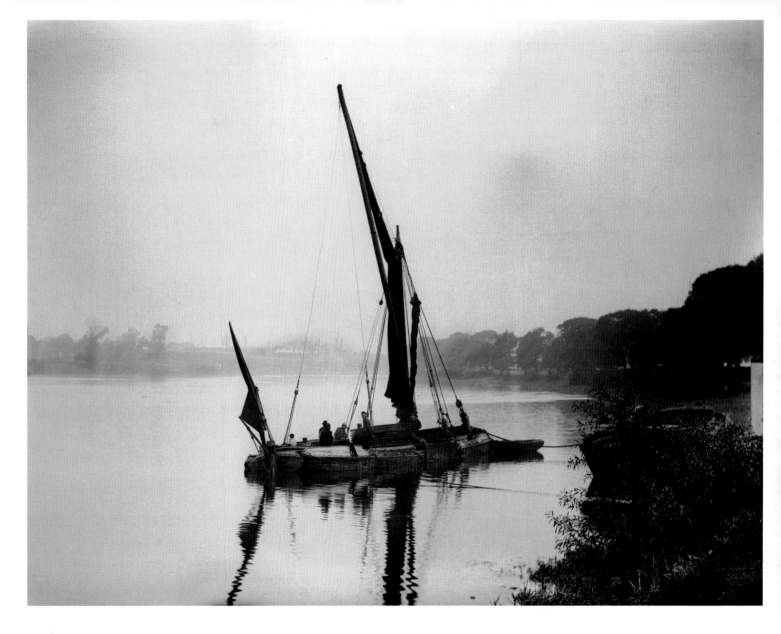

In this photograph, a sailing barge is shown resting by the Surrey bank in Corney Reach, upstream from Chiswick. The industries of the Middlesex bank may be seen in the distance, giving the lie to this otherwise rural scene. There were several variants of the standard Thames barge, notably the 'Stumpie', shown here. It had no top mast, but a large spar, called a sprit or spreet, running from the foot of the mast to the head of the sail. The whole could be lowered to allow it to pass under bridges on its way up or down the river. This example dates from before about 1885 as it is steered by tiller, which from that time was replaced by wheel steering. Although it was hard work, a barge could be sailed by a crew of two, but it was common for there to be six men and a boy – there appear to be seven aboard this vessel.

CORNEY REACH, CHISWICK

H. W. Taunt, c.1895. CC73/648

49

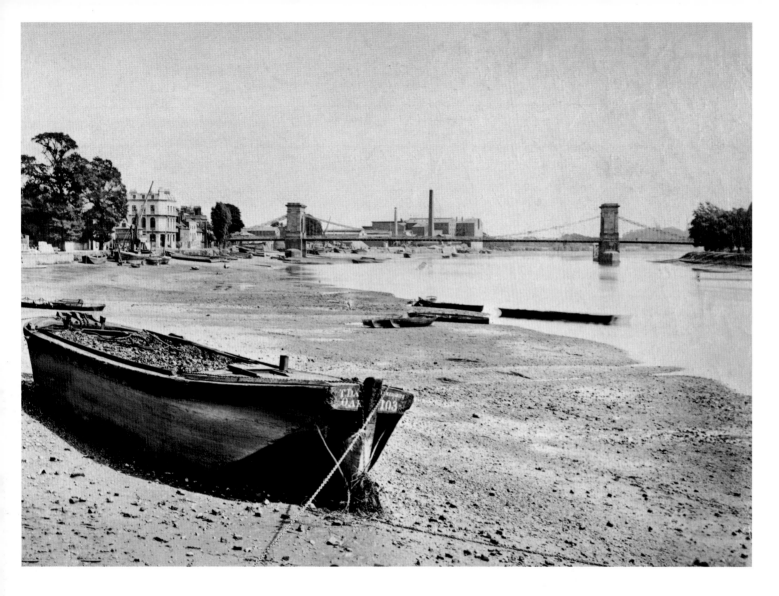

HAMMERSMITH

H. W. Taunt, 1870s. BB99/15626

Hammersmith village grew up originally in the sixteenth century around the Broadway and the parish church with development towards the bend in the river where the bridge now stands. In the eighteenth century the Lower and Upper Malls were built up with houses overlooking the river and extending upstream to Chiswick. As was common elsewhere, barges and lighters may be seen drawn up on the foreshore. The entrance to Hammersmith Creek is just to the left. Also in this photograph are a number of rowing boats of a type that confusingly was known as a wherry (a term more commonly used for an East Anglian sailing barge). Used for ferrying passengers, it developed in the seventeenth century and continued throughout the nineteenth century. The Thames wherry differed from a skiff in being longer and narrower with sharply pointed stem and stern. Those with three sets of oars, shown here, were known as a ran-dan wherry, which gave its name to a system of propulsion. Stroke and bow-man had an oar each, while the middle man rowed with a pair of sculls. This method was widely employed for speed and convenience by river police and customs officials.

This navigable waterway on the north bank, a little way upstream from Hammersmith Bridge, formerly extended to King Street and like so many of the inlets along the Thames was flanked by industries. On the west bank opposite Sankey's Wharf were malthouses belonging to the town brewery, founded in 1780. The wooden lighter moored ready for loading belonged to Sankey & Co., builders merchants. The creek continued in use for river traffic until 1930, but was filled in during 1935–6. Hammersmith Town Hall, built in 1938–9, now covers the site. This commemorated its associations with the river by the installation of huge sculpted heads of Father Thames flanking the steps to the main entrance overlooking the river.

HAMMERSMITH CREEK

J. Edmunds, 1914. AA63/7516

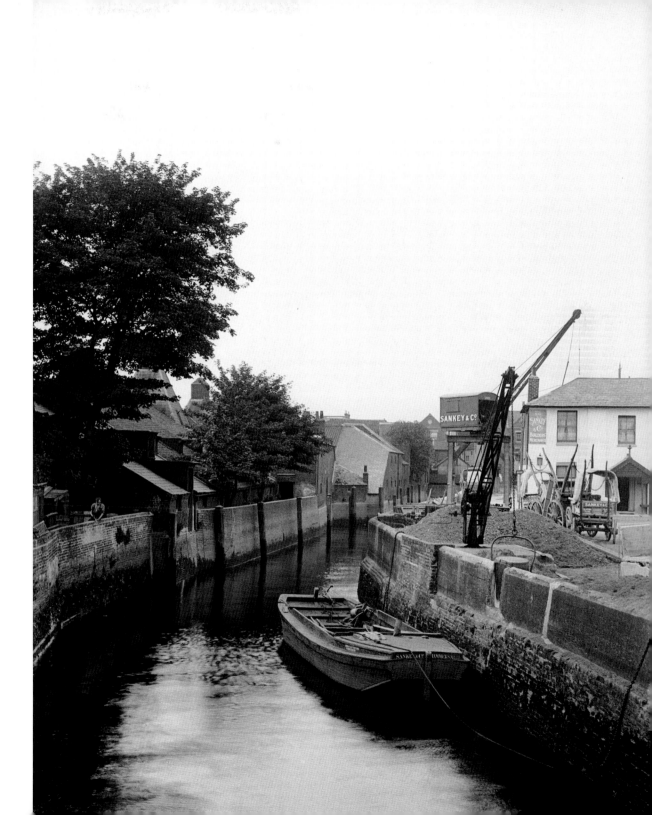

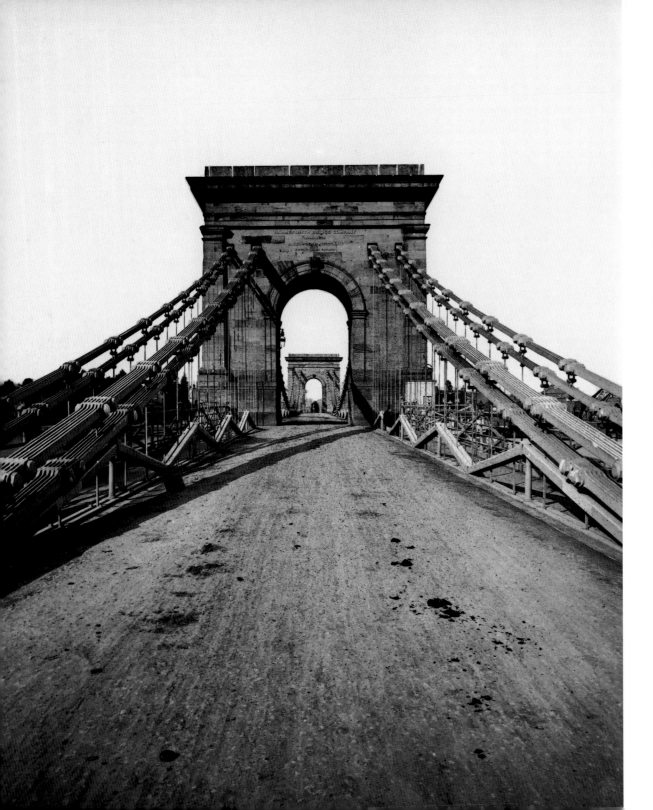

An Act of Parliament authorising the building of a bridge at Hammersmith was passed in 1824 and the foundation stone was laid in the following year. The bridge was opened to traffic on 6 October 1827. It was constructed to the designs of the engineer William Tierney Clark, who lived in Hammersmith. He died in 1852 and was buried in the parish church, where his monument was carved with the representation of a suspension bridge. As the first suspension bridge over the Thames and one of the earliest in the country, Hammersmith Bridge was the source of much wonder and admiration. A contemporary, but anonymous author enthused: 'Every person having his mind directed to the rapid advance made by human intellect must reflect with pleasing satisfaction on the completion of an undertaking to be hailed as the valuable result of industry and genius, encouraged by the spirit of adventure and the employment of British capital'. This last observation may give a clue to the source, as Hammersmith Bridge had been financed by a local consortium including several builders, who hoped to profit by developing the land on the south side of the river. However, to this day the Barn Elms peninsula remains relatively rural. Towards the end of the century it became clear that the bridge was no longer capable of coping with the increased traffic. In 1882, Sir Joseph Bazalgette, the chief engineer of the Metropolitan Board of Works, which by then had responsibility for the bridge, recommended its replacement. The new suspension bridge was begun in 1884 to Bazalgette's design. The opening ceremony was performed by Prince Albert Victor, Duke of Clarence, on 18 June 1887. Since the advent of motor traffic, there have been recurring fears for the safety of the bridge. As a result, the structure has been strengthened regularly and the weight limit has been reduced steadily, but after more than a century Bazalgette's Hammersmith Bridge remains open and heavily used.

HAMMERSMITH BRIDGE

York & Son, 1870s. CC97/863 (left)
H. W. Taunt, c. 1895. CC63/26 (right)

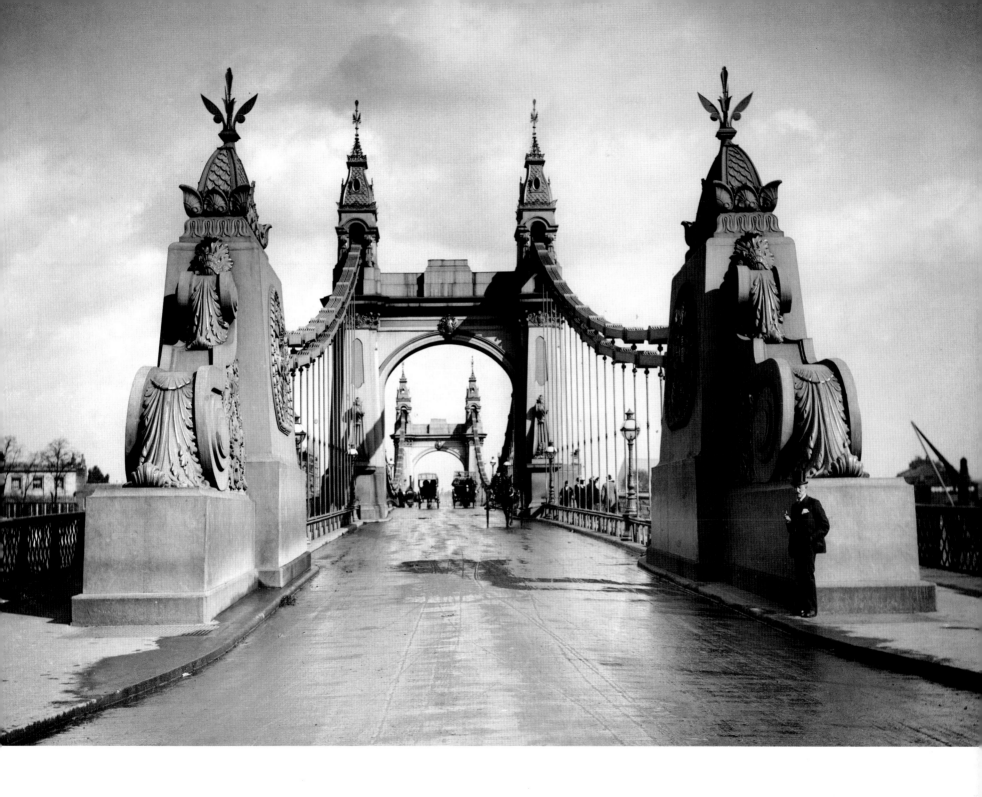

HAMMERSMITH BRIDGE

York & Son, 1870s. CC97/671

The University Boat Race between the eights of Oxford and Cambridge has traditionally been accepted as one of the main events of the English sporting calendar. First held at Henley in 1829, it has been rowed between Putney and Mortlake since 1845. It became an annual contest from 1839 (except for the war years) and is rowed upstream, but on an incoming tide, over a distance of 4 miles and 374 yards (about 7 kilometres). Before the advent of commentaries on radio and television, the race attracted huge crowds, as may be seen here on the first Hammersmith suspension bridge. As early as 1870 crowds numbering some 12,000 people occupied every possible vantage point on the bridge, much to the alarm of the owners. The old bridge was declared free of tolls by the Prince and Princess of Wales (the future King Edward VII and Queen Alexandra) on 26 June 1880, the same day as they performed similar ceremonies at Putney and Wandsworth.

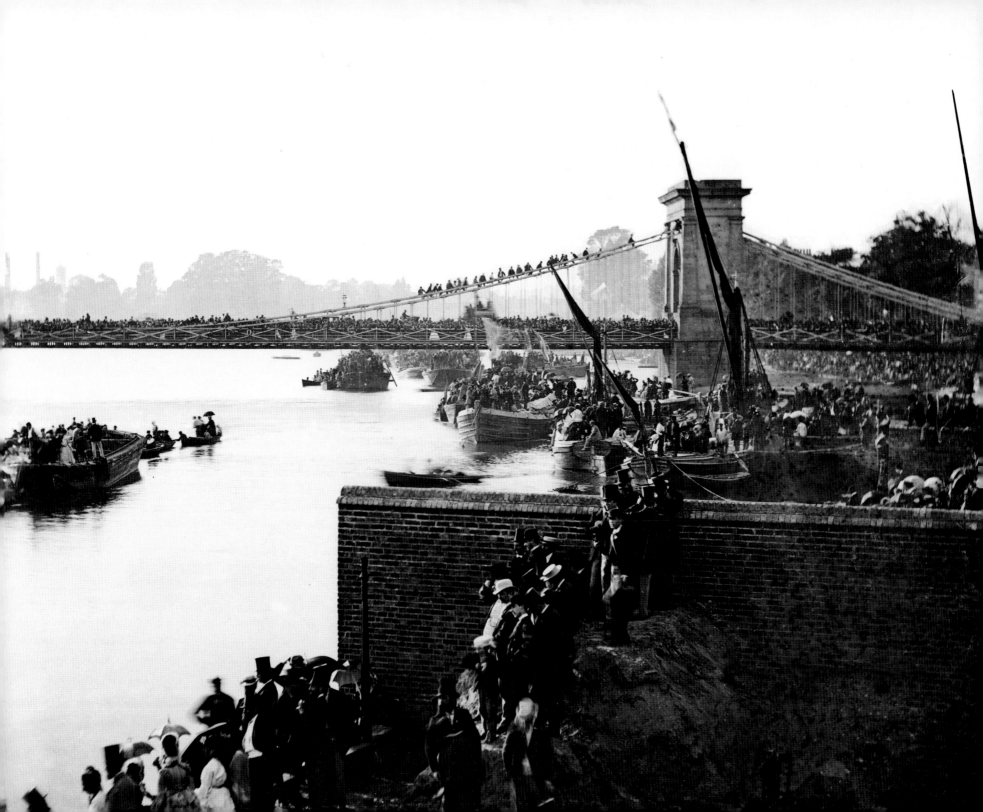

MANBRÉ WHARF, BARNELMS REACH

S. W. Rawlings, 1950s. A593

Alexandre Manbré came to England from Valenciennes in the 1850s. He filed his first patent for the manufacture of starch sugar for the brewing industry in 1858. In 1864, Manbré's first company was set up and an early investor and a sponsor for his naturalisation in 1867 was the architect Samuel Whitfield Daukes, but whether or not he was involved in designs for the later factory is not recorded. The riverside site at Hammersmith was acquired in 1873 and work began in the following year. The new factory was built on part of the Brandenburg Farm estate, just downstream from the site of Brandenburg House (where Haig's Distillery had been built). The refinery for the Manbré Saccharine Company opened in April 1876. The location on the Thames was important for the bulk delivery of raw materials and fuel, and as cooling water could be drawn directly from the river. Manbré took out further patents, particularly for developments in apparatus, and the refinery at Hammersmith figured in important advancements in the sugar industry as a whole. Alexandre Manbré died in 1891, after which the firm diversified into other sugar products and became a public company in 1897. The provision of supplies for the brewing industry remained a staple part of their business, and a large wet milling plant was installed in 1904–5, but the company experienced financial difficulties, which were exacerbated by the First World War. The firm was bought out in 1919 by Albert Eustace Berry, a chemist with business acumen, who ran a refinery in east London. In 1926 he took over the Battersea works of Garton, Sons & Co. and Manbré & Garton was established. Under Berry's guidance the firm expanded between the wars, even during the Depression, when in 1931 he devised the method of distribution of liquid sugar in bulk that was to be important for the whole industry. During the 1950s, the site was redeveloped. This photograph was taken before the installation of bulk storage containers and a much larger crane on the wharf in 1958–60. Albert Berry died in 1961 and his two sons took over in succession. Manbré & Garton was an important employer in Hammersmith, but the works closed and the site was cleared in 1978–9. The local authority encouraged a change to residential development and groups of flats named Thames Reach were built here in 1985–8 to designs by the Richard Rogers Partnership.

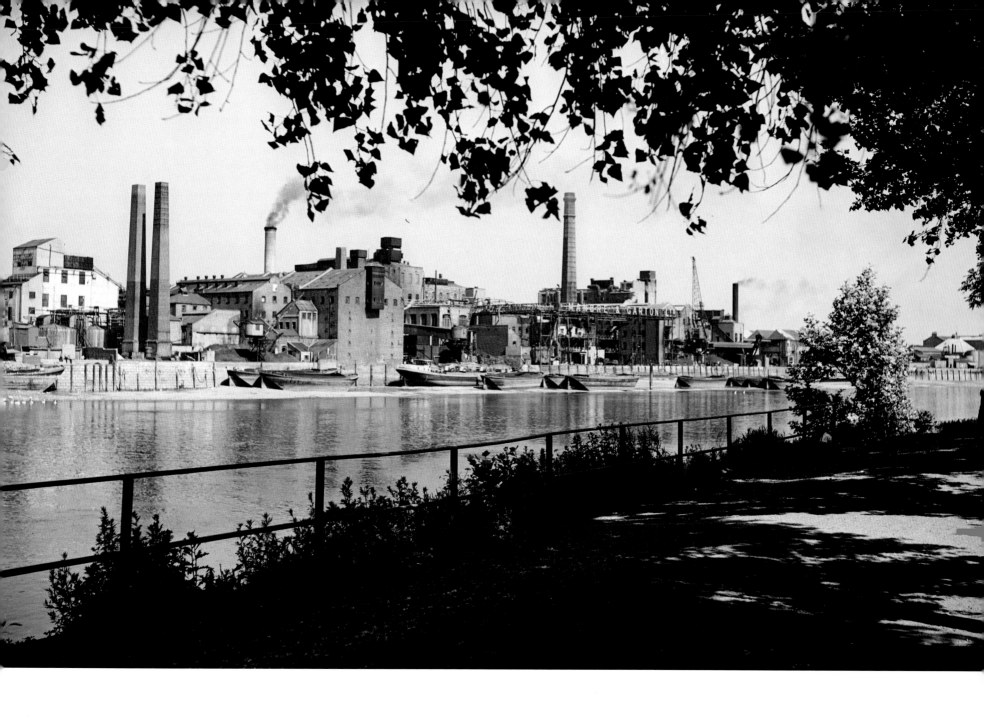

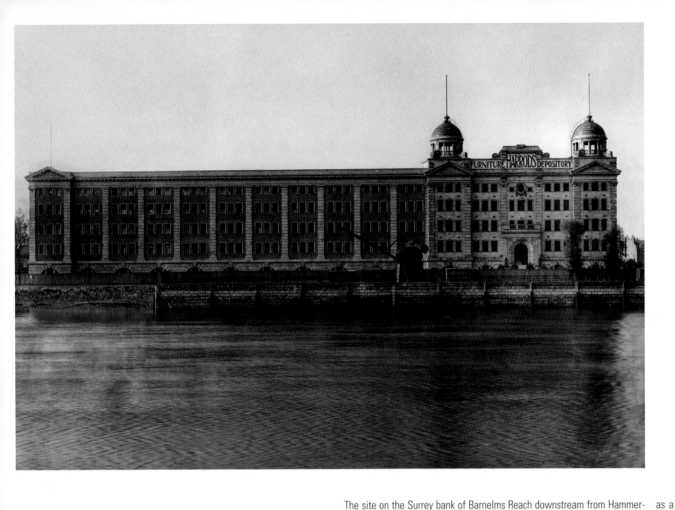

HARRODS DEPOSITORY, CASTELNAU

Bedford Lemere, October 1921. BL 25838/1

The site on the Surrey bank of Barnelms Reach downstream from Hammersmith Bridge was acquired by Lewis Cowan in 1856. It was then farmland, described as 'one huge smiling garden of flowers and fruit and grass and corn'. Cowan built a soapworks and sugar refinery – a curious combination – which were unpopular in the neighbourhood because of the effluent and noxious fumes they produced. Harrods Stores Ltd took over the site in 1894 and staged a grand opening, perhaps in an effort to be more acceptable to the local population. More than four thousand visitors arrived and were entertained by military bands, sports, fortune telling, dramatic recitals, concerts, singers and dancers, variety acts and, most intriguing of all, 'The Merry Mummers' Seismic Sensation – The Earthquake'. The evening concluded with a grand ball. At first, Harrods used the buildings for stabling, storing animal feed and as a slaughterhouse. Soon they developed the site

as a depository with new buildings being erected in stages from 1896 to 1908. The Depository facing the Thames, seen here, was designed by William George Hunt, who had designed the earlier buildings, but for the river front he employed a style more akin to the store in Knightsbridge. Work began in 1911 and the first phase (the right-hand block) was completed in 1913. The long range to the south (left) was added in 1920, but the balancing wing to the north was never built. The impressive river façade was faced in Doulton's terracotta. However, what makes the building of particular importance is that Hunt used the Kahn system of reinforced concrete for the frame. This method of construction was devised in 1903 by Julius Kahn in America and its use for the Harrods Depository marks only its third or fourth appearance in England. In 1988 the building was converted into flats by Elsom, Pack & Roberts.

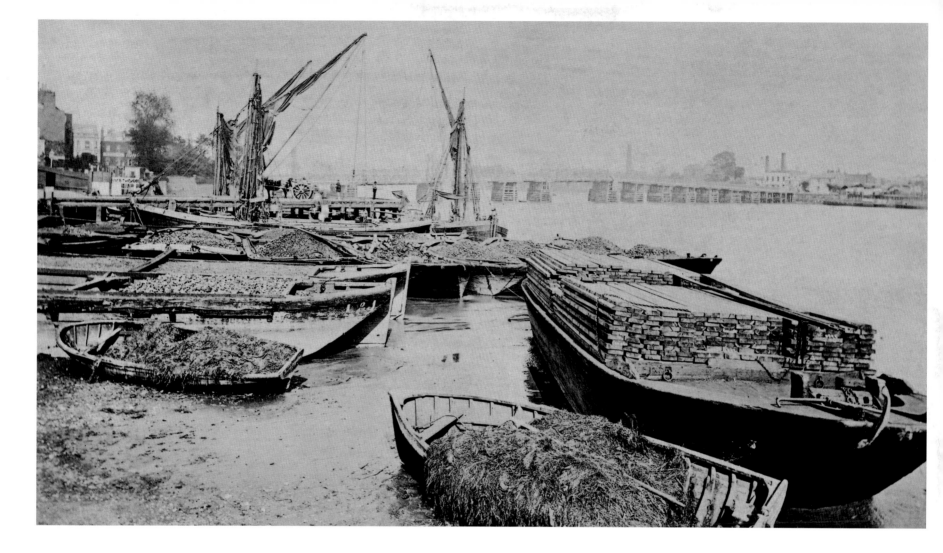

This photograph taken from the Surrey bank downstream from Putney Bridge shows, in the foreground, lighters laden with coal and building materials and punts piled with rubbish awaiting removal. The power and influence of the watermen and ferry owners had prevented the building of any permanent crossing between London Bridge and Kingston until 1726, when an Act of Parliament received royal assent. The promoters of the bridge between Putney and Fulham had to pay £8387 9s 11d in compensation to the ferry owners and operators, as well as an annual pension of £62 for distribution to impoverished watermen and their dependants. After several proposals had been considered, a timber structure designed by Sir Jacob Ackworth was begun in March 1729. However, at some point Ackworth's scheme was supplanted by one from William Cheseldon, a surgeon at St Thomas's Hospital, who directed the contractor Thomas Phillips. The bridge was opened on 14 November 1729. The wooden bridge was supported on 25 piers and the openings varied from 14 to 32 feet (4.3 to 9.8 metres) in width. Nonetheless, this was a serious obstruction to river traffic and in 1870 two of the openings were thrown into one. In 1871–2, after severe damage caused by a collision with a barge, the centre opening was widened to 70 feet (21.3 metres) by replacing two of the wooden piers with cast-iron cylinders supporting an iron span. This photograph shows the bridge before the latter alteration.

PUTNEY BRIDGE

H. W. Taunt, c.1870

Long before the building of a bridge in 1729, there had been a busy crossing linking the settlements of Fulham and Putney. The medieval parish church of St Mary, seen here, stands close to the Putney river bank. The west tower, much restored, dates from a complete rebuilding of the church in the fifteenth century. The body of the church, largely rebuilt by Edward Lapidge in 1836–7, was gutted by fire in 1973. Fortunately, the fine early-sixteenth-century chantry chapel survived, but the rest was rebuilt in 1980–2 to the designs of Ronald Sims. This photograph was taken in January 1881 during one of the periodic frosts, when the river became iced up and there was much disruption to trade. William Reid took this view from one of the pedestrian refuges formed above the piers of the wooden bridge. These became popular vantage points, not only for viewing the river, but also for romantic assignations. In addition, this view shows how the bridge did not run straight across the river, but curved along the north side of the church to join Putney High Street. The bridge had been bought by the Metropolitan Board of Works in 1879 and freed from tolls at a ceremony performed by the Prince of Wales on 26 June 1880. Later the same year, plans were announced for a new bridge to be built to the designs of Sir Joseph Bazalgette. The new stone bridge was constructed just upstream on the site of the aqueduct built in 1855 by the Chelsea Waterworks Company. This may be seen to the right in this photograph.

PUTNEY

William Reid, January 1881. Harrod Collection, F1-11

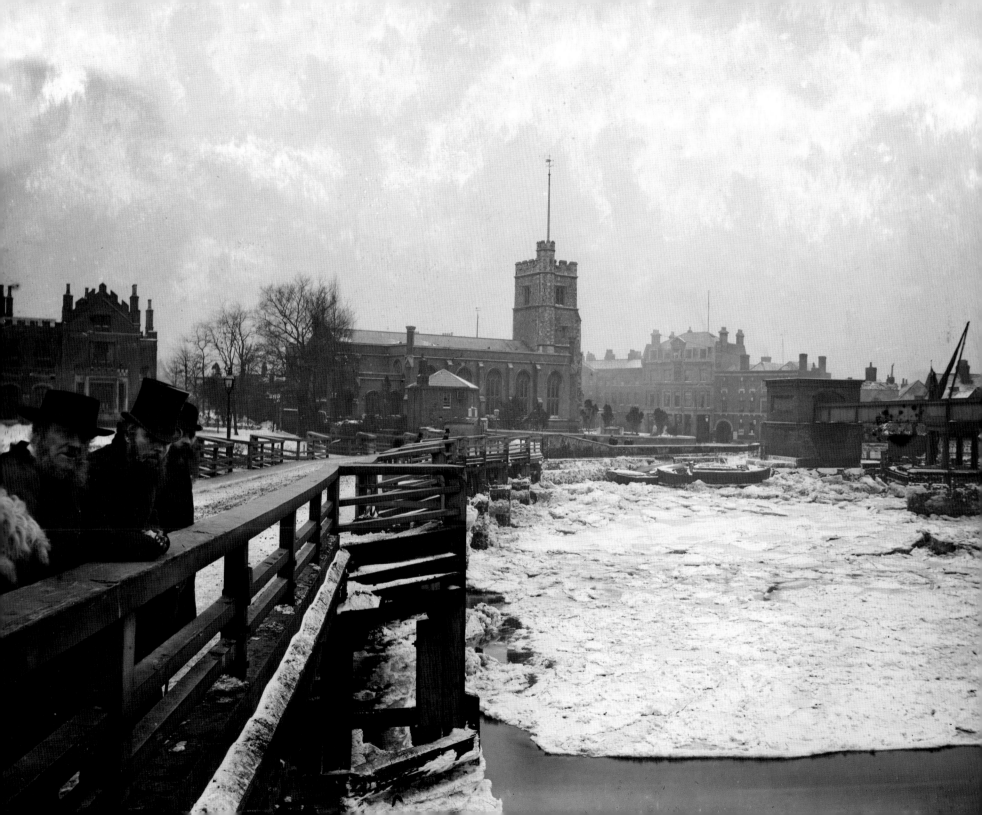

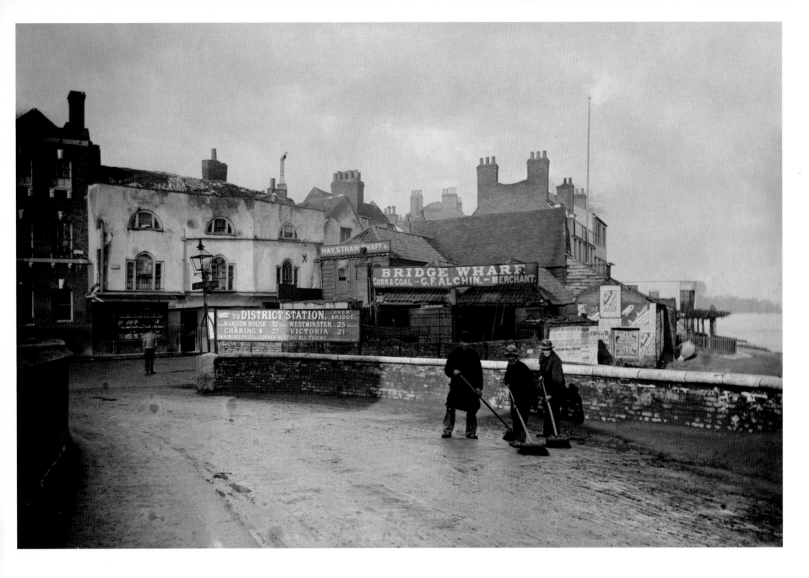

PUTNEY HIGH STREET

William Reid, 1881. Harrod Collection, F8–7 (left)

William Reid, February 1882. Harrod Collection, F5–2 (right)

Local photographer William Reid recorded a particularly high tide in February 1882 flooding the dock at Bridge Wharf and flowing up Putney High Street. Among the onlookers, Reid noted that the man pointing at the water was a character known as 'Flash' Sibley. The pedestrians and two horse 'buses were waiting patiently for an opportunity to cross the bridge. The double-decker omnibuses seen here were of the so-called 'knifeboard' type, introduced in the 1850s and progressively replaced by the more advanced 'garden-seat' type from 1881. The High Street leading down to the river and the parish church – the gates to the churchyard may be seen to the right – formed the nucleus of the ancient settlement of Putney, which from the Conquest to the sixteenth century had been the property of the See of Canterbury. In the first photograph, Reid posed the three sweepers who kept the old bridge clean. When the new bridge was built in 1882–6, the dock and Bridge Wharf were cleared away, together with the old houses, some dating from the seventeenth century or earlier. On the right, behind the posters in this photograph was the Eight Bells inn, frequented by barge-men and rowers. Beyond was the Star and Garter Hotel, another popular venue for rowers, and the boat-houses of several rowing clubs, whose successors remain to this day.

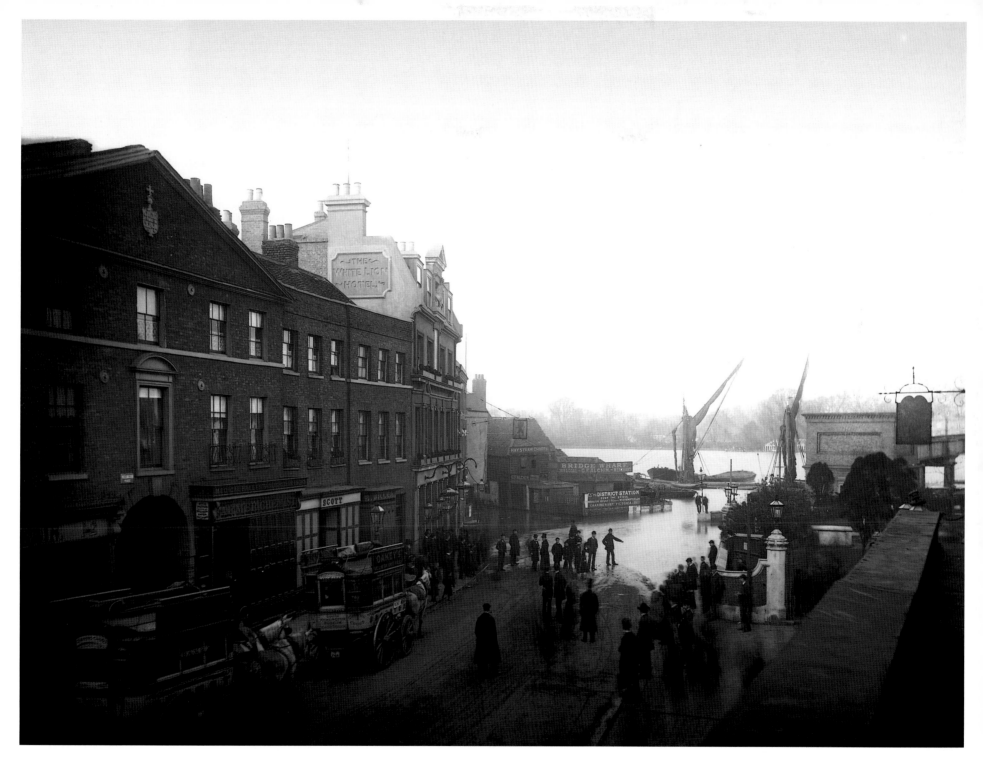

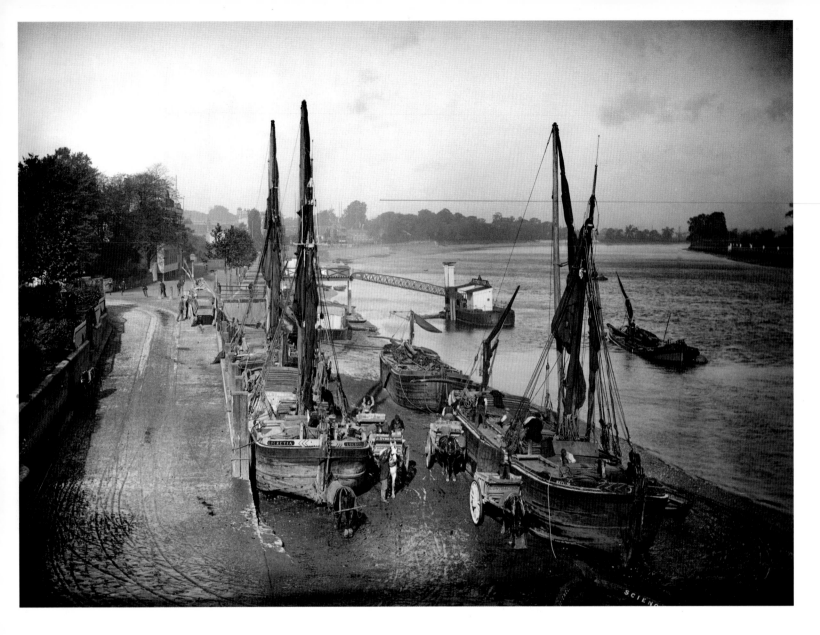

PUTNEY WHARF

H. W. Taunt, c.1895. CC73/611

This view was taken from the new Putney Bridge and shows the rebuilt wharf and pier with the sweep of Barnelms Reach upstream towards Hammersmith. On the opposite bank (right) are the grounds of Fulham Palace. Thames sailing barges had a shallow draft to allow them to navigate the creeks of the Kent and Essex coasts as well as the river. Lee boards were employed to enable them to sail safely into the wind. Flat bottoms meant they could sit upright on the foreshore for unloading at low tide, as these examples admirably demonstrate. However, the constant grounding resulted in much wear and tear and regular repairs were necessary. Loading and unloading was achieved by using tumbrels – horse-drawn tip-carts carrying a one-ton load. The barge offshore in this photograph has its mast lowered to allow it to pass under Putney Bridge.

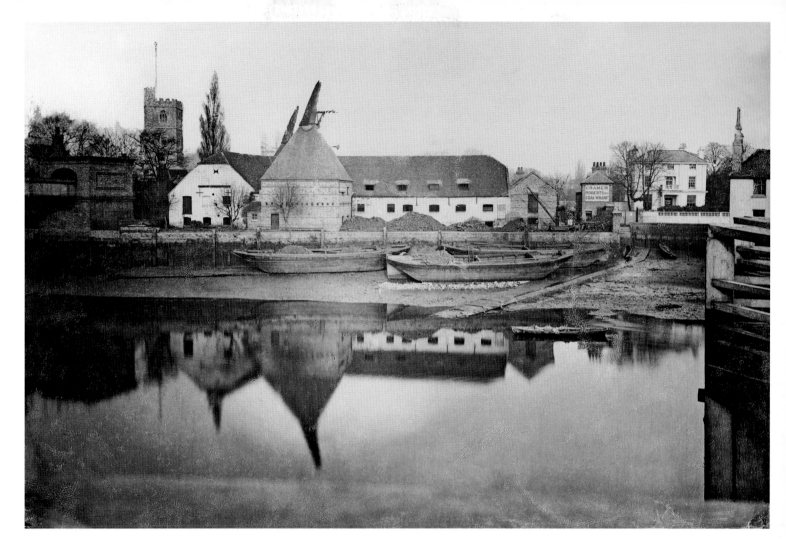

Fulham is situated on the Middlesex bank of the Thames, immediately opposite Putney. It was unusual for two ancient villages to have grown up in this way, as normally the inner bend of the meander would be too marshy to support a settlement. Before the mid nineteenth century, there were a few riverside houses near the parish church with the area largely given over to market gardening. It was said that more than half the fruit and vegetables sold at Covent Garden market were grown in Fulham. The most important surviving building is the medieval Fulham Palace, the former seat of the bishops of London, which stands upstream close by the parish church of All Saints (left). This has a west tower that was documented to be under construction in 1440. It was built of ragstone brought up-river from quarries in Kent. The church was altered in 1840–1 by Edward Lapidge and rebuilt by Sir Arthur Blomfield exactly 40 years later. This photograph was taken from the old Putney Bridge and shows the toll-house (far right) and the aqueduct (left). The early-nineteenth-century maltings stood on the riverbank adjacent to Swan Wharf, the coal wharf of Cramer Roberts & Co., with Cambridge House in the background. In 1900, Swan Wharf and the maltings were acquired by the Fulham Vestry for use as a refuse depot. Domestic rubbish was loaded into lighters and dumped downstream. Swan Court, a small sheltered-housing development, now stands on the site.

FULHAM

William Reid, 1878. Harrod Collection, R7–13

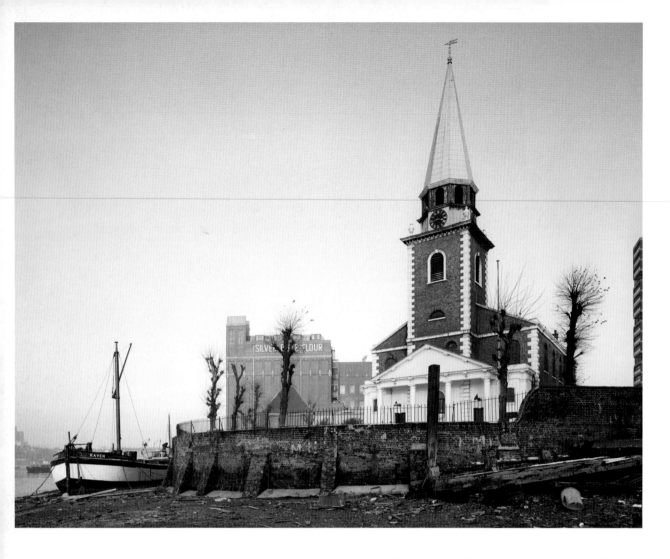

ST MARY'S CHURCH, BATTERSEA

Gordon Barnes, November 1969. AA84/455

The ancient Surrey village of Battersea once clustered around the parish church, which was mentioned first in the mid twelfth century. The church still stands on the shore overlooking a working wharf, but the present building dates from 1775–6. It is a plain Georgian preaching box, designed by Joseph Dixon. This simplicity is attractive to today's visitors, but in 1859 it was described as being 'especially odious … the architect seems to have studied how far it was in his power to render it repugnant'. The present church retains some notable fittings from the earlier building, including a fine collection of monuments and the east window, datable to c.1631 and attributed to Bernard van Linge. This stained glass is an unusual survival from this period and commemorates the St John family, lords of the manor. The church was restored in 1876–8 by Sir Arthur Blomfield, architect to the diocese of London. The former manor house of the St Johns lay east of the church, but was demolished in the late eighteenth century, when industry began to supplant the market gardens for which Battersea had been noted. Industrial development accelerated in the later nineteenth century encouraged by the arrival of the railways. On the manor house site for most of the twentieth century a huge flour mill loomed over the church, but now this has been replaced by an even more imposing block of flats – a striking sign of the times.

The Cremorne Estate was originally Chelsea Farm and in 1803 came into the possession of the first Viscount Cremorne, after whom it was renamed. The property lay west of Battersea Bridge between the King's Road and the river. Cremorne House was sold in the 1820s for use as a sports club, the Stadium. This was not successful and because of the natural beauty of its situation it was turned into a pleasure garden in 1843. There were brilliant firework displays and it became renowned for balloon ascents. Under new management, the grounds were laid out at great expense and reopened to the public in 1846. As the splendour of Vauxhall Gardens began to wane, so Cremorne took over as one of London's principal summer pleasure resorts. Among other attractions were a marionette theatre, a circus, grottoes and a dining hall. This photograph shows the central walk. An enthusiastic contemporary account described a 'perfectly entrancing scene, with coloured lamps, well-kept walks, lovely flowers, brilliantly illuminated temples, splendid conservatories, unrivalled ballets, and a platform with a thousand mirrors and a magic orchestra, which may well recall the glowing pages of the *Arabian Nights*'. The gardens were popular with artists including local Chelsea residents James Whistler and Dante Gabriel Rossetti, whose brother William reported another of the attractions. He noted that Cremorne was 'a place of demi-reputable entertainment and assignations, with all their accompaniments and sequels'. In the words of a popular slogan, the pleasure grounds became known for 'the three D's – dancing, drinking, and deviltry'. As a result, opposition grew and finally in 1877 Cremorne Gardens were closed on the orders of the Chelsea Vestry. Lots Road Power Station and a maze of small streets today occupy the site.

CREMORNE GARDENS

York & Son, 1870s. BB80/164

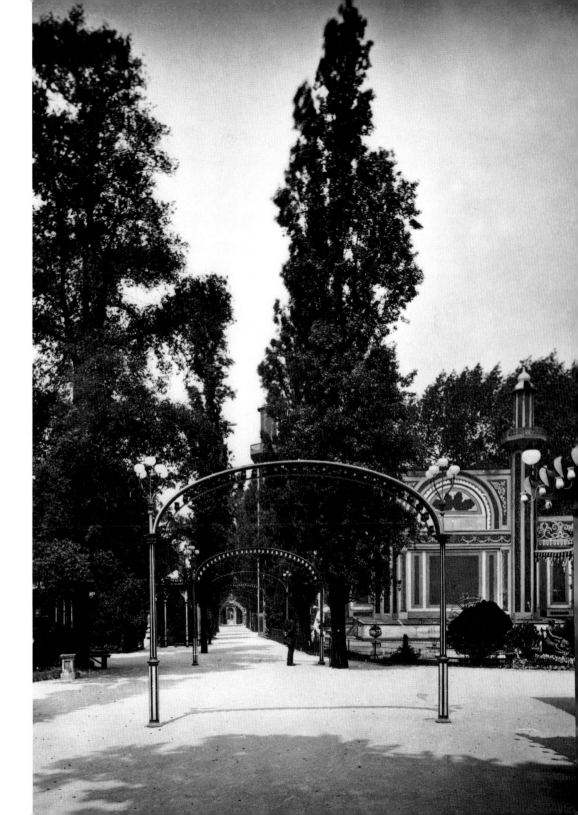

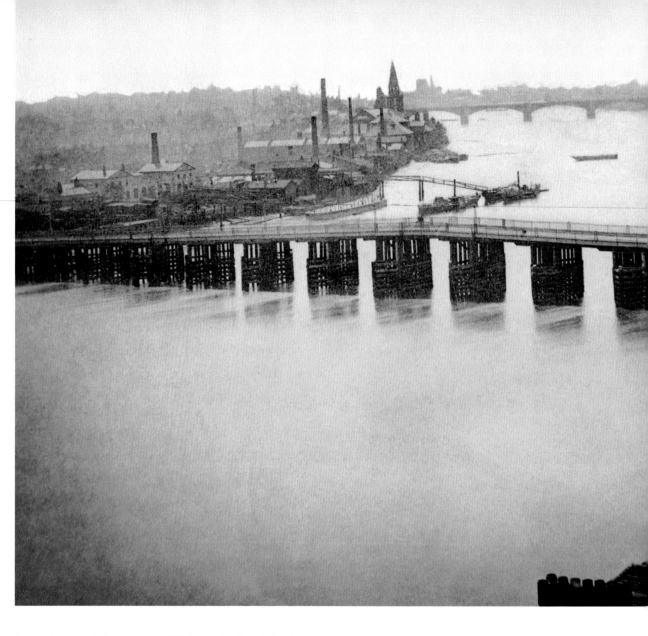

BATTERSEA BRIDGE

James Hedderly, c.1870. Philip Norman Collection,
BB82/13057 and BB99/1042

As part of his record of the area around Chelsea parish church before it was transformed by the construction of the embankment (see page 70), James Hedderly took this panorama from the top of the church tower. The view looking upstream shows in the distance on the left the spire of St Mary's Church, Battersea, and beyond that the West London Extension Railway Bridge. This was designed by Benjamin Baker and T. H. Bertram and opened on 2 March 1863. To the right in the distance are Cremorne Gardens. In the foreground are the houses on both sides of Duke Street, the river side of which was to disappear for the new embankment. However, the view is dominated by old Battersea Bridge. The former ferry crossing between Chelsea and Battersea was owned by the first Earl Spencer and in 1766 he obtained an Act to allow the building of a bridge. The timber structure seen

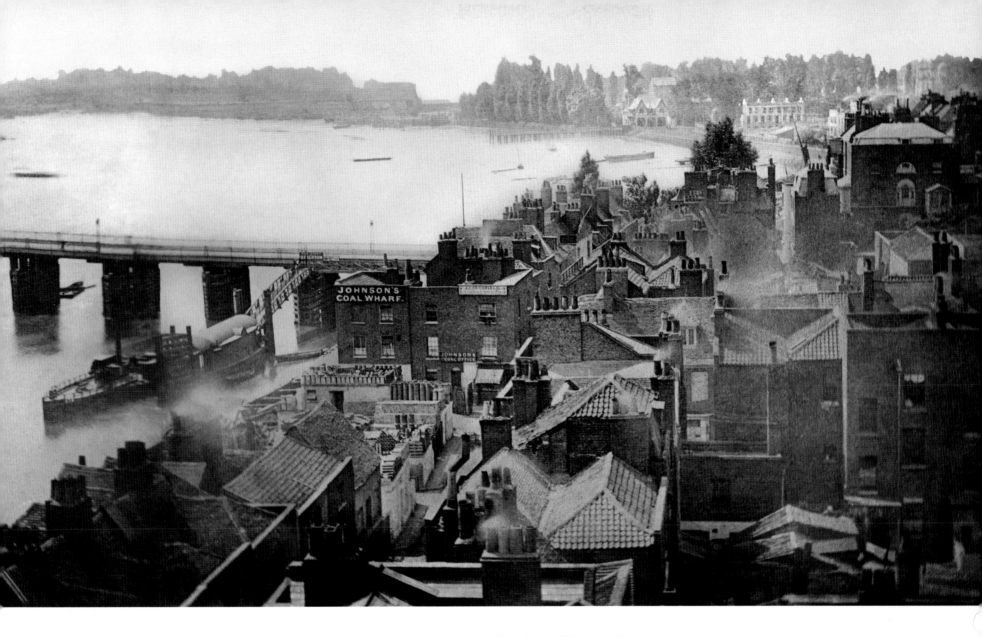

here was built in 1771–2 by John Phillips, nephew of Thomas Phillips, the builder of Putney Bridge, whose London business he took over when his uncle died in 1775. The construction was directed by the young Henry Holland, then working for his father's building firm at Fulham. The narrow openings made navigation difficult, so four of the original 19 spans were subsequently thrown into two to allow easier passage. This bridge was to be made famous in the paintings and etchings of James Whistler, who lived nearby in Chelsea.

The new embankment exposed the inadequacies of the old bridge and in 1884 work began on a replacement to the designs of Sir Joseph Bazalgette. The new iron bridge opened on 21 May 1890.

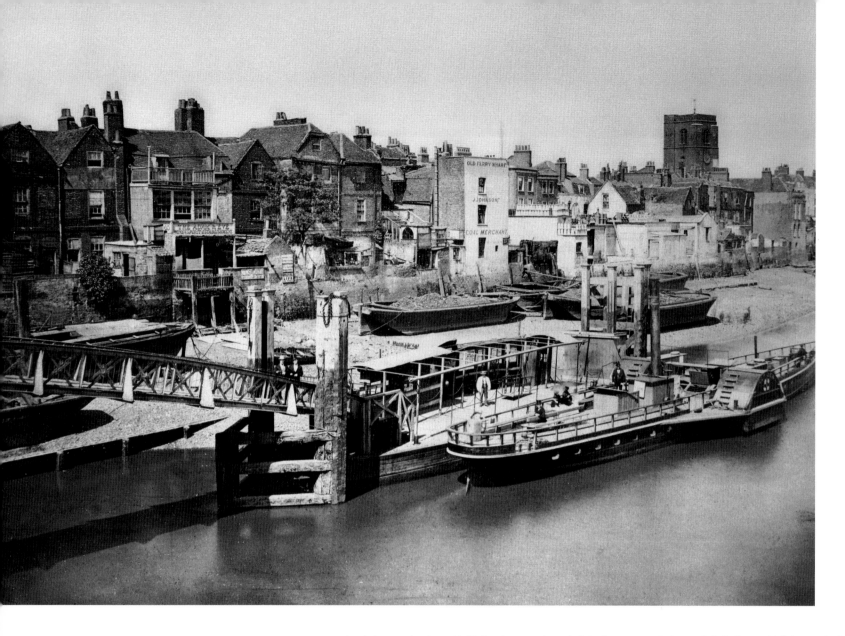

CHELSEA EMBANKMENT

James Hedderly, 1872. BB94/15622

Local photographer James Hedderly, whose own house in Duke Street was one of those swept away for the building of the Chelsea Embankment, recorded the area in detail before the work began. In addition, throughout the early 1870s, he photographed the progress of the construction westwards from Chelsea Bridge. This view, taken from old Battersea Bridge with the tower of Chelsea parish church in the background, shows the backs of the houses in Duke Street with lighters unloading coal drawn up on the foreshore. The picturesque Adam & Eve tavern, accessible from the river, is prominent to the left. The paddle steamer *Citizen* was one of six built in 1845–7 by Ditchburn & Mare, later to become the Thames Ironworks (see page 174). The floating pier with its footbridge to Battersea Bridge may also be seen in the following photograph.

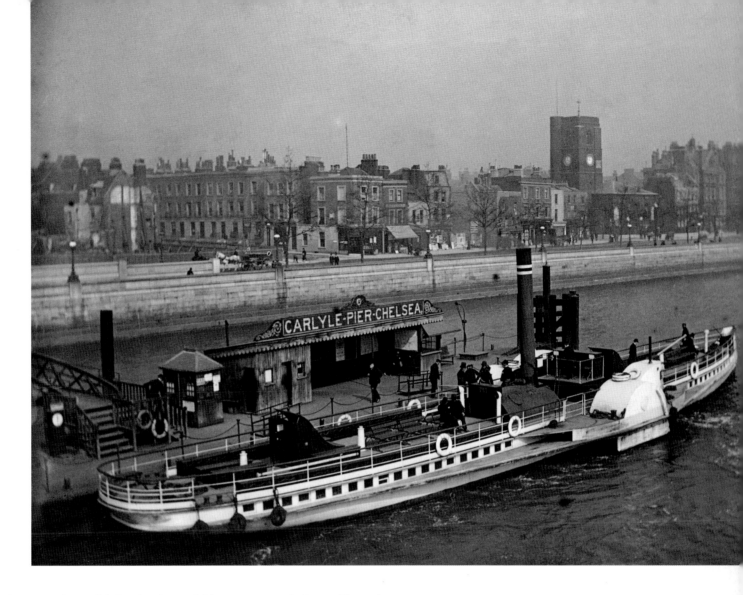

This photograph, taken from a similar position to Hedderly's picture, shows the completed embankment. Paddle steamers still plied from the pier, by then renamed after the author Thomas Carlyle, one of Chelsea's most famous residents. He had lived near the church and died in 1881. The reason for building the Chelsea Embankment was the same as that which had prompted the construction of the Victoria and Albert embankments – in order to improve drainage. At first it was proposed that a sewer should be constructed under the foreshore, but the cost of the temporary dam required would have been little less than that needed for a permanent embankment with a roadway under which the sewer could be laid. The Act of Parliament was passed in 1868 and in July 1871 the Metropolitan Board of Works under its engineer Sir Joseph Bazalgette began construction of the embankment between Chelsea Bridge and Battersea Bridge. It was completed in 1874 and on 9 May the new thoroughfare was opened officially by the Duke and Duchess of Edinburgh. This part of London had changed forever and the only building to survive to the present is the parish church, albeit rebuilt after wartime bombing.

CHELSEA EMBANKMENT

M. Hodgson, c.1893. BB84/604

BATTERSEA PARK

Campbell's Press Studio, 1951. BB73/7119

The marshy ground, known as Battersea Fields, had been an area of market gardens, 'occupied mainly by cabbage-planters and asparagus-growers'. In 1846 an Act of Parliament was passed to allow the Commission for Metropolitan Improvements to purchase the land for a public park. Work began in 1854 and the river was embanked in 1861. The architect James Pennethorne was responsible for the design and from 1857 the layout was supervised by John Gibson, who included a renowned sub-tropical garden and a lake excavated in 1860. Battersea Park became one of the sites for the Festival of Britain in 1951. Although the Festival has become synonymous with the South Bank at Lambeth, it was not confined to this location, but was meant to be a 'tonic for the nation' – a phrase coined by Gerald Barry, editor of the

News Chronicle. So in addition to the South Bank, there was a Land Travelling Exhibition, which toured the country, and a Festival Ship, the *Campania*, which visited towns around the coast. The Festival Gardens at Battersea were intended to recreate the feeling of an eighteenth-century pleasure garden at Vauxhall or Ranelagh. The co-ordinating designer for the gardens, James Gardner, declared that they were to be a place where 'people could relax and have elegant fun' as 'architects and scientists seem to be running away with' the South Bank. The illuminations and nightly firework displays were to be a welcome contrast to the wartime black-out. There was a Dance Pavilion, an amusement park with a Big Dipper and a whimsical miniature railway designed by Rowland Emmett to transport visitors around the site.

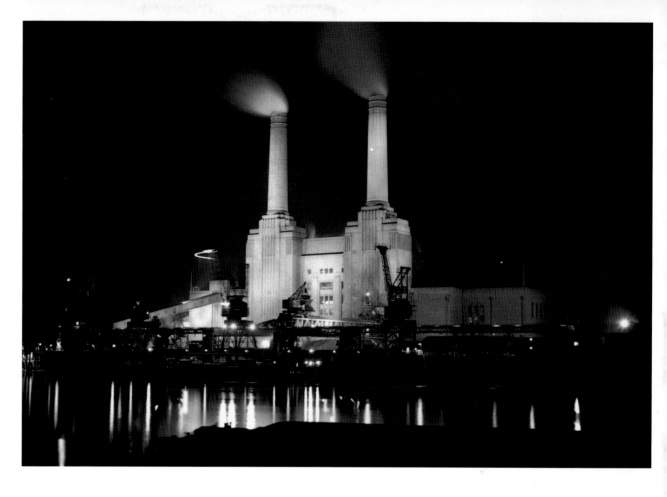

The mighty power station with its tall chimneys floodlit at night was ever a source of controversy. In April 1927 the London Power Company applied for permission to build a generating station on the river at Battersea. Work began in 1929 with S. L. Pearce as engineer, assisted by H. N. Allot and J. Theo Halliday, who was architect of the exterior and the Art Deco interiors. After construction had begun, Sir Giles Gilbert Scott was brought in as consultant. Attacks on the new building came from every quarter: the structure was denounced by *The Times* and even *The Architects' Journal* lamented 'a civilisation condemned to live under a pall of smoke and in the shadow of ugly buildings of its own devising'. The new power station was unveiled by the Chairman of the London Power Company, Sir Francis Fladgate, on St George's Day, 23 April 1931, and the building's supporters began to have their say. It was praised as 'a flaming altar of the modern temple of power' and the observation made that 'Standing as it will so near to the centre of London and of the Empire, Battersea Power Station will typify the growth of electric power in this country'. It started to supply power in June 1933 and was so far ahead of its time that it would remain the largest generating station in the country until 1956. Originally only the western (right) half with two chimneys was completed, but it was intended from the outset that the capacity would be doubled. Construction work on the second generating set was delayed by the war, but resumed in 1944 and it was brought into service in 1953. The earlier west set closed in 1974. The familiar outline with a chimney at each corner has become a landmark, so much so that when Battersea ceased generating altogether in 1983 and demolition was a real possibility there was a huge outcry. However, to date, all the proposals for alternative uses have come to naught and the building remains an empty shell.

BATTERSEA POWER STATION

Eric de Maré, 1950s. AA98/5903

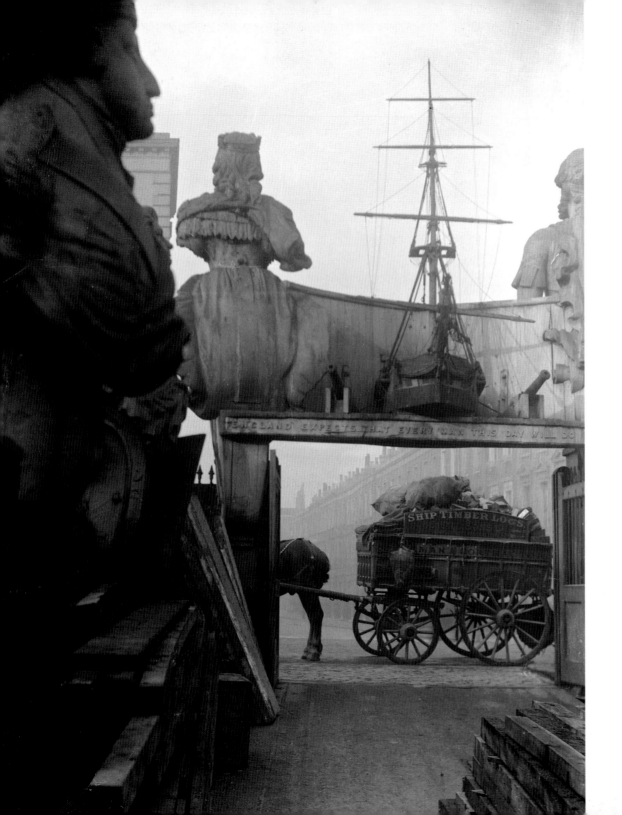

Shipbuilding on the Thames declined as the nineteenth century progressed, but shipbreaking prospered. As iron began to supplant wood, so the proud merchantmen and battleships of the sailing navy were replaced. The painter J. M. W. Turner witnessed the poignant sight of HMS *Temeraire*, a veteran of Trafalgar, being towed up the Thames to the breaker's yard. Henry Castle & Son at Baltic Wharf on Millbank, just north of Vauxhall Bridge, operated a flourishing shipbreakers and timber merchants from the mid nineteenth century. The inscription on the waggon in the first photograph reads 'Ship Timber Logs', leading one to wonder how many great warships had been reduced to firewood. Some items were advertised as garden ornaments. The figureheads displayed over the gates were prominent features on Millbank. The figureheads in the second photograph (from left to right) were from HMS *Princess Royal* (1853), HMS *Cressy* (1853) and HMS *Colossus* (1854). Between the last two, the supporting angels came from HMS *Ocean* (1804). In the first photograph, (also from left to right) are figureheads from HMS *Edinburgh* (1811), HMS *Princess Royal*, here seen from the rear, and HMS *Orion* (1854). Some of these warships had begun their lives on the Thames: *Ocean* at the Royal Naval Dockyard at Woolwich, *Edinburgh* was built by Randall & Brent at Rotherhithe, and *Orion* and *Colossus* by John Penn & Son at Greenwich. This yard was renowned for the quality of its work and following closure in 1912 a contemporary reminisced that 'Thus passed the Glory of the Thames'. Castles' yard at Baltic Wharf was bombed in 1941 and the large collection of items from the last of the wooden warships was destroyed.

BALTIC WHARF, MILLBANK

Unknown photographer, c.1900. BB76/4423 (left) and BB76/4422 (right)

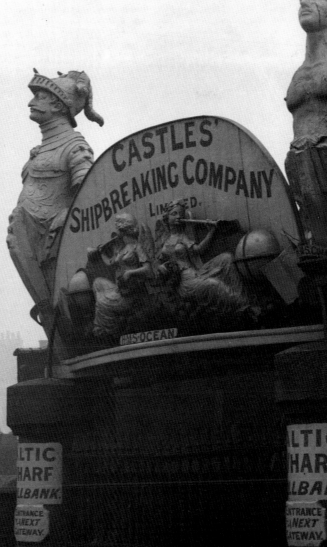

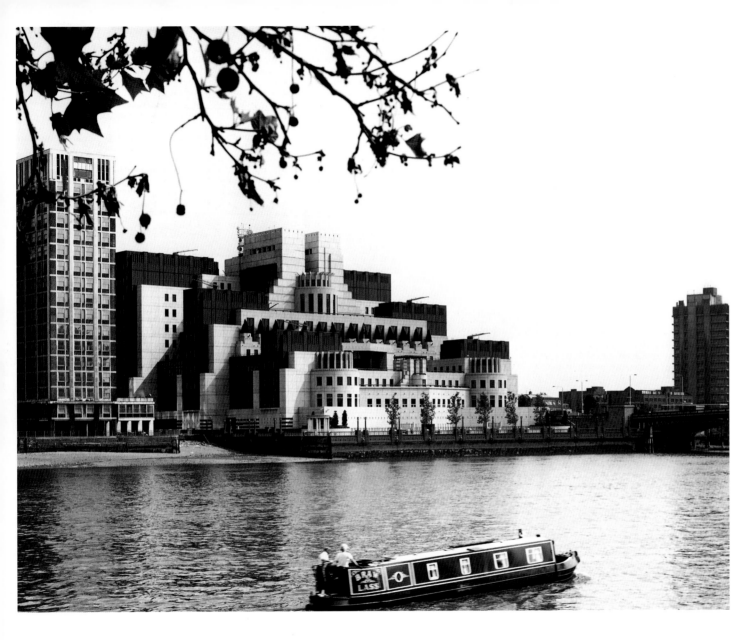

VAUXHALL CROSS

Sid Barker, RCHME, July 1998. BB98/12930

A prestige riverside site is still much sought after by companies and public organisations. Somewhat incongruously, this extremely prominent landmark is the headquarters of the Secret Intelligence Service, MI6. Standing on the Albert Embankment adjacent to Vauxhall Bridge, it was built in 1988–92 to the designs of Terry Farrell & Co. The vast and dramatic office block rises in tiers like an Art Deco ziggurat and relies for much of its impact on the use of colour. It is faced in cream-coloured concrete with dark bottle-green glass and at the centre of the river elevation is a single column in dark red. As may be seen here, this huge building stands out into the stream beyond its neighbour behind a new extension of the Albert Embankment. Its international fame was enhanced when it featured in the James Bond film *The World is not Enough* (1999).

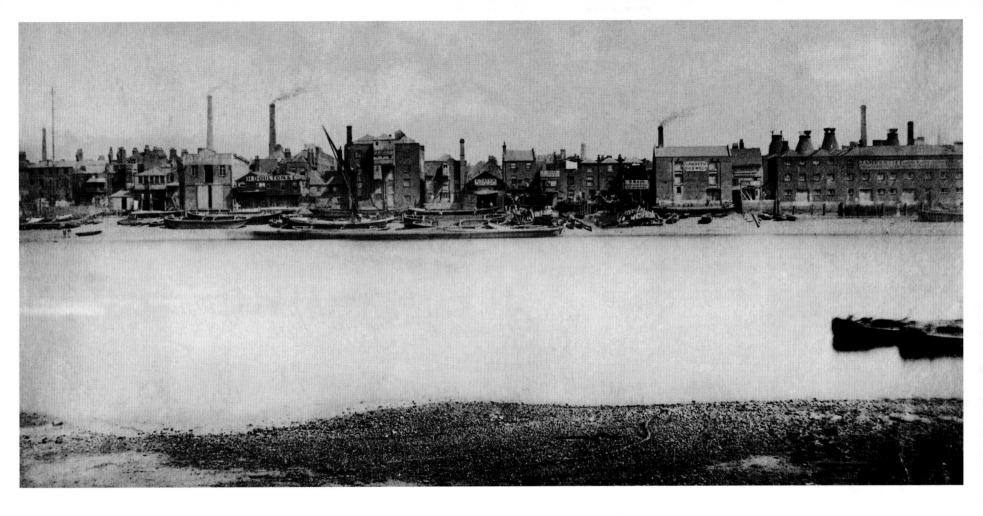

Potteries had been well established in this area of Lambeth, upstream from Lambeth Palace, since the eighteenth century. In 1815, John Doulton moved from the Fulham Pottery to join one of these small riverside works. Through his hard work the pottery thrived and he became a partner in the firm, which by 1826 was trading as Doulton & Watts. It was already one of the most important potteries in the area when Doulton's son Henry joined the company. Under Henry Doulton the Lambeth Pottery, as it became known, expanded rapidly, taking over its smaller neighbours and moving into the large-scale production of sewer and water pipes. With this lucrative foundation, the Lambeth Pottery was able to branch out in the late 1830s into the decorative and art works for which it was to become internationally famous. The general view from across the river illustrates a whole range of small industries vying for space on the bank. The largest pottery in this view (right) belonged to James Stiff, who with Doulton gradually bought up the land between High Street and Fore Street and came to monopolise the pottery industry in this area. A sign for H. Doulton & Co. is clearly visible and their Drainpipe Wharf was just out of sight to the left adjacent to Lambeth suspension bridge. The second photograph (page 78), taken from the bridge, shows more of the same stretch of river bank with construction work for the new embankment then underway. A steam pile-driver has been set up on the wooden trestles. The third photograph (page 79) shows the backs of a small group of tenements on Fore Street. They may be seen in the second view located in the middle distance between the two barges drawn up on the foreshore.

LAMBETH

William Strudwick, c.1860. BB94/20550 (above), BB94/20544 and BB94/20526 (left and right overleaf)

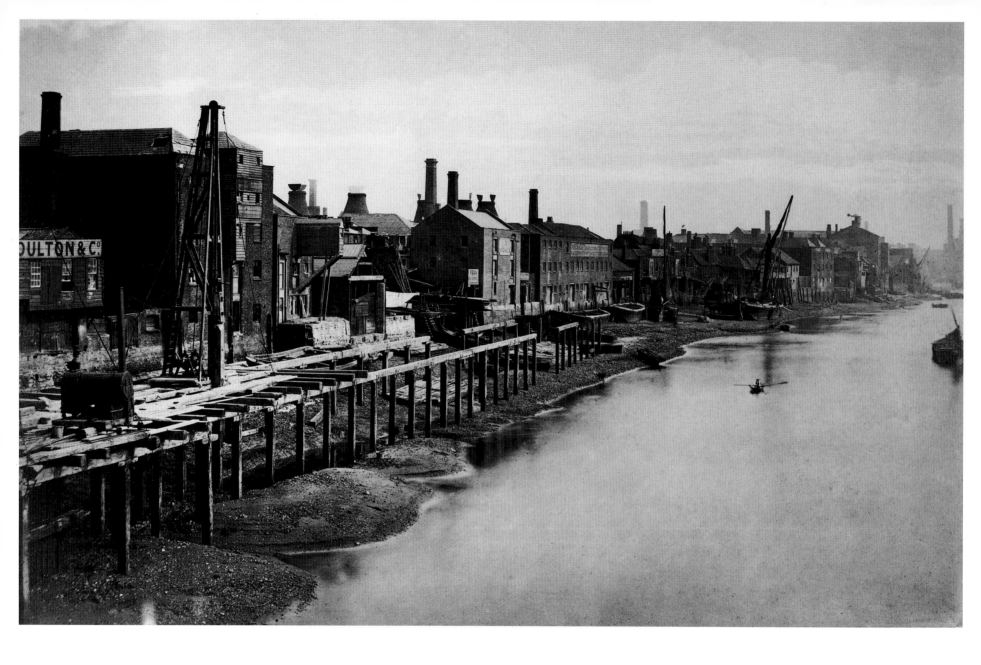

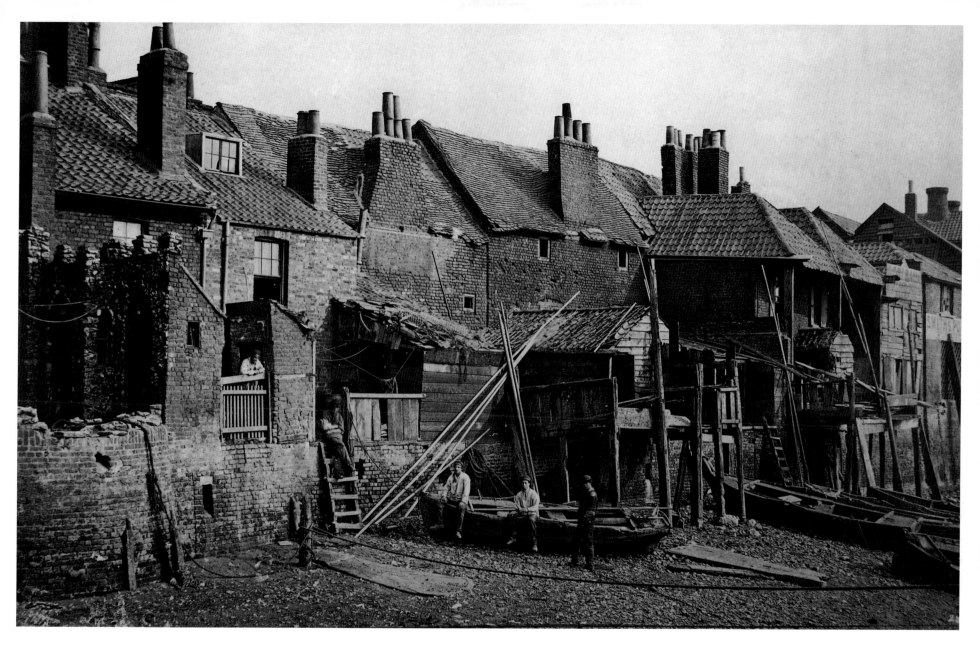

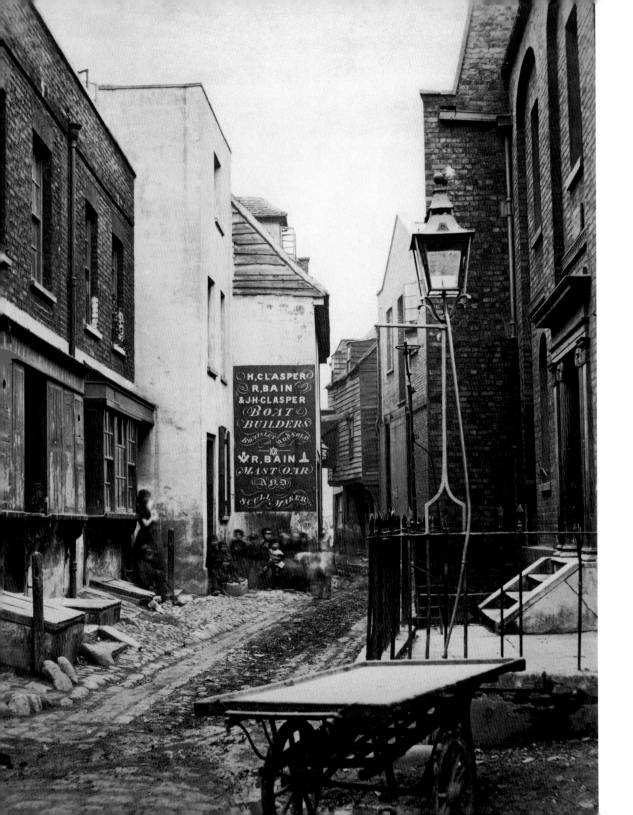

Among the many boat builders and repairers who lost out as a result of the construction of the embankment was R. Bain. This small business is to be seen just right of centre next to Lambeth Rice Mills in Strudwick's general view of the waterfront from across the river (page 77). In the photograph taken from a boat on the foreshore, the three men have stopped work to pose for the camera. The fronts of these buildings were on Fore Street. This narrow road, which ran close to the river and parallel to the High Street, was the nucleus of the original riverside settlement of Lambeth. The street's appearance is vividly displayed in the first photograph, where the photographer was a source of fascination for the group of children huddled under the boatbuilder's sign. The whole street, running south from Lambeth church to Broad Street (now Black Prince Road), with its warren of alleys, wharves, shops and houses was to disappear under the new thoroughfare behind the Albert Embankment. It is salutary to note that nearly all of the important buildings – headquarters for Doulton & Co., Smith & Sons, the Ministry of Works and the London Fire Brigade – that took up their positions overlooking the river on the Albert Embankment have been replaced in their turn.

FORE STREET, LAMBETH

William Strudwick, c.1860. BB94/20530 (left) and BB94/20537 (right)

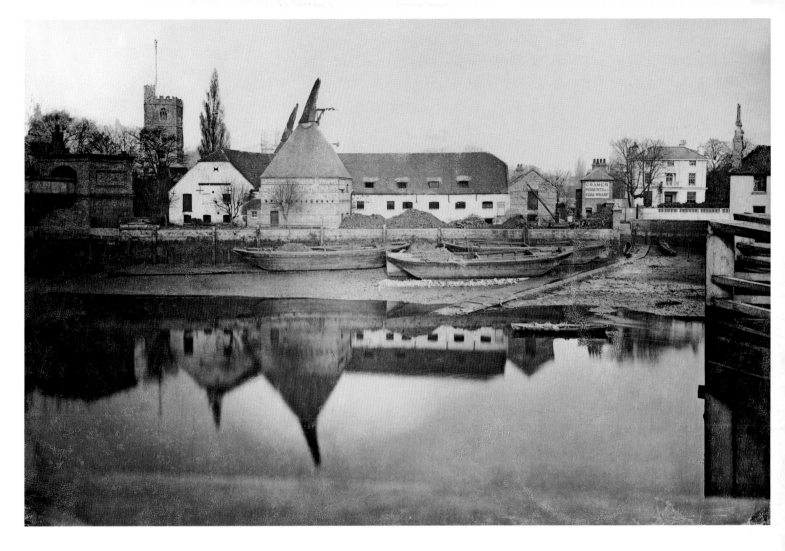

Fulham is situated on the Middlesex bank of the Thames, immediately opposite Putney. It was unusual for two ancient villages to have grown up in this way, as normally the inner bend of the meander would be too marshy to support a settlement. Before the mid nineteenth century, there were a few riverside houses near the parish church with the area largely given over to market gardening. It was said that more than half the fruit and vegetables sold at Covent Garden market were grown in Fulham. The most important surviving building is the medieval Fulham Palace, the former seat of the bishops of London, which stands upstream close by the parish church of All Saints (left). This has a west tower that was documented to be under construction in 1440. It was built of ragstone brought up-river from quarries in Kent. The church was altered in 1840–1 by Edward Lapidge and rebuilt by Sir Arthur Blomfield exactly 40 years later. This photograph was taken from the old Putney Bridge and shows the toll-house (far right) and the aqueduct (left). The early-nineteenth-century maltings stood on the riverbank adjacent to Swan Wharf, the coal wharf of Cramer Roberts & Co., with Cambridge House in the background. In 1900, Swan Wharf and the maltings were acquired by the Fulham Vestry for use as a refuse depot. Domestic rubbish was loaded into lighters and dumped downstream. Swan Court, a small sheltered-housing development, now stands on the site.

FULHAM

William Reid, 1878. Harrod Collection, R7–13

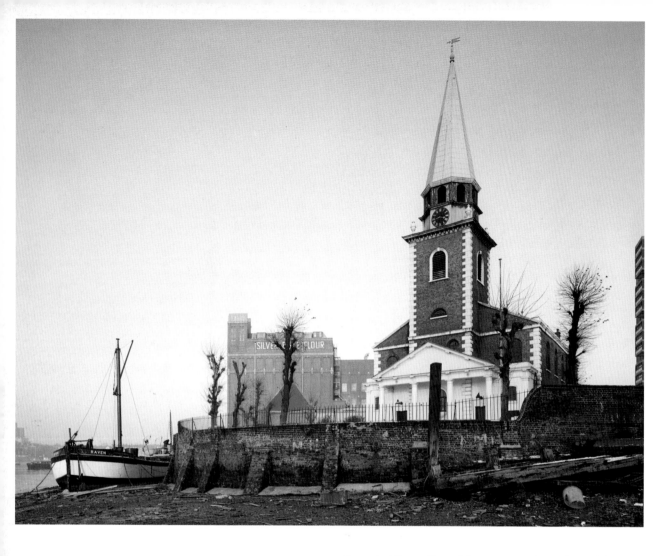

ST MARY'S CHURCH, BATTERSEA

Gordon Barnes, November 1969. AA84/455

The ancient Surrey village of Battersea once clustered around the parish church, which was mentioned first in the mid twelfth century. The church still stands on the shore overlooking a working wharf, but the present building dates from 1775–6. It is a plain Georgian preaching box, designed by Joseph Dixon. This simplicity is attractive to today's visitors, but in 1859 it was described as being 'especially odious … the architect seems to have studied how far it was in his power to render it repugnant'. The present church retains some notable fittings from the earlier building, including a fine collection of monuments and the east window, datable to c.1631 and attributed to Bernard van Linge. This stained glass is an unusual survival from this period and commemorates the St John family, lords of the manor. The church was restored in 1876–8 by Sir Arthur Blomfield, architect to the diocese of London. The former manor house of the St Johns lay east of the church, but was demolished in the late eighteenth century, when industry began to supplant the market gardens for which Battersea had been noted. Industrial development accelerated in the later nineteenth century encouraged by the arrival of the railways. On the manor house site for most of the twentieth century a huge flour mill loomed over the church, but now this has been replaced by an even more imposing block of flats – a striking sign of the times.

The Cremorne Estate was originally Chelsea Farm and in 1803 came into the possession of the first Viscount Cremorne, after whom it was renamed. The property lay west of Battersea Bridge between the King's Road and the river. Cremorne House was sold in the 1820s for use as a sports club, the Stadium. This was not successful and because of the natural beauty of its situation it was turned into a pleasure garden in 1843. There were brilliant firework displays and it became renowned for balloon ascents. Under new management, the grounds were laid out at great expense and reopened to the public in 1846. As the splendour of Vauxhall Gardens began to wane, so Cremorne took over as one of London's principal summer pleasure resorts. Among other attractions were a marionette theatre, a circus, grottoes and a dining hall. This photograph shows the central walk. An enthusiastic contemporary account described a 'perfectly entrancing scene, with coloured lamps, well-kept walks, lovely flowers, brilliantly illuminated temples, splendid conservatories, unrivalled ballets, and a platform with a thousand mirrors and a magic orchestra, which may well recall the glowing pages of the *Arabian Nights*'. The gardens were popular with artists including local Chelsea residents James Whistler and Dante Gabriel Rossetti, whose brother William reported another of the attractions. He noted that Cremorne was 'a place of demi-reputable entertainment and assignations, with all their accompaniments and sequels'. In the words of a popular slogan, the pleasure grounds became known for 'the three D's – dancing, drinking, and deviltry'. As a result, opposition grew and finally in 1877 Cremorne Gardens were closed on the orders of the Chelsea Vestry. Lots Road Power Station and a maze of small streets today occupy the site.

CREMORNE GARDENS
York & Son, 1870s. BB80/164

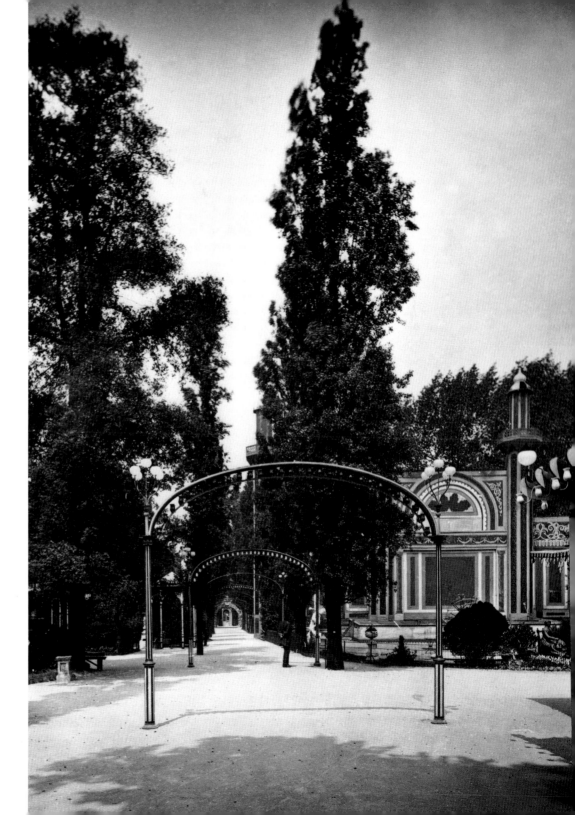

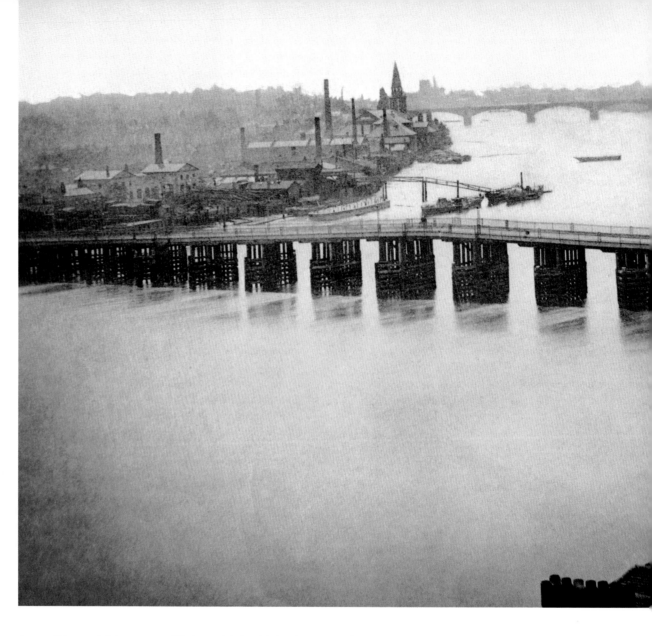

BATTERSEA BRIDGE

James Hedderly, c.1870. Philip Norman Collection,
BB82/13057 and BB99/1042

As part of his record of the area around Chelsea parish church before it was transformed by the construction of the embankment (see page 70), James Hedderly took this panorama from the top of the church tower. The view looking upstream shows in the distance on the left the spire of St Mary's Church, Battersea, and beyond that the West London Extension Railway Bridge. This was designed by Benjamin Baker and T. H. Bertram and opened on 2 March 1863. To the right in the distance are Cremorne Gardens. In the foreground are the houses on both sides of Duke Street, the river side of which was to disappear for the new embankment. However, the view is dominated by old Battersea Bridge. The former ferry crossing between Chelsea and Battersea was owned by the first Earl Spencer and in 1766 he obtained an Act to allow the building of a bridge. The timber structure seen

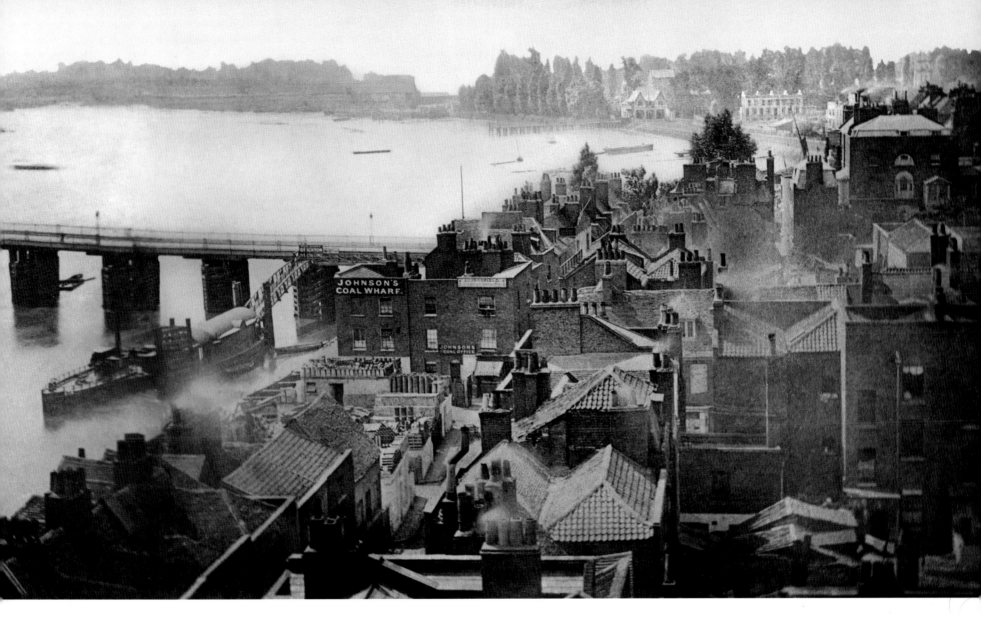

here was built in 1771–2 by John Phillips, nephew of Thomas Phillips, the builder of Putney Bridge, whose London business he took over when his uncle died in 1775. The construction was directed by the young Henry Holland, then working for his father's building firm at Fulham. The narrow openings made navigation difficult, so four of the original 19 spans were subsequently thrown into two to allow easier passage. This bridge was to be made famous in the paintings and etchings of James Whistler, who lived nearby in Chelsea.

The new embankment exposed the inadequacies of the old bridge and in 1884 work began on a replacement to the designs of Sir Joseph Bazalgette. The new iron bridge opened on 21 May 1890.

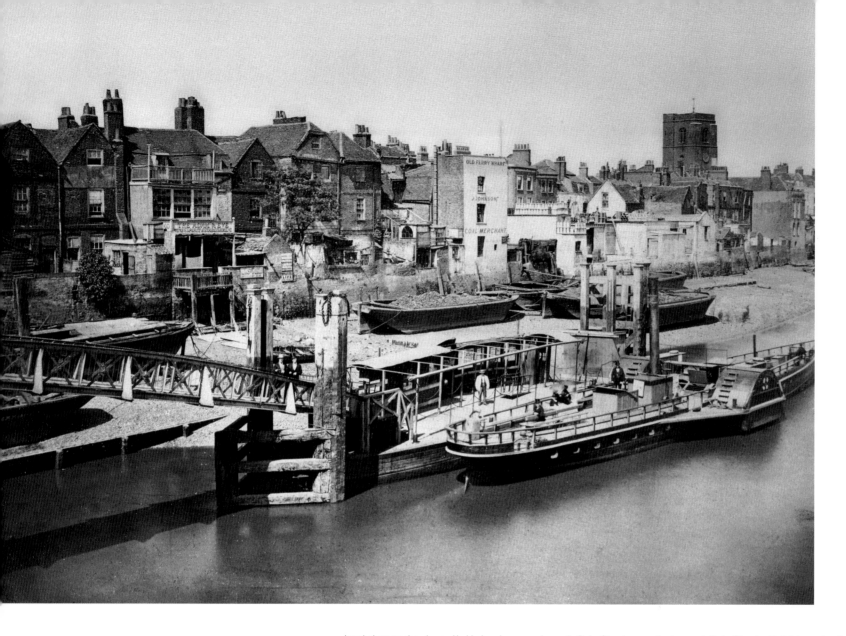

CHELSEA EMBANKMENT

James Hedderly, 1872. BB94/15622

Local photographer James Hedderly, whose own house in Duke Street was one of those swept away for the building of the Chelsea Embankment, recorded the area in detail before the work began. In addition, throughout the early 1870s, he photographed the progress of the construction westwards from Chelsea Bridge. This view, taken from old Battersea Bridge with the tower of Chelsea parish church in the background, shows the backs of the houses in Duke Street with lighters unloading coal drawn up on the foreshore. The picturesque Adam & Eve tavern, accessible from the river, is prominent to the left. The paddle steamer *Citizen* was one of six built in 1845–7 by Ditchburn & Mare, later to become the Thames Ironworks (see page 174). The floating pier with its footbridge to Battersea Bridge may also be seen in the following photograph.

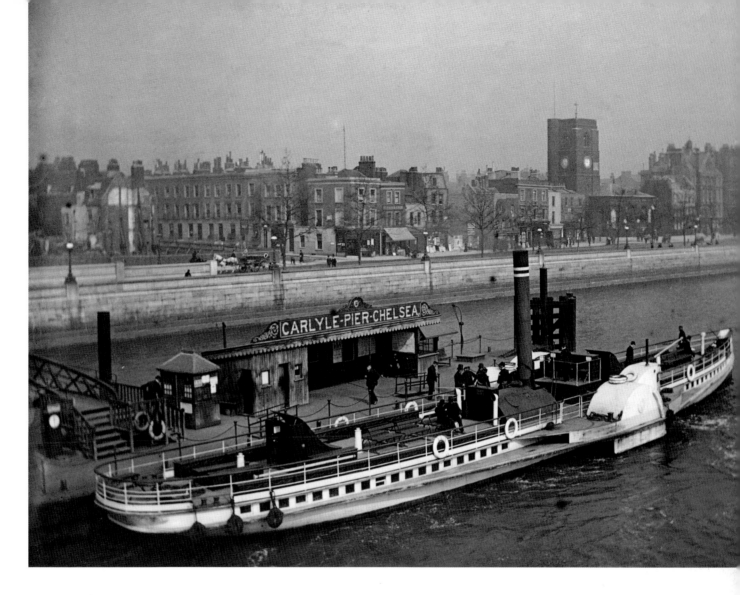

This photograph, taken from a similar position to Hedderly's picture, shows the completed embankment. Paddle steamers still plied from the pier, by then renamed after the author Thomas Carlyle, one of Chelsea's most famous residents. He had lived near the church and died in 1881. The reason for building the Chelsea Embankment was the same as that which had prompted the construction of the Victoria and Albert embankments – in order to improve drainage. At first it was proposed that a sewer should be constructed under the foreshore, but the cost of the temporary dam required would have been little less than that needed for a permanent embankment with a roadway under which the sewer could be laid. The Act of Parliament was passed in 1868 and in July 1871 the Metropolitan Board of Works under its engineer Sir Joseph Bazalgette began construction of the embankment between Chelsea Bridge and Battersea Bridge. It was completed in 1874 and on 9 May the new thoroughfare was opened officially by the Duke and Duchess of Edinburgh. This part of London had changed forever and the only building to survive to the present is the parish church, albeit rebuilt after wartime bombing.

CHELSEA EMBANKMENT

M. Hodgson, c.1893. BB84/604

BATTERSEA PARK

Campbell's Press Studio, 1951. BB73/7119

The marshy ground, known as Battersea Fields, had been an area of market gardens, 'occupied mainly by cabbage-planters and asparagus-growers'. In 1846 an Act of Parliament was passed to allow the Commission for Metropolitan Improvements to purchase the land for a public park. Work began in 1854 and the river was embanked in 1861. The architect James Pennethorne was responsible for the design and from 1857 the layout was supervised by John Gibson, who included a renowned sub-tropical garden and a lake excavated in 1860. Battersea Park became one of the sites for the Festival of Britain in 1951. Although the Festival has become synonymous with the South Bank at Lambeth, it was not confined to this location, but was meant to be a 'tonic for the nation' – a phrase coined by Gerald Barry, editor of the

News Chronicle. So in addition to the South Bank, there was a Land Travelling Exhibition, which toured the country, and a Festival Ship, the *Campania*, which visited towns around the coast. The Festival Gardens at Battersea were intended to recreate the feeling of an eighteenth-century pleasure garden at Vauxhall or Ranelagh. The co-ordinating designer for the gardens, James Gardner, declared that they were to be a place where 'people could relax and have elegant fun' as 'architects and scientists seem to be running away with' the South Bank. The illuminations and nightly firework displays were to be a welcome contrast to the wartime black-out. There was a Dance Pavilion, an amusement park with a Big Dipper and a whimsical miniature railway designed by Rowland Emmett to transport visitors around the site.

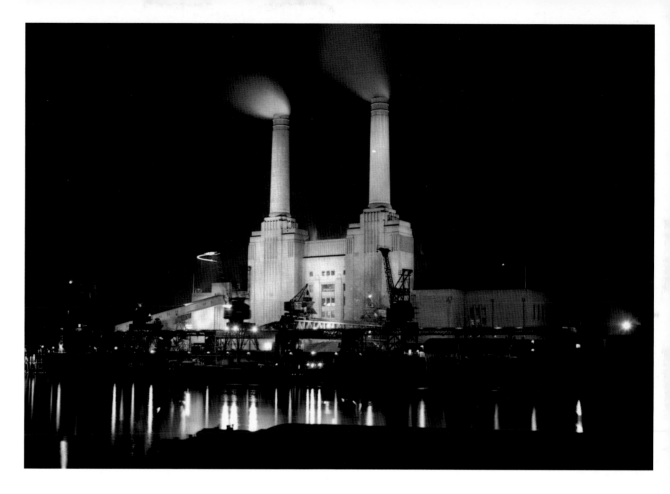

The mighty power station with its tall chimneys floodlit at night was ever a source of controversy. In April 1927 the London Power Company applied for permission to build a generating station on the river at Battersea. Work began in 1929 with S. L. Pearce as engineer, assisted by H. N. Allot and J. Theo Halliday, who was architect of the exterior and the Art Deco interiors. After construction had begun, Sir Giles Gilbert Scott was brought in as consultant. Attacks on the new building came from every quarter: the structure was denounced by *The Times* and even *The Architects' Journal* lamented 'a civilisation condemned to live under a pall of smoke and in the shadow of ugly buildings of its own devising'. The new power station was unveiled by the Chairman of the London Power Company, Sir Francis Fladgate, on St George's Day, 23 April 1931, and the building's supporters began to have their say. It was praised as 'a flaming altar of the modern temple of power' and the observation made that 'Standing as it will so near to the centre of London and of the Empire, Battersea Power Station will typify the growth of electric power in this country'. It started to supply power in June 1933 and was so far ahead of its time that it would remain the largest generating station in the country until 1956. Originally only the western (right) half with two chimneys was completed, but it was intended from the outset that the capacity would be doubled. Construction work on the second generating set was delayed by the war, but resumed in 1944 and it was brought into service in 1953. The earlier west set closed in 1974. The familiar outline with a chimney at each corner has become a landmark, so much so that when Battersea ceased generating altogether in 1983 and demolition was a real possibility there was a huge outcry. However, to date, all the proposals for alternative uses have come to naught and the building remains an empty shell.

BATTERSEA POWER STATION

Eric de Maré, 1950s. AA98/5903

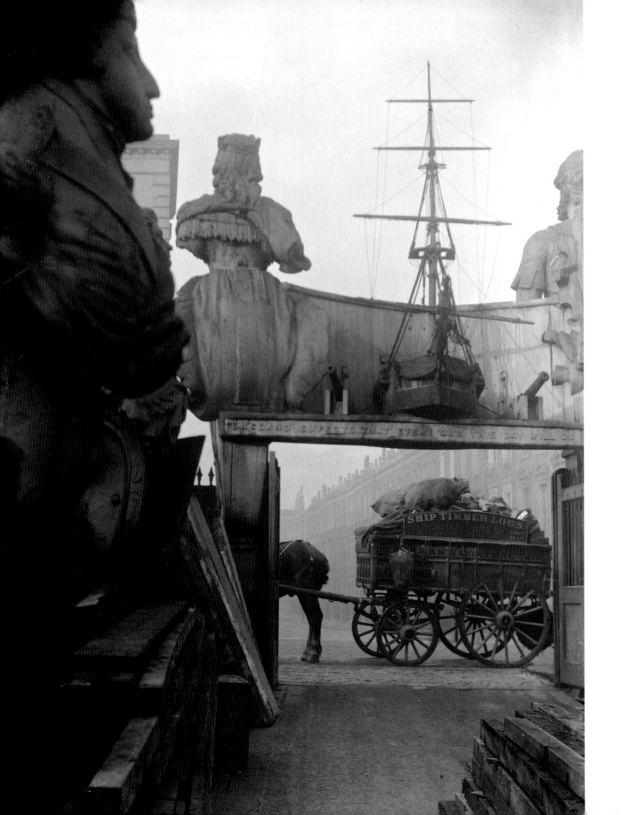

Shipbuilding on the Thames declined as the nineteenth century progressed, but shipbreaking prospered. As iron began to supplant wood, so the proud merchantmen and battleships of the sailing navy were replaced. The painter J. M. W. Turner witnessed the poignant sight of HMS *Temeraire*, a veteran of Trafalgar, being towed up the Thames to the breaker's yard. Henry Castle & Son at Baltic Wharf on Millbank, just north of Vauxhall Bridge, operated a flourishing shipbreakers and timber merchants from the mid nineteenth century. The inscription on the waggon in the first photograph reads 'Ship Timber Logs', leading one to wonder how many great warships had been reduced to firewood. Some items were advertised as garden ornaments. The figureheads displayed over the gates were prominent features on Millbank. The figureheads in the second photograph (from left to right) were from HMS *Princess Royal* (1853), HMS *Cressy* (1853) and HMS *Colossus* (1854). Between the last two, the supporting angels came from HMS *Ocean* (1804). In the first photograph, (also from left to right) are figureheads from HMS *Edinburgh* (1811), HMS *Princess Royal*, here seen from the rear, and HMS *Orion* (1854). Some of these warships had begun their lives on the Thames: *Ocean* at the Royal Naval Dockyard at Woolwich, *Edinburgh* was built by Randall & Brent at Rotherhithe, and *Orion* and *Colossus* by John Penn & Son at Greenwich. This yard was renowned for the quality of its work and following closure in 1912 a contemporary reminisced that 'Thus passed the Glory of the Thames'. Castles' yard at Baltic Wharf was bombed in 1941 and the large collection of items from the last of the wooden warships was destroyed.

BALTIC WHARF, MILLBANK

Unknown photographer, c.1900. BB76/4423 (left) and BB76/4422 (right)

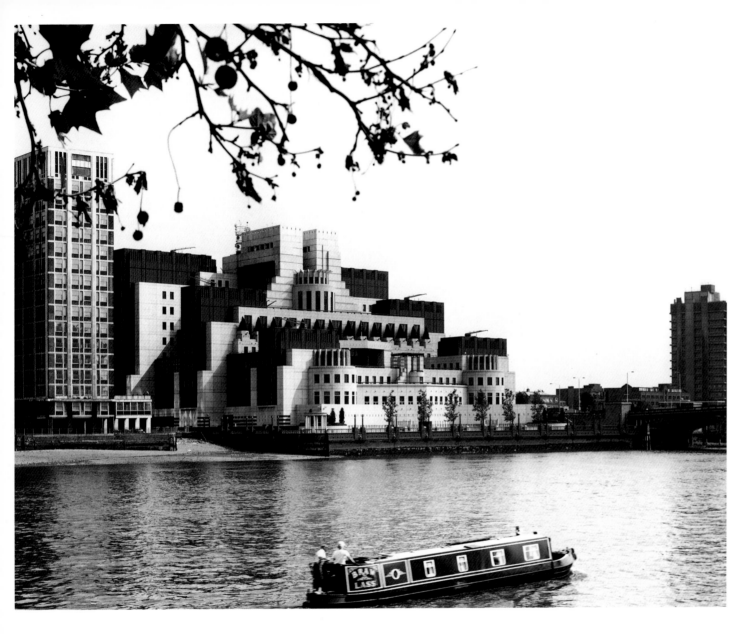

VAUXHALL CROSS

Sid Barker, RCHME, July 1998. BB98/12930

A prestige riverside site is still much sought after by companies and public organisations. Somewhat incongruously, this extremely prominent landmark is the headquarters of the Secret Intelligence Service, MI6. Standing on the Albert Embankment adjacent to Vauxhall Bridge, it was built in 1988–92 to the designs of Terry Farrell & Co. The vast and dramatic office block rises in tiers like an Art Deco ziggurat and relies for much of its impact on the use of colour. It is faced in cream-coloured concrete with dark bottle-green glass and at the centre of the river elevation is a single column in dark red. As may be seen here, this huge building stands out into the stream beyond its neighbour behind a new extension of the Albert Embankment. Its international fame was enhanced when it featured in the James Bond film *The World is not Enough* (1999).

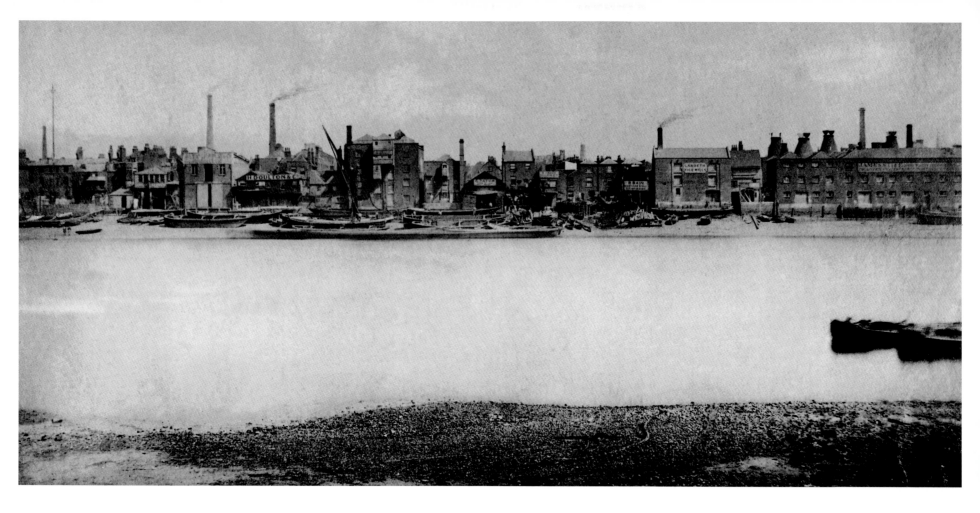

Potteries had been well established in this area of Lambeth, upstream from Lambeth Palace, since the eighteenth century. In 1815, John Doulton moved from the Fulham Pottery to join one of these small riverside works. Through his hard work the pottery thrived and he became a partner in the firm, which by 1826 was trading as Doulton & Watts. It was already one of the most important potteries in the area when Doulton's son Henry joined the company. Under Henry Doulton the Lambeth Pottery, as it became known, expanded rapidly, taking over its smaller neighbours and moving into the large-scale production of sewer and water pipes. With this lucrative foundation, the Lambeth Pottery was able to branch out in the late 1830s into the decorative and art works for which it was to become internationally famous. The general view from across the river illustrates a whole range of small industries vying for space on the bank. The largest pottery in this view (right) belonged to James Stiff, who with Doulton gradually bought up the land between High Street and Fore Street and came to monopolise the pottery industry in this area. A sign for H. Doulton & Co. is clearly visible and their Drainpipe Wharf was just out of sight to the left adjacent to Lambeth suspension bridge. The second photograph (page 78), taken from the bridge, shows more of the same stretch of river bank with construction work for the new embankment then underway. A steam pile-driver has been set up on the wooden trestles. The third photograph (page 79) shows the backs of a small group of tenements on Fore Street. They may be seen in the second view located in the middle distance between the two barges drawn up on the foreshore.

LAMBETH

William Strudwick, c.1860. BB94/20550 (above), BB94/20544 and BB94/20526 (left and right overleaf)

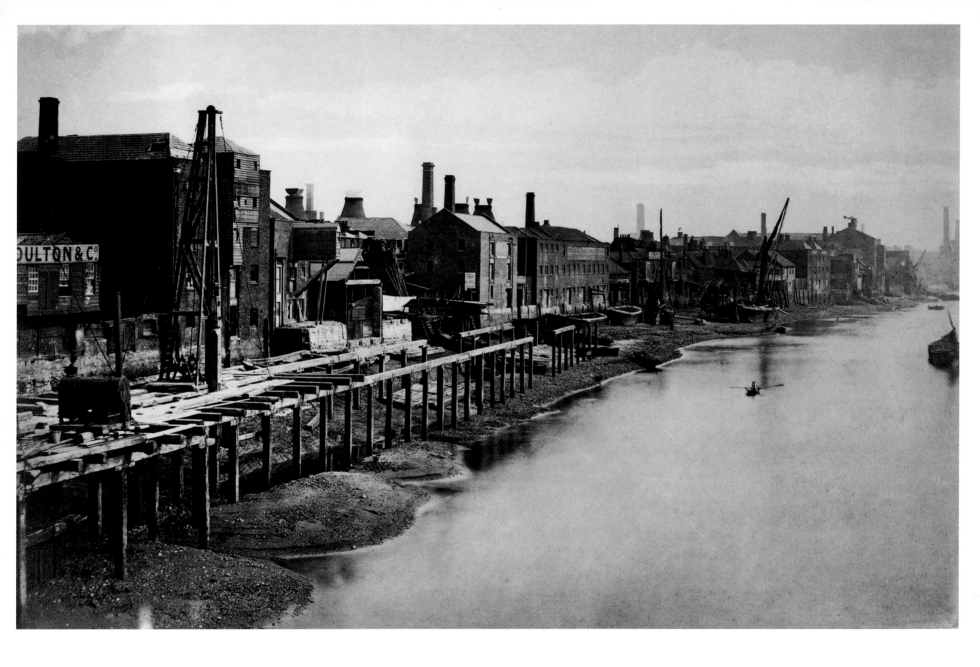

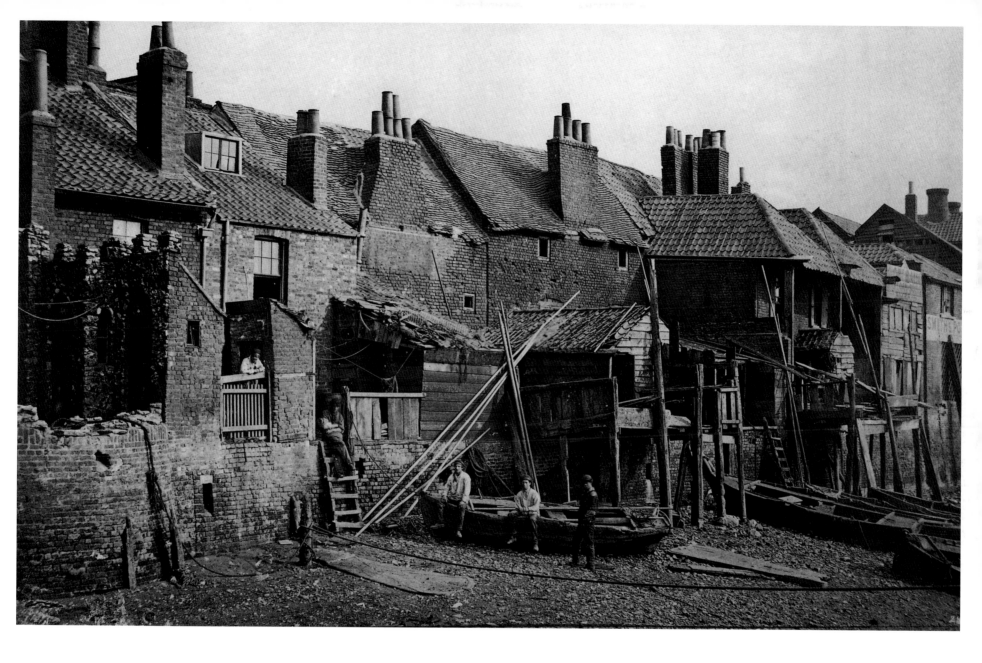

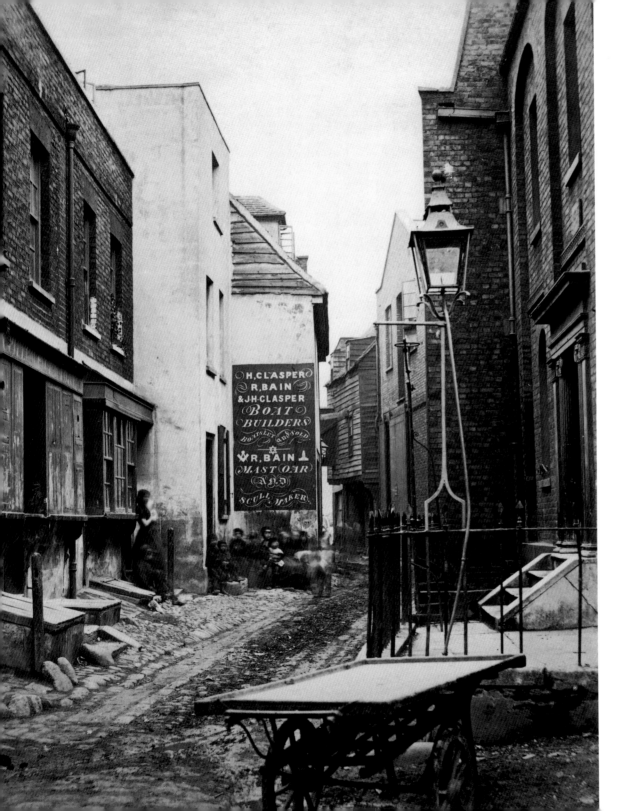

Among the many boat builders and repairers who lost out as a result of the construction of the embankment was R. Bain. This small business is to be seen just right of centre next to Lambeth Rice Mills in Strudwick's general view of the waterfront from across the river (page 77). In the photograph taken from a boat on the foreshore, the three men have stopped work to pose for the camera. The fronts of these buildings were on Fore Street. This narrow road, which ran close to the river and parallel to the High Street, was the nucleus of the original riverside settlement of Lambeth. The street's appearance is vividly displayed in the first photograph, where the photographer was a source of fascination for the group of children huddled under the boat-builder's sign. The whole street, running south from Lambeth church to Broad Street (now Black Prince Road), with its warren of alleys, wharves, shops and houses was to disappear under the new thoroughfare behind the Albert Embankment. It is salutary to note that nearly all of the important buildings – headquarters for Doulton & Co., Smith & Sons, the Ministry of Works and the London Fire Brigade – that took up their positions overlooking the river on the Albert Embankment have been replaced in their turn.

FORE STREET, LAMBETH

William Strudwick, c.1860. BB94/20530 (left) and BB94/20537 (right)

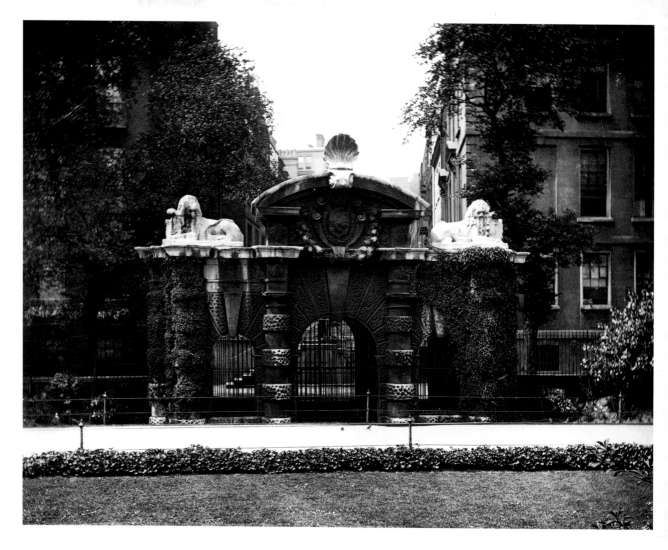

The grand houses which once stood along the riverside road – hence Strand – between the City of London and Westminster all employed the Thames as a highway. The York House Watergate is the sole survivor of the entrances from the landing stages, known as stairs. Its distance now from the water, some 500 yards (450 metres), is another demonstration of the changes wrought by the building of the embankments. York House, a seat of the dukes of Suffolk in the sixteenth century and known as Suffolk House, was acquired by the Archbishop of York in the time of Queen Mary. Having been given its new name, from 1561 it was leased to the Crown and became the official residence of the Lord Keeper of the Great Seal. The holder of the office at that time was Sir

Nicholas Bacon and it was at York House that his son Francis Bacon was born. In 1624 the king's favourite, the first Duke of Buckingham, schemed to take over the house and rebuild it in the latest fashion. He employed Sir Balthazar Gerbier to advise on designs, but the Duke was murdered before these came fully to fruition. In 1672 the second Duke sold the property for redevelopment, stipulating that the streets erected on the site should commemorate the family. To this day there are, among others, George Court, Villiers Street and Buckingham Street. Against the odds, the watergate also survived. This dates from c.1625 and although the designer is not known for certain it has been plausibly attributed to Inigo Jones, Nicholas Stone and Balthazar Gerbier.

YORK HOUSE

York & Son, 1890s. CC97/1642

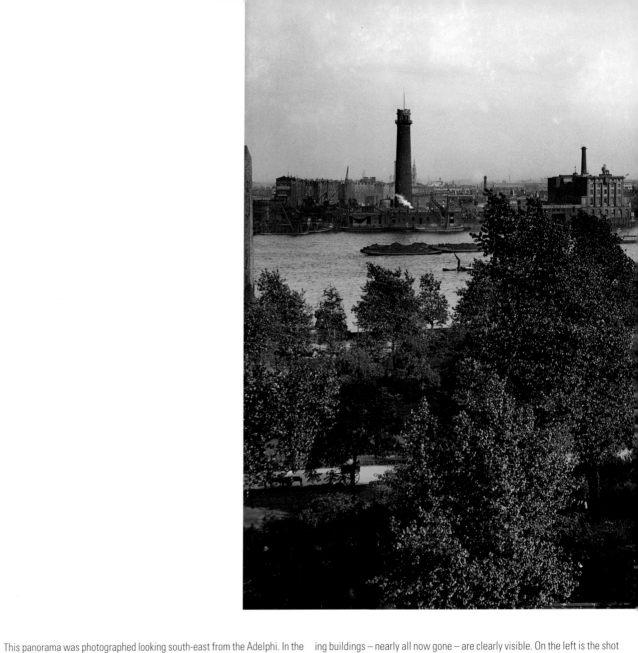

EMBANKMENT GARDENS

Bedford Lemere, August 1901. BL 16618–4 and BL 16618–2

This panorama was photographed looking south-east from the Adelphi. In the foreground are the Embankment Gardens, opened in July 1872. These were created in front of the York House Watergate when the Victoria Embankment made a smooth line of the north shore of King's Reach between Hungerford and Waterloo bridges. To the left, one of the sphinxes flanking Cleopatra's Needle may be glimpsed through the trees. On the far bank, several interest-

ing buildings – nearly all now gone – are clearly visible. On the left is the shot tower by David Riddal Roper, 1826, for Thomas Maltby & Co. This continued as a going concern until 1949, became a feature of the Festival of Britain in 1951, but was demolished in 1962. The conspicuous Lion Brewery, designed in 1836 by Francis Edwards, was topped by W. F. Woodington's Coade-stone lion. The brewery was demolished in 1950 for the building of the Royal Festi-

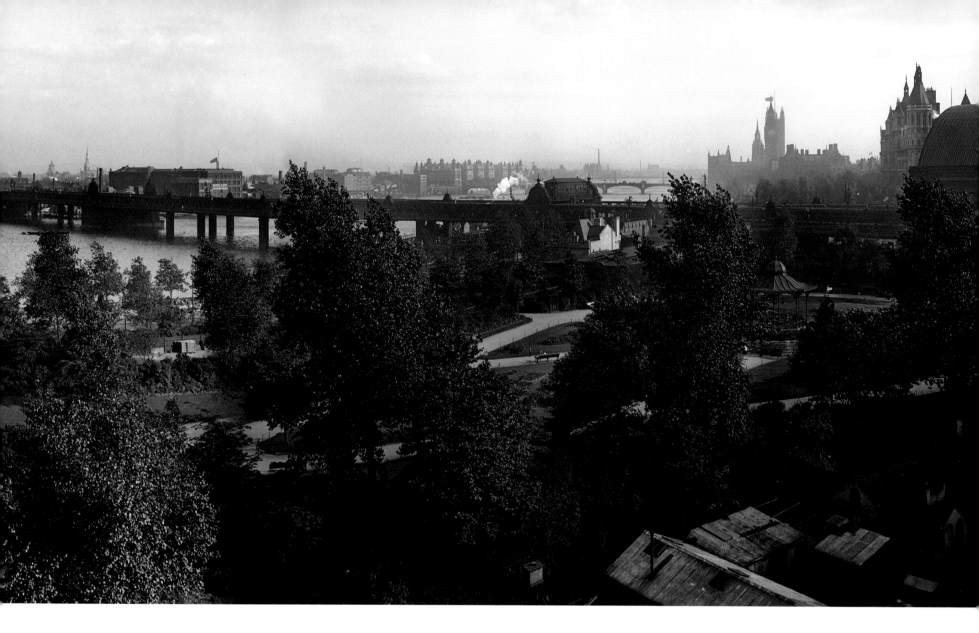

val Hall. Beyond Hungerford Bridge are the warehouses and wharves where Jubilee Gardens – the site of the London Eye – and County Hall now stand. The most prominent block is the East India Military Stores, the supply depot for the India Office, built in 1861–2 to the designs of Sir Matthew Digby Wyatt. It was damaged by bombing and the site was cleared in 1949. St Thomas's Hospital is easily visible just beyond Westminster Bridge. The tall chimney above the signal box on the railway bridge was attached to the Royal Doulton Pottery. This was the elaborate works designed by Tarring Son & Wilkinson in collaboration with Henry Doulton himself and built in 1876–8. Across the river are the Houses of Parliament and, to the right, the end turret of the National Liberal Club, 1884–7, by Sir Alfred Waterhouse. This is partly obscured by the train shed of Charing Cross Station on the extreme right.

In emulation of Classical Rome, which had shipped Egyptian obelisks to Europe, the Victorians wanted their own example for Imperial London. Originally intended to commemorate Nelson's victory at the Battle of the Nile, 1798, and despite offers to George IV and William IV by the then ruler of Egypt, it was not until 1867 that work began in earnest. However, even with the benefit of nineteenth-century technology, this was a perilous undertaking. A cylindrical vessel, named *Cleopatra*, was especially constructed to carry the obelisk and in 1877 the tug *Olga* began the tow from Alexandria. A violent storm in the Bay of Biscay resulted in the parting of the tow-line and the loss of six sailors during the attempt to rescue the cylinder. The vessel was eventually recovered by the steamer *Fitzmaurice* and safely brought to England. In 1878, the obelisk – which has no connection with Cleopatra – was set up on the Victoria Embankment, in itself a complicated procedure as may be seen from this photograph. A memorial tablet at its base lists the names of the seamen who drowned during the voyage, together with the names of those who were instrumental in bringing the obelisk to London.

CLEOPATRA'S NEEDLE, VICTORIA EMBANKMENT

Unknown photographer, September 1878. BB71/1648

Until the advent of the Victoria Embankment, opened in 1870, the gardens at the Temple – the legal quarter of London – ran down to the river. The name derived from the Knights Templar, a religious order whose twelfth-century church still stands just outside the City boundary. The order was suppressed by the Papacy in 1312 and their London house passed to the Knights Hospitallers, who granted part of the site to a group of lawyers. In their turn the Hospitallers were suppressed in 1539 and the ownership of the riverside site was granted by the Crown to the Benchers of the Inns of Court. At the end of Middle Temple Lane were Temple Stairs, a more elaborate landing stage to cope with the numerous arrivals and departures by boat. When the embankment was built, these steps, part of Bazalgette's and Vulliamy's grand design, perpetuated the memory of this jetty, although they have become more popular for recreation than travel.

TEMPLE STAIRS
Campbell's Press Studio, 1950s. AA74/5

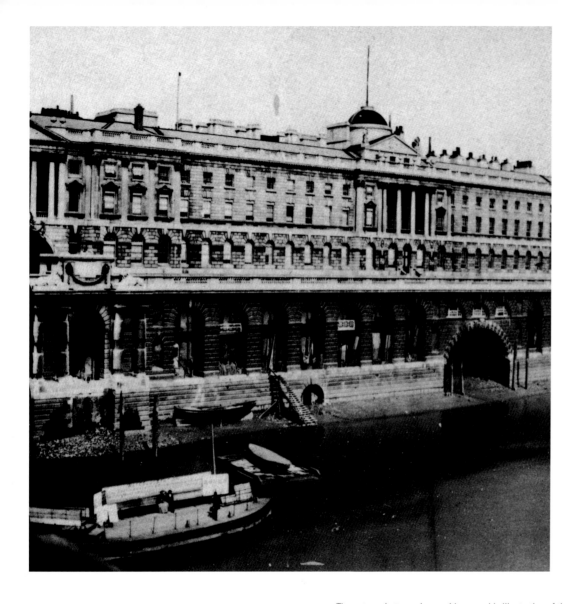

SOMERSET HOUSE

Unknown photographer, 1850s. Howarth Loomes Collection,
BB81/1594 (above)

York & Son, 1890s. DD97/290 (right)

These two photographs provide a graphic illustration of the extension of the embankment into the Thames. In the 1770s, the Prime Minister Lord North decided to bring together as many government departments as possible under one roof. The old Somerset House, dating from the sixteenth century, which already housed a number of official bodies, including the Royal Academy, was demolished to make way for William Chambers' masterpiece. Begun in 1776, the new Somerset House was completed only in 1801, after Chambers' death. The building was extended with flanking wings later in the century. Chambers housed the naval departments in the river front, which stood high above the foreshore. The central arch was designed to allow the Royal Barge to pass underneath. The other offices were arranged around a large courtyard, in the centre of which stands a bronze statue of George III with Father Thames reclining below. The sculptor John Bacon was paid £2000 for this when it was erected in 1789. The maritime theme continues on the Strand front with carved keystones representing the Thames, Humber, Mersey, Dee, Medway, Tweed, Tyne and Severn – with 'Ocean' in the centre.

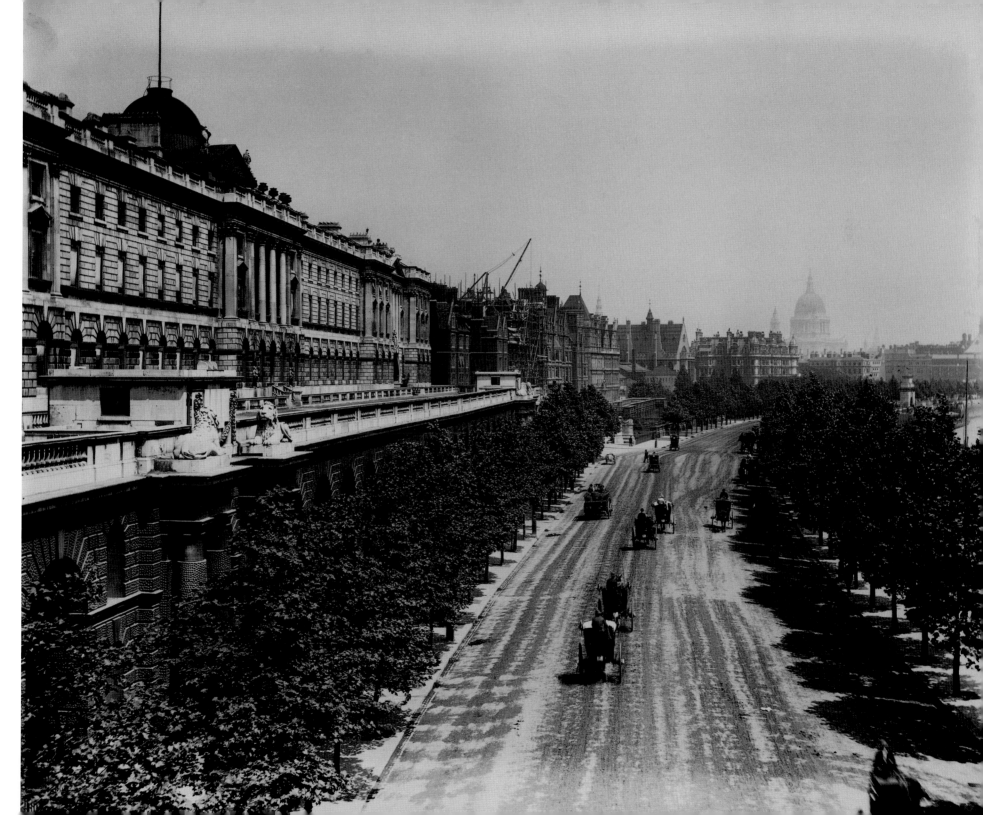

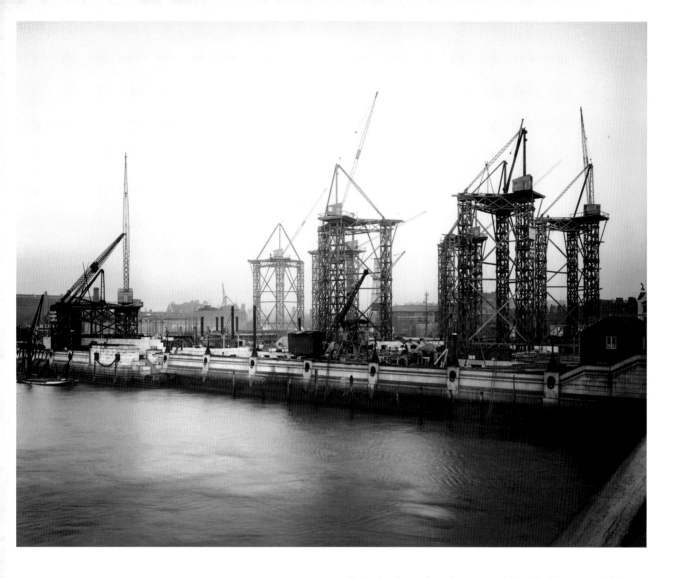

COUNTY HALL, LAMBETH

Bedford Lemere, November 1913. BL 22441–2

The London County Council was created in 1888, taking parts of Middlesex and Kent and Surrey to form a new county surrounding the ancient City of London. With its increasing responsibilities, the LCC soon outgrew its original headquarters and in 1907 chose a new site on the south bank of the Thames adjacent to Westminster Bridge. This was a worthy position for the forward-looking authority wishing to make its mark upon the capital. The following year a grand architectural competition was held and the surprising winner was the relatively unknown Ralph Knott. Work began on the new building after the completion in September 1910 of the embankment wall designed by the LCC's chief engineer Maurice Fitzmaurice. In this photograph the tripod cranes known as 'Scotsmen' are being erected. At the outbreak of the Great War the partially completed building was requisitioned and the opening ceremony performed by King George V and Queen Mary did not take place until 17 July 1922. Even then the north wing remained to be built and Knott's original concept was not realised until 1933. Ernest Stone Collins completed the downstream range after Knott died in 1929 at the early age of 50. The Greater London Council, successor to the LCC, was disbanded in 1986 and the building now houses, among other things, an aquarium and hotel.

The adage that 'when the lions drink, London will drown' nearly became a self-fulfilling prophecy. It derived from the lion-headed mooring rings ornamenting the Thames embankments. The example illustrated here is on the Albert Embankment fronting the former County Hall and was designed by the sculptor Gilbert Bayes (1910). Since Roman times, Londoners have encroached upon the river for wharves and building sites, thereby forcing the tides into a narrower channel and raising water levels. In February 1910, during excavations for the foundations of County Hall, the remains of a Roman boat were discovered. This was thought to have foundered on a sandbank indicating that in the fourth century the river here was more than twice as wide as it is at present. The discovery was the cause of much excitement and attracted large crowds when 18 months afterwards the timbers were lifted in one piece and transported to the London Museum on a specially constructed waggon drawn by 12 dray horses. The keeper of the London Museum, Sir Guy Laking, led the procession on horseback and a motor car carrying officers of the museum and of the LCC brought up the rear.

ALBERT EMBANKMENT

Derek Kendall, RCHME, April 1990. BB91/17249

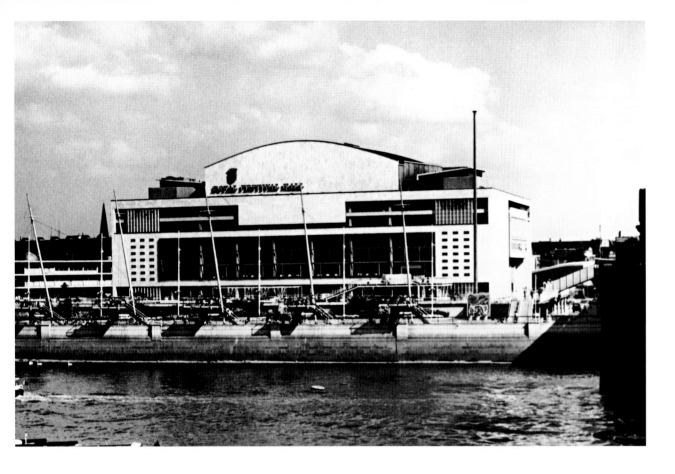

Plans for the redevelopment of the run-down area on the south bank between Hungerford and Waterloo bridges had been outlined by the LCC during the Second World War. The area was designated for 'culture', but in a period of post-war austerity it appeared that nothing would happen. However, the opportunity was taken both to commemorate the Great Exhibition of 1851 and to provide a 'tonic for the nation'. The former leader of the LCC, Herbert Morrison, by then a cabinet minister as Lord President of the Council, announced that the centenary of the 1851 exhibition would be marked by three displays covering Arts, Architecture, Science, Technology and Industrial Design. Quickly this became one 'Festival of Britain' to be housed in temporary pavilions, but with a permanent concert hall. The style throughout was to be modern. On 17 January 1949, Morrison started the pneumatic hammer that drove in the first pile for the new Thames wall along the south bank. The Royal Festival Hall was designed and built in less than three years. The architects were Robert Matthew and Leslie Martin, both later knighted, with Peter Moro and Edwin Williams. It was to be Britain's first major public building designed in the contemporary style and it was praised by Nikolaus Pevsner in 1953 (*Buildings of England*) thus: 'Aesthetically the greatest achievement, and one which is without doubt internationally remarkable, is the management of inner space'. He described the interior in detail, but was less expansive about the exterior: 'The principal façade is towards the river, symmetrical, with much glass, an ingeniously informal asymmetrical arrangement of the staircases, and just one motif which betrays the new urge for something decorative – the curious stone apron in the middle of the top storey'. King George VI opened the Festival and the Royal Festival Hall on 3 May 1951. In 1962 Sir Hubert Bennett made changes to the exterior and the Royal Festival Hall has retained its popularity with the public.

ROYAL FESTIVAL HALL

J. H. Stone, 1951. BB86/813

Plans for a national theatre had been mooted for more than a century before a site was chosen on the south bank of the Thames in 1946. Even then the exact location changed at least three times. The architect Brian O'Rorke prepared designs and in 1951 the Queen (later Her Majesty The Queen Mother) laid the foundation stone at a site next to County Hall. However, nothing happened for ten years until the project was cancelled. This act seems to have galvanised the theatre's supporters and in 1962 Sir Laurence (later Lord) Olivier was installed as Director of the National Theatre. Sir Denys Lasdun was appointed as architect in the following year. Originally an adjoining National Opera House was planned, but this was abandoned in 1967 as a cost-cutting measure. Work started on the theatre in 1969. Performances began in March 1976 and the building was opened officially by Her Majesty The Queen on 25 October. The National Theatre was awarded the title 'Royal' on the twenty-fifth anniversary of the company's first production – Hamlet –

on 22 October 1963. Although the Royal National Theatre has had its critics, the building makes a wonderfully positive contribution to the riverscape immediately opposite Somerset House. Sir Denys Lasdun made suitably riparian comparisons when speaking about his new building in 1976: 'It's in a magical position. Probably the most beautiful site in London. The two main theatres are signalled on the outside by two large blank concrete fly-towers. … The two towers are then tied as it were by a series of terraces, which step down to the river … I call these terraces, which are very horizontal in emphasis, "strata" – it's a geological term that rather goes with concrete – and these strata are available to the public to just mill around in … The rhythm of the building is interesting, given that it's by a river. Because I want the feeling that the audience – like the tides of the river – flow into the auditoriums … Then the tide ebbs and they come out into the creeks of the small spaces that are made by all these terraces …'.

ROYAL NATIONAL THEATRE

Paul Barkshire, September 1986. M5

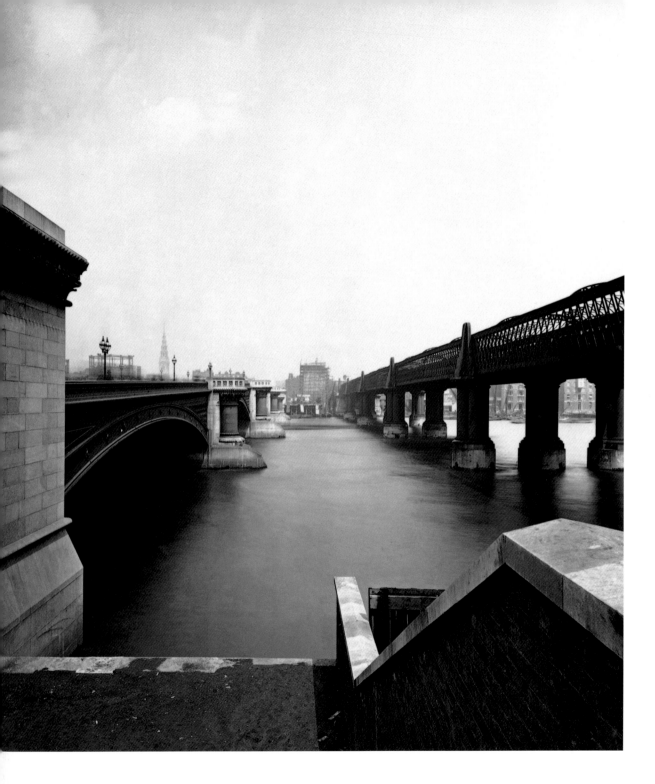

The first bridge to be built between Westminster Bridge and London Bridge was at Blackfriars. Opened on 19 November 1769, it survived until 1860, when it was demolished for the construction of the present road bridge (left). The piers of the original stone bridge at Blackfriars had been undermined by the increased flow of the river following the removal of old London Bridge. A temporary bridge was erected while Joseph Cubitt's wrought-iron structure on granite piers was built. The foundation stone was laid in 1865 and the new bridge was opened by Queen Victoria on the same day, 6 November 1869, as the Holborn Viaduct. Both were designed to improve communications and speed the flow of traffic. Blackfriars Bridge was widened on the upstream side in 1907–10, but to the original design. The parallel railway bridge (right) carrying the tracks of the City extension of the London, Chatham & Dover Railway into Blackfriars Station was also designed by Joseph Cubitt, but here in association with F. T. Turner, 1862–4. Another railway bridge was added downstream in 1884-6 to the designs of Sir John Wolfe Barry and H. M. Brunel. The lattice-girder spans of the original railway bridge were removed in 1985, but leaving the piers, which in the words of the *Buildings of England* (1997) provide 'one of the strangest sights in London, marching across the river, carrying nothing nowhere'. During excavations in the bed of the river in 1970 near the north end of the railway bridge, the almost complete remains of a medieval river vessel – of a type known as a shout – were discovered. This appeared to have been built locally about 1400 and to have sunk almost exactly a century later.

BLACKFRIARS ROAD AND RAILWAY BRIDGES

York & Son, 1870s. CC97/687

The original power station on Bankside, built in 1891, was bombed in the Second World War and in 1947 Sir Giles Gilbert Scott, with the engineers Mott, Hay & Anderson, produced plans for its replacement. The first stage was opened in 1953 and the power station was completed soon after Scott's death in 1960. The site directly opposite St Paul's Cathedral was always a sensitive one, but Scott produced a hugely impressive symmetrical design in brick. The outcry that followed the proposal to demolish Bankside power station when it ceased production in 1980 bore witness to its popularity. An imaginative scheme designed by the Swiss architects Jacques Herzog and Pierre de Meuron to convert it into the Tate Gallery of Modern Art – to be known simply as Tate Modern – was celebrated with a grand opening on 11 May 2000 by Her Majesty The Queen, who had opened the power station in 1962. Access from the north bank is via a new footbridge, begun in April 1999 to a unique design by the architect Sir Norman (now Lord) Foster with the engineer Chris Wise and the sculptor Sir Anthony Caro. The Millennium Bridge is intended to bring another stretch of the river into use for recreation and was dedicated by Her Majesty The Queen on 9 May 2000, although then incomplete and not opened to the public until 10 June. On 12 June the bridge was closed. The rhythmic tread of thousands of walkers resonated with the natural frequency of the bridge and caused the platform to sway dramatically. Several months of exploration followed until a solution involving massive damping (and millions of pounds) was found and the bridge – now vibration-free – reopened to the public.

BANKSIDE POWER STATION

John Bassham, October 1955

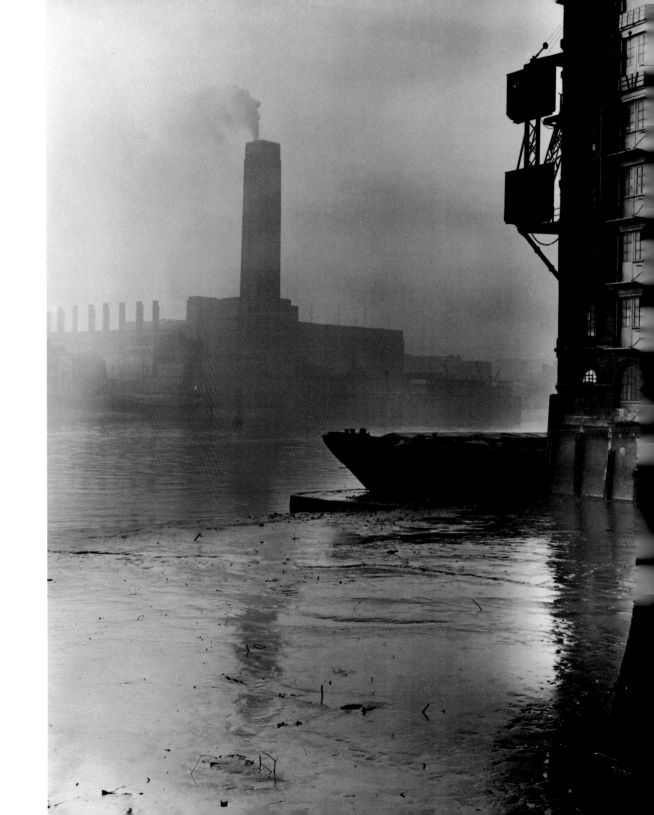

PAUL'S WHARF

This close-up view of White Lion Wharf and Paul's Wharf from Paul's Stairs or Pier gives a good impression of mid-Victorian industry on the City waterfront. Locket & Judkins were coal merchants – note the lighters, empty and laden, drawn up on the foreshore. Heighton and Hutchinson and William Barnard were ironmongers, who advertised their wares to passers-by on the river. It is instructive to note how small-scale industries were able to flourish cheek by jowl. To the left was the more imposing Carron Company warehouse, designed by Henry Garling, c.1840, belonging to the famous ironfounders. The innumerable wharves along this stretch of the river were served by Upper Thames Street, which suffered badly in the Second World War, but even as late as 1957 Sir Nikolaus Pevsner recalled its pre-war atmosphere of 'warehouses, horse-lorries and smells'. However, this mid-nineteenth-century view also illustrates a much earlier change of use from the town houses of City magnates to industry. The Carron warehouse stood on part of the site of Baynard's Castle, built in the early fifteenth century and fragments of which survived for nearly 300 years. The other buildings seen here occupied the site of Scroop's Inn, the London house of the Yorkshire family of Scroop or Scrope from the late fourteenth century. In the background are the west towers and dome of St Paul's Cathedral, while between them is the spire of St Benet's Church.

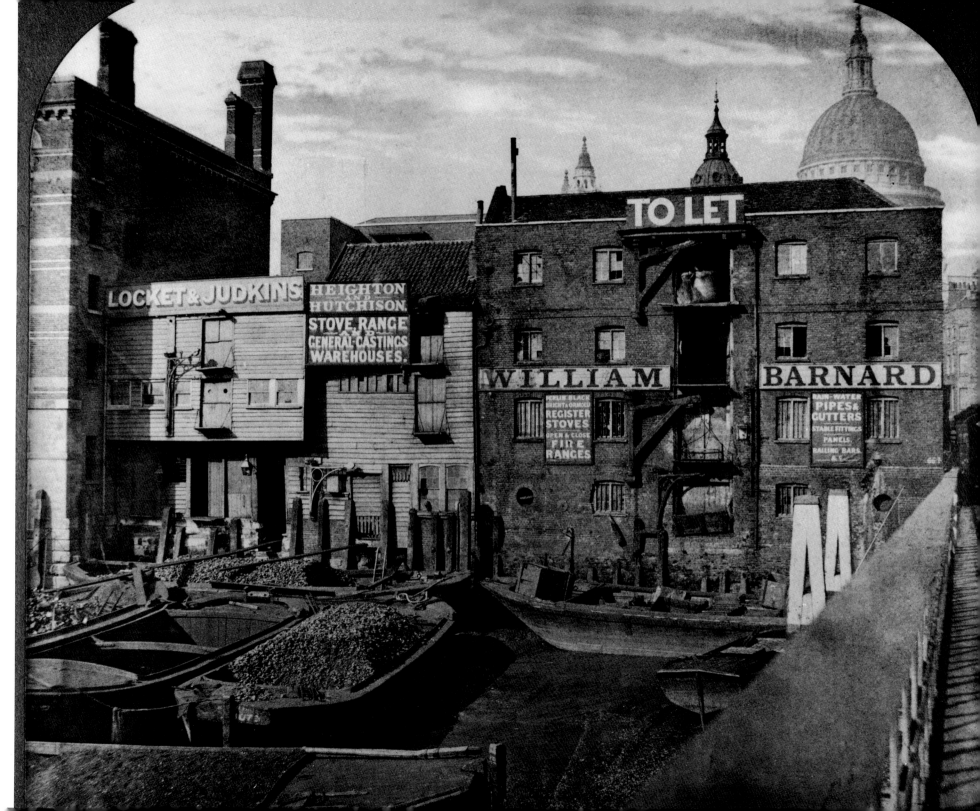

The small dock near the centre of this photograph marks one of the earliest areas of growth on the Thames waterfront. From Saxon times it was an important site and documents from 889 and 898–9 in the reign of King Alfred relate to tolls and mooring rights at what was then known as 'Aetheredes hyd' – the landing place of Aethelred, Alfred's son-in-law and ealdorman in London. Queenhithe declined in importance after the rebuilding of London Bridge, which restricted traffic from down river, but it remained a centre for unloading grain from upstream. The inlet was created by the reclamation of land on either side and was divided into three wharves – Abbey Wharf belonging to the Fishmongers' Company, Smith's Wharf, which belonged to the City Corporation from the seventeenth century, and Bull Wharf. Less than a decade before this photograph was taken, S. C. and A. M. Hall in 1859 commented on its ancient appearance then: 'It retains more of the characteristic features of the Thames bank during the last century than are to be seen in any other part of London. The old wooden wharves, the boats in the little dock, the high steps leading from the water, and the picturesque tree overshadowing them, seem to belong to the days of [Queen] Anne, when the traffic in boats on the river was considerable, and the rich citizen and his wife would "take water" here for Vauxhall or Ranelagh'. The feel of a working river lingered here until the later twentieth century, but in 1971 planning permission was given for the construction of an hotel, which at that time attracted a government grant. Despite opposition, the warehouses were demolished and a large block was built in 1972–5, which ironically never opened as an hotel, but was converted into flats.

QUEENHITHE

Francis Frith, c.1865. Wren Society Collection, BB90/4674

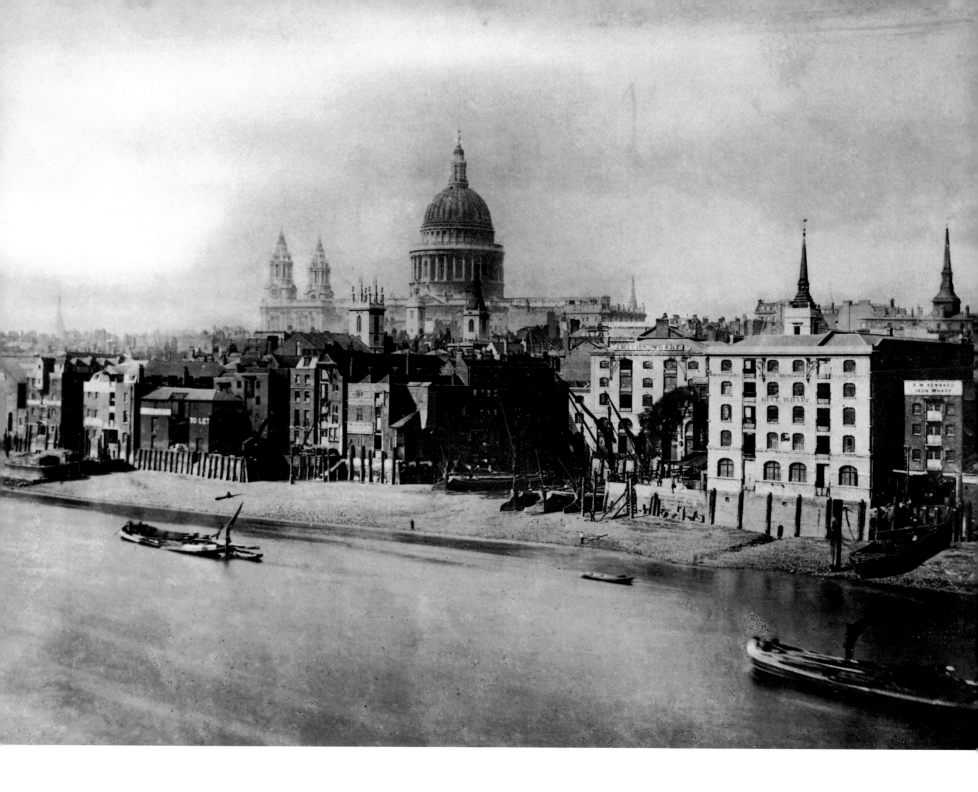

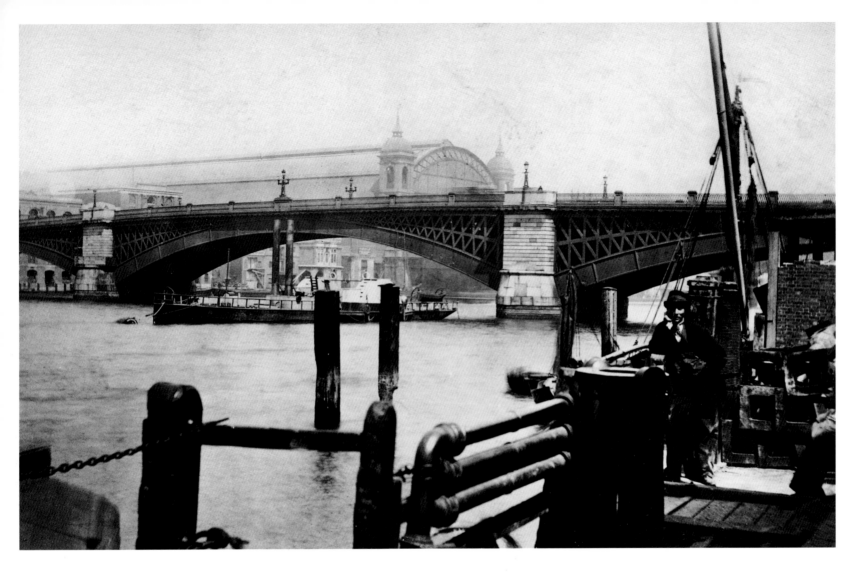

SOUTHWARK BRIDGE

Unknown photographer, 1870s. BB86/3427

In 1813 a company was formed to provide a bridge at Southwark upstream from London Bridge to help alleviate overcrowding as the city's population grew and traffic wishing to cross the river increased. It followed closely upon Vauxhall, originally known as Regent's Bridge, 1811–16, the first iron bridge over the Thames, and Waterloo, 1811–17. John Rennie, who had designed the new Waterloo Bridge in stone, was appointed as engineer. At Southwark he designed a cast-iron bridge in three spans to allow the widest possible waterway. When built in 1815–19, it was the largest cast-iron structure to date. To publicise another attraction, lighting on the bridge, it was declared open at midnight on 24 March 1819. Surviving just less than a century, demolition began in 1913 and the new Southwark Bridge opened in 1921. Moored in mid-stream in this photograph is a paddle tug. Despite its inferior economy and efficiency compared with screw-driven vessels, the paddle wheel retained its popularity for tugs. Steam tugs were established on the Clyde and Tyne before they appeared on the Thames, where they first arrived in 1833. The Crimean War, when shipping enjoyed the usual war boom, provided a spur to the development of the paddle tug.

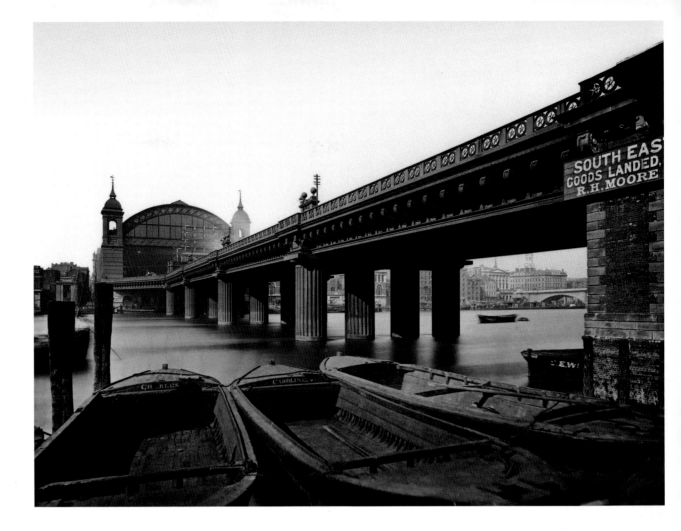

The first railway permitted to cross the Thames was the London, Brighton & South Coast Railway into Victoria in 1859. Although the City of London tried to resist, crossings at Blackfriars and Cannon Street soon followed. The Act of Parliament to allow a station in Cannon Street was passed in 1861. Sir John Hawkshaw, consulting engineer to the South Eastern Railway, designed the station, river bridge and approach viaducts. On the north bank, these covered Dowgate at the mouth of the Walbrook and originally the site of a pre-Conquest settlement founded by a group of foreign traders given royal privileges. In the mid twelfth century it was settled by merchants of the Hanseatic League, whose enclave known as the Steelyard was built on reclaimed land and where fragments of the medieval buildings were discovered during excavations in 1987. Work on the railway began in July 1863 and Cannon Street Station opened on 1 September 1866. The station was designed by Hawkshaw in collaboration with J. W. Barry and the towers on the river bank were completed with leaded domes and spires in deference to Wren's City churches. The river bridge standing on monumental cast-iron columns was officially named the Alexandra Bridge to commemorate the Danish princess who married Edward, Prince of Wales, in 1863. Its prominent overhead gantry signal box, seen here in front of the arch of the iron train shed, was constructed by John Saxby to his patented safety system. The bridge was widened in 1886–93 and strengthened in 1979–81. The station was badly damaged in the Second World War and completely rebuilt in the 1960s.

ALEXANDRA BRIDGE

York & Son, 1870s. DD97/141

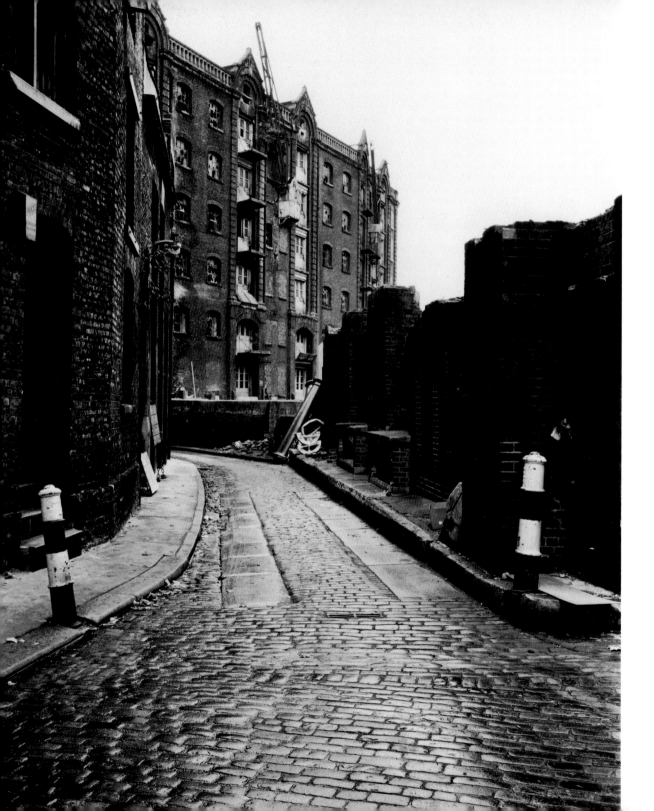

These two photographs by Paul Barkshire taken from almost the same spot in Cathedral Street, but seven years apart, provide a most telling example of the changes that took place on the waterfront in the 1980s. They show St Mary Overy's Wharf on the south bank between Southwark and London bridges. The earlier photograph portrays the elaborate polychrome-brick warehouse constructed in 1882-3 to the designs of George Alchin Dunnage. In September 1883, this was the first wharf to utilise the public hydraulic power supply system, set up by the Wharves and Warehouses Steam Power and Hydraulic Pressure Company – renamed more succinctly the London Hydraulic Power Company in 1884. Despite powerful opposition from the Greater London Council and others at a public inquiry in 1981 into the redevelopment of the site, the Secretary of State for the Environment over-ruled the inspector's findings and demolition was allowed in the following year. The run-down appearance of the area in 1980 is in marked contrast to the new development. However, it is interesting to note that the flats and offices are housed in buildings designed in a style reminiscent of early-nineteenth-century warehouse architecture. The architects of the new development were Michael Twigg Brown & Partners, 1985, and the engineers were the long-established firm of Mott, Hay & Anderson, with the builders Costain.

ST MARY OVERY'S WHARF, SOUTHWARK

Paul Barkshire, October 1980. 801 (left)

Paul Barkshire, April 1987. M12 (right)

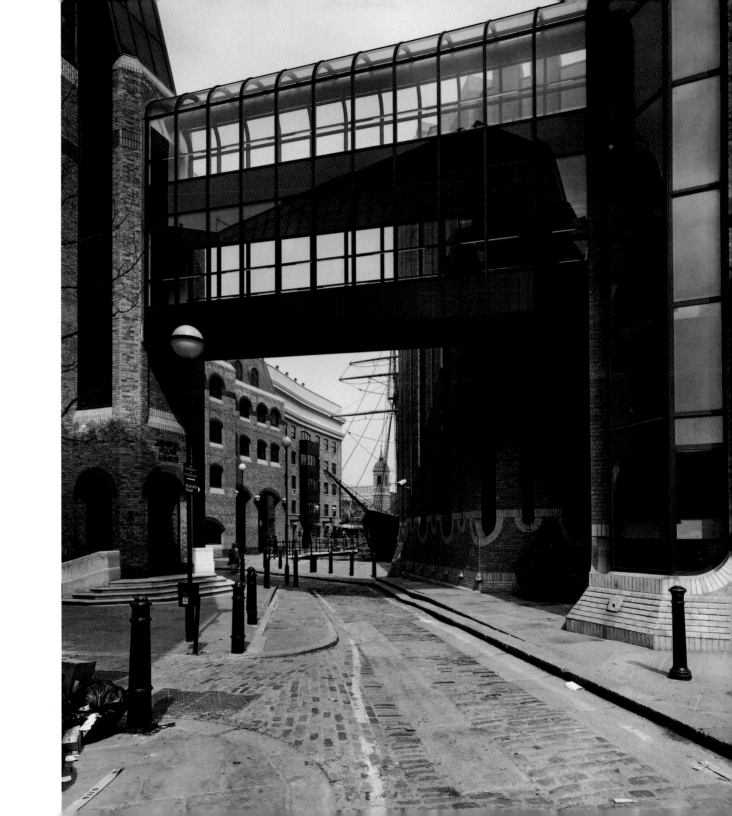

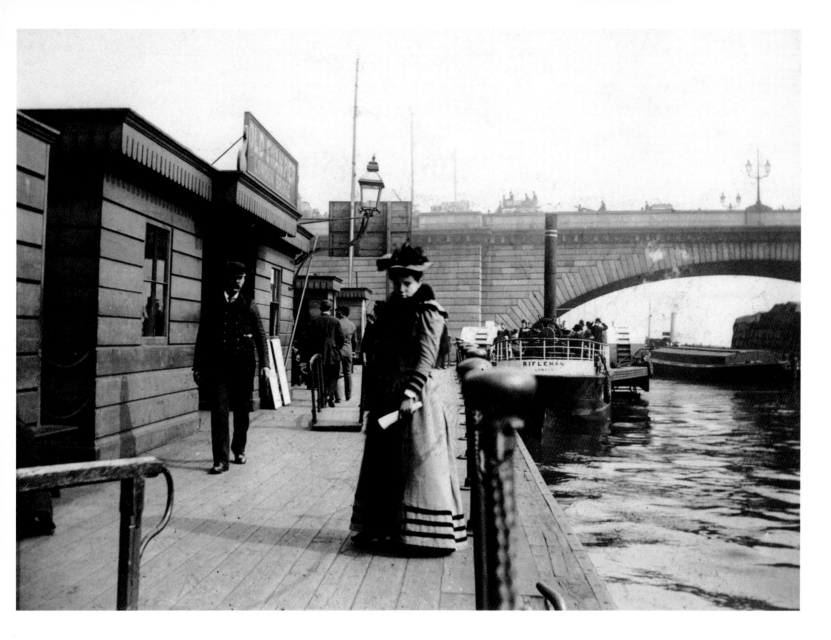

OLD SWAN PIER

M. Hodgson, c.1893. BB84/597

Swan Stairs just upstream from London Bridge was named after an ancient tavern in Thames Street. This was the favoured landing place for passengers who were unwilling to risk the perilous journey under old London Bridge, but who preferred to walk round the bridge and re-embark at Billingsgate. James Boswell recorded in 1763 that he and Samuel Johnson 'landed at the "Old Swan" and walked to Billingsgate where we took oars and moved smoothly along silver Thames'. Among the many journeys undertaken from Swan Pier was the so-called 'long ferry' to Gravesend. The paddle-steamers that plied this route used various enticements to encourage travellers including a small orchestra, providing playing cards and draught-boards. When John Rennie's London Bridge was built upstream from the old, the Swan Pier was also relocated

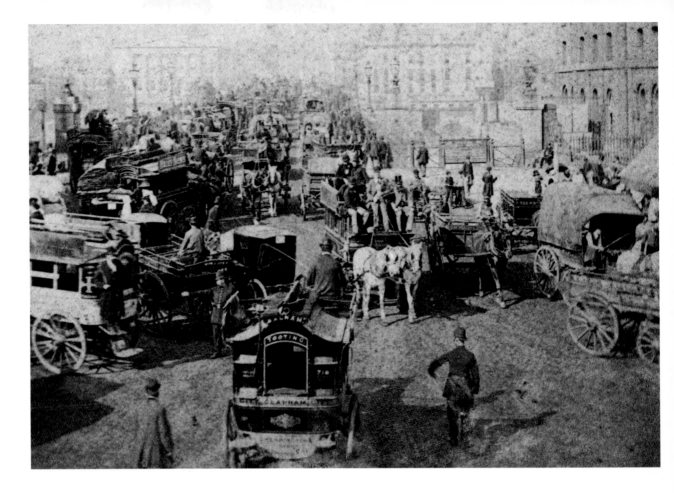

The first bridge across the Thames was constructed by the Romans and lay immediately downstream of the present structure. For 1700 years a bridge on this site was the only means of crossing apart from ferries. The famous medieval bridge, 1176–1209, remained until the 1820s, although shorn of its houses, gatehouse and chapel. It was comprised of 19 arches with the stone piers protected by starlings – palisades filled with rubble and supported by wooden piles driven into the river bed. More timbers were added over the centuries to prevent undermining of the piers and the narrow channels created an infamous bottleneck. Although it was just possible for boats to pass under on a flood tide, shooting the rapids between the piers at other times resulted in overturned boats and numerous drowned watermen. An eighteenth-century proverb observed that 'London Bridge was made for wise men to go over and fools to go under'. In 1758–62, the houses were at last cleared away and two central arches were replaced by a single span to allow more freedom for shipping. However, this was only a short-term solution and in March 1821 the engineer John Rennie advocated the building of a new bridge. He died in October of that year and a competition was held in 1823 to choose a design for the new work. More than 100 entries were received, but none was considered satisfactory, so Rennie's original plans were eventually executed by his son, also named John, who was knighted on its completion. The foundation stone was laid in 1825 and the bridge was declared open by King William IV and Queen Adelaide on 1 August 1831. Although by the time this photograph was taken, Southwark Bridge had been opened not far upstream, there was still enormous congestion on London Bridge. It was widened in 1902–4, but proved inadequate for modern traffic and was eventually replaced in 1967–73.

LONDON BRIDGE

Unknown photographer, 1850s. Howarth Loomes Collection, BB83/4742

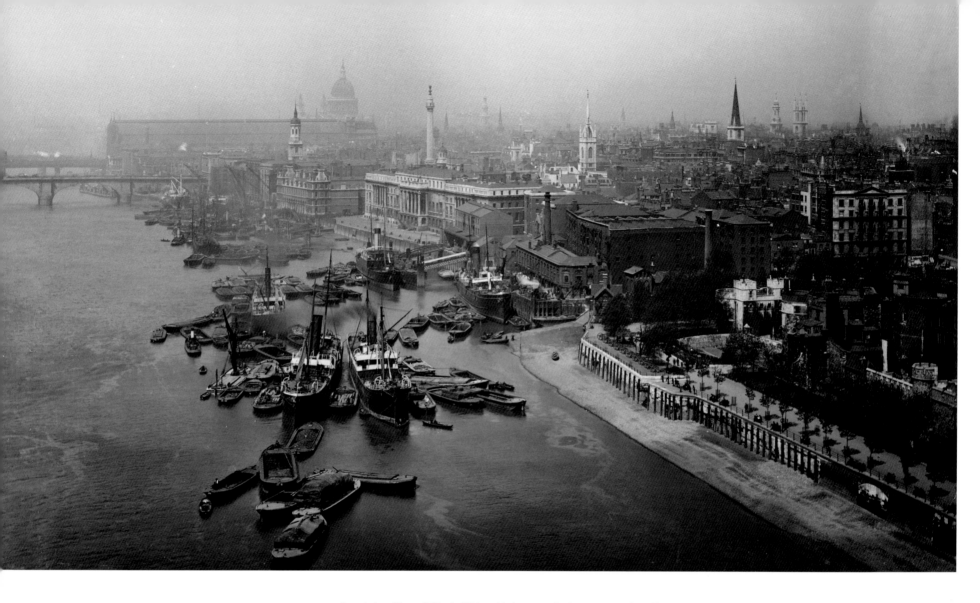

POOL OF LONDON

York & Son, 1930s. CC97/1095

Completion of Tower Bridge in 1894 provided a new and unique vantage point for photographers. This view of the Upper Pool of London by York & Son shows steam ships surrounded by a swarm of lighters and barges loading and unloading in front of the wharves on the north bank. In the immediate foreground (right) is Tower Beach and upstream the inlet is Tower Dock at the foot of Great Tower Hill in front of Wool Quay. Next, the Custom House shows prominently with Billingsgate Market beyond. These two important sites have at least a thousand-year history. To the left is Rennie's London Bridge.

The skyline is dominated by St Paul's Cathedral, seen looming over the massive shed of Cannon Street Station. Even at this time the only other structures rising above the City were the towers and spires of Wren's churches. Notable, too, above the Custom House, is the Monument to the Great Fire, built 1671–6, also designed by Sir Christopher Wren in collaboration with Robert Hooke. The tower of J. B. Bunning's much-lamented Coal Exchange, 1847–9, is to be seen low down to the right of the Monument just above the Custom House roof.

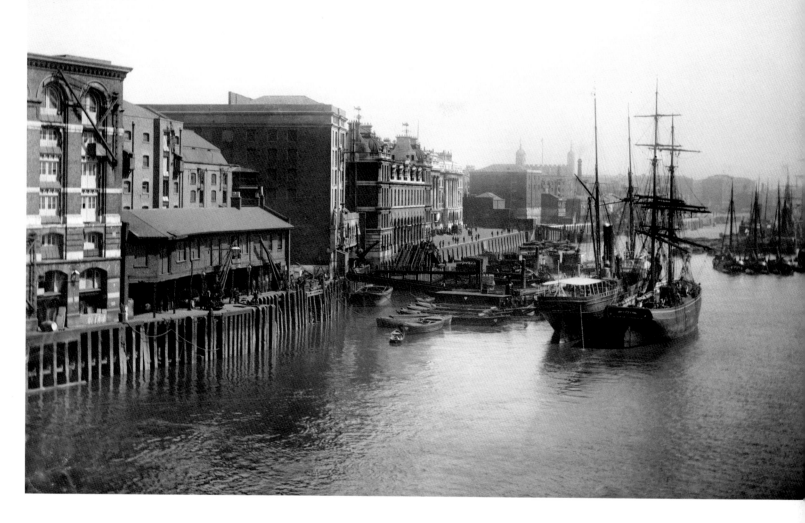

Billingsgate Market, shown here just left of centre in front of the Custom House, is a vivid example of continuity over centuries until the huge changes of recent decades. The first mention of a market here occurs before the year 1000 and the 'gate' in the name may refer to one of the two gates in the Roman river wall (the other being Dowgate). Encroachment on to the fore-shore had created a dock here by the thirteenth century and the associated market specialised in corn. By the time that the sixteenth-century building was destroyed in the Great Fire, the market had a monopoly in fish. The rebuilt market, designed by George Dance the Younger, 1799–1800, survived until the middle of the nineteenth century, when the dock was filled in and a new, enlarged fish market was constructed in 1848–52 to the designs of the architect to the City of London, J. B. Bunning. This building lasted less than a generation and was replaced in 1874–8 by Sir Horace Jones, Bunning's successor as City architect. The dolphin weather vanes on top of the corner towers announcing its fishy theme may clearly be seen. As early as 1908, there were proposals to move the market out of the City, but fish continued to arrive here by boat until the 1950s. Eventually it closed in 1982 when a new fish market was opened near Canary Wharf in Docklands. Jones's market building was converted for use as offices to the designs of the Richard Rogers Partnership.

BILLINGSGATE MARKET

H. W. Taunt, c.1890. CC72/1834

CUSTOM HOUSE

H. W. Taunt, c.1890. CC72/1025

The principal functions of the Customs Service of levying duty on imported goods and preventing smuggling have been carried out on or near this site since at least the fourteenth century, perhaps even as far back as 1275, when Edward I established duty on wool. Dues were collected from a wharf just to the east of the present building at a site known as Wool Quay and later as Custom House Quay. Such was the importance of the Custom House that after the great fire of London in 1666 it was one of the first buildings to be replaced, to a design by Sir Christopher Wren. The present Custom House was designed by David Laing, Surveyor to the Customs, and built in 1812–7.

Put up in haste after another fire, the central block collapsed and had to be re-built by Sir Robert Smirke in 1825–8. Custom House Quay was reconstructed by the engineer John Rennie at the same time as Laing's new building. The east wing of the Custom House was gutted by bombing in 1940 and rebuilt in 1962–3. The building was completely refurbished in 1992. Immediately adjacent upstream is Billingsgate Market. In the foreground of this photo-graph is a barge spectacularly loaded with hay. Known as 'Stackies', their cargo was piled high up into the rigging and they travelled with reefed sails. These were a common sight on the Thames when London ran on horse power.

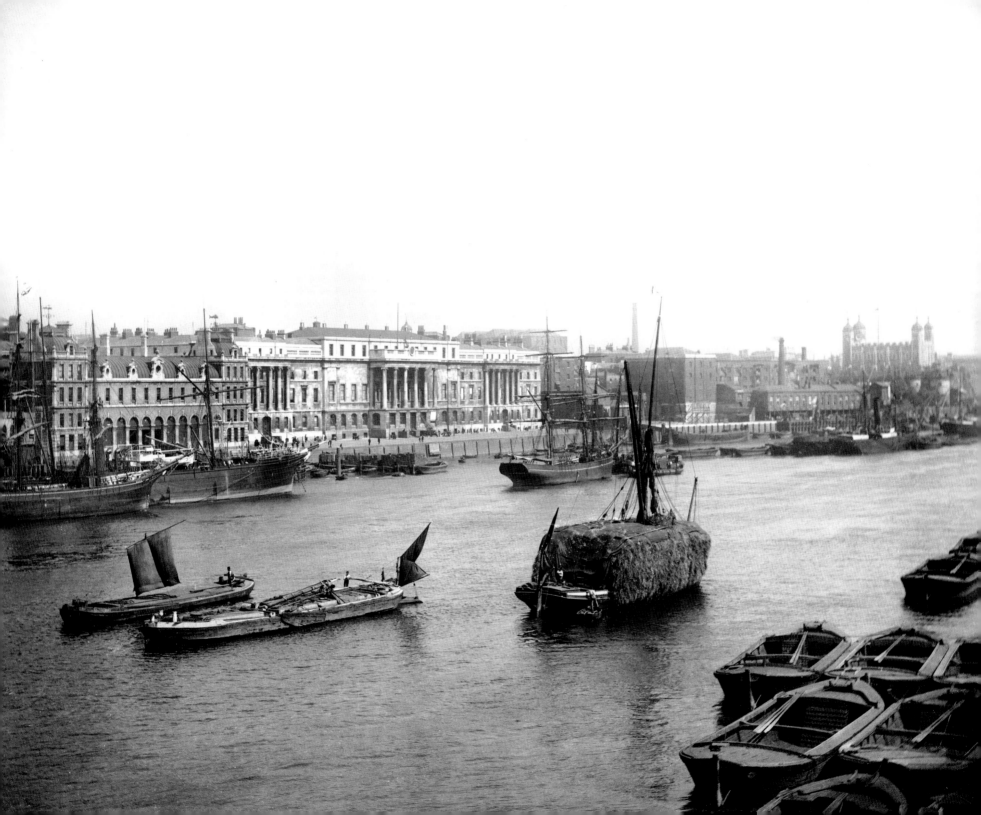

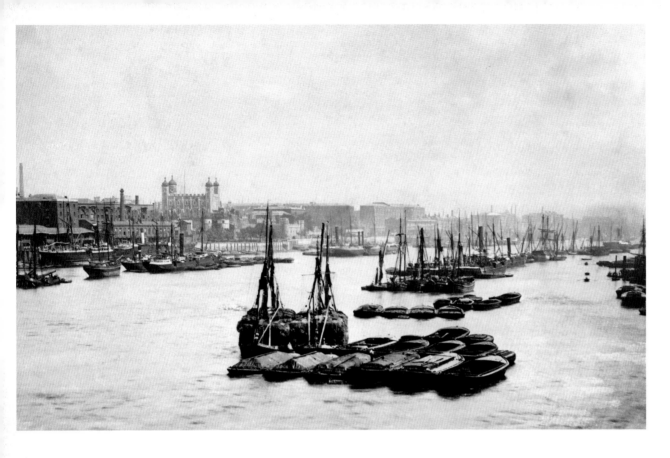

POOL OF LONDON

H. W. Taunt, 1870s. BB99/15628 (above)
York & Son, 1894. CC97/578 (right)

These two views show the Pool of London before and after the building of Tower Bridge. In the former the Tower of London is seen standing high above the river, while in the latter the bridge has become the dominant landmark. This was the first bridge downstream from London Bridge and for almost a century was the last before the sea. Although many proposals had been put forward for a river crossing in the busy port area, the erection of a bridge here presented numerous problems. The first solution was to excavate a tunnel – the second under the Thames. P. W. Barlow designed a small subway to help alleviate overcrowding on London Bridge, the nearest crossing. It was constructed in 18 months and opened on 2 August 1870. Originally there was a cable-hauled carriage on narrow-gauge track, but this proved unreliable and the tunnel was converted for pedestrians. It closed in 1896 after Tower Bridge opened and is used now for cables and pipes. Eventually in 1885, the City Corporation obtained an Act of Parliament to permit the construction of a bridge, but the Thames Conservators insisted on stringent

conditions. The most important was that a clear passage for ships should be provided, 200 feet (61 metres wide) and with 135 feet (41 metres) headway. As built, the leeway was slightly greater. Also Parliament stipulated that the new bridge should harmonise with the Tower of London – hence its Gothic skin. Another condition, that the bridge should be armed with cannon, was later dropped. The designs were prepared by the city architect, Sir Horace Jones, advised by Sir John Wolfe Barry, the engineer, and with E. W. Crutwell as resident engineer. Jones proposed a bascule bridge to allow tall ships to enter the Pool of London. Work began in June 1886, but had not progressed far when the architect died early in the following year. After numerous delays, the bridge was declared open on 30 June 1894 by the Prince of Wales (later Edward VII) amid the usual celebrations. The bascules were raised by hydraulic power and the engines by Armstrong Mitchell & Co. remained in service until 1976, when the operation was electrified. The original machinery has been retained and is now a tourist attraction.

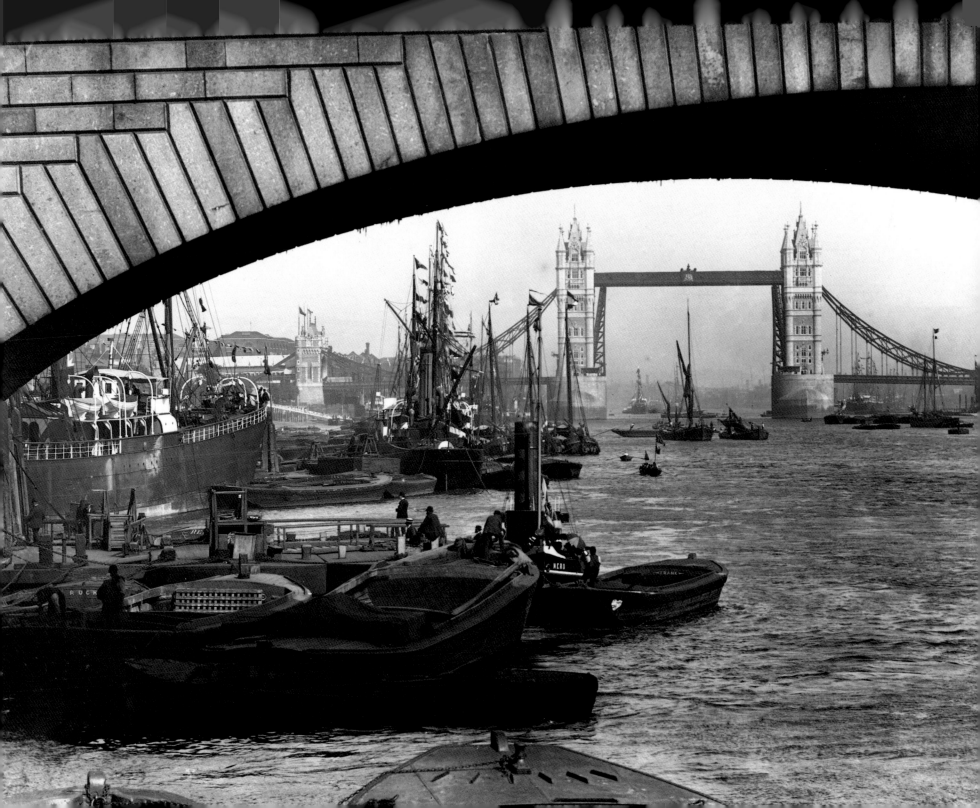

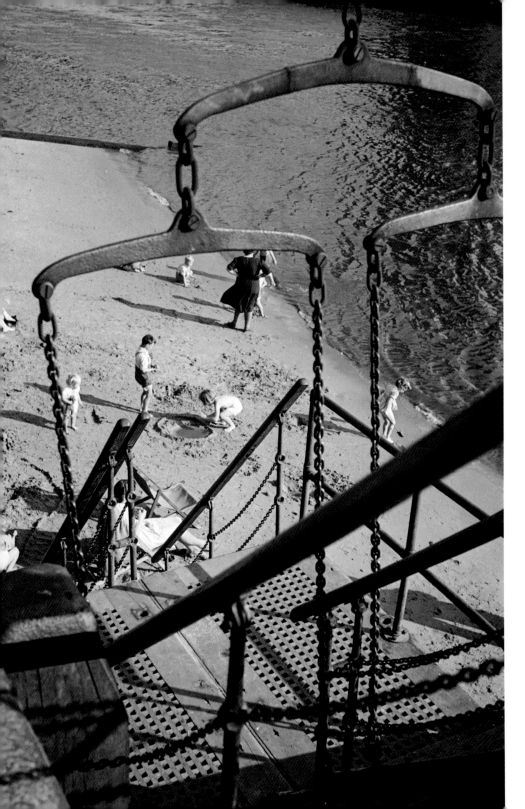

The tidal playground for children laid out in front of Tower Wharf was the inspiration of the Reverend Philip Thomas Byard Clayton (1885–1972), universally known as 'Tubby', rector of All Hallows by the Tower. Clayton had been an army chaplain in the First World War and in 1915 founded Toc H, the Christian movement dedicated to service in the community. The beach for poor local children was created with barge loads of sand dumped on the muddy foreshore of the Pool of London. It opened in 1934 and for a time was a substitute seaside for half a million visitors. However, it declined in popularity as holidays, even abroad, became cheaper and fewer people lived in the vicinity. This was associated with the closure of the docks and an increase in pollution. The steps down to the beach had been the accommodation ladders removed from the former P & O liner *Rawalpindi* when she was conscripted and they commemorated her lone gallant action in the north Atlantic. The *Rawalpindi* was built for P & O in 1925 and was one of four sister ships requisitioned by the Admiralty for conversion to armed merchant cruisers at the outbreak of the Second World War. She was on patrol off Iceland, when on the afternoon of 23 November 1939 she sighted and engaged the German battle-cruisers *Scharnhorst* and *Gneisenau*. The *Scharnhorst* alone had enormous superiority and shelled the *Rawalpindi* to destruction. Her captain, E. C. Kennedy, went down with his ship and only 37 of her crew of 303 survived.

TOWER BEACH

S. W. Rawlings, 1950s. A420 and A492

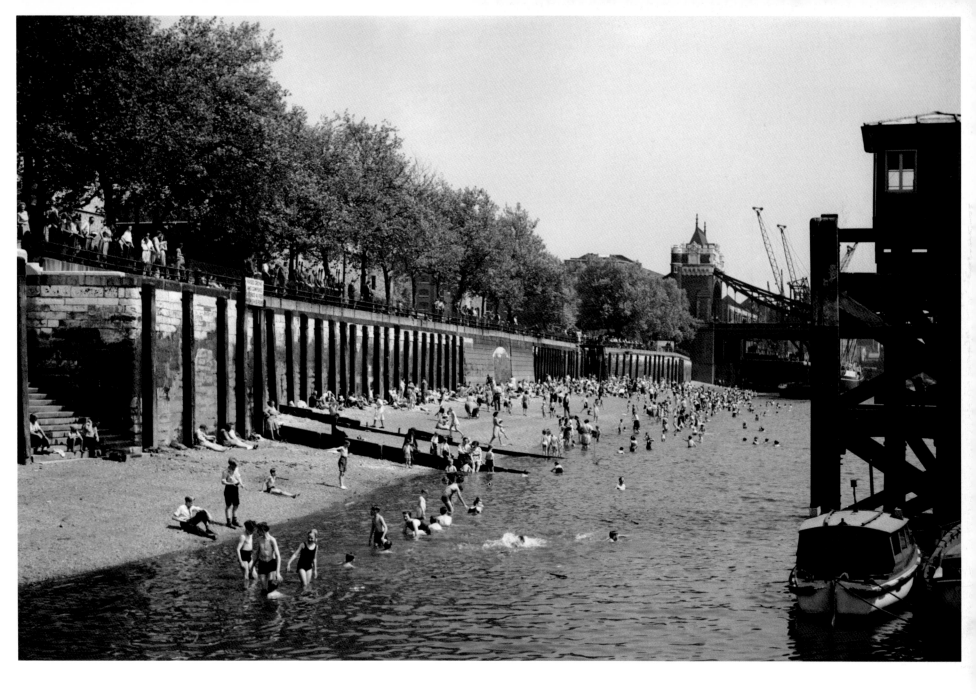

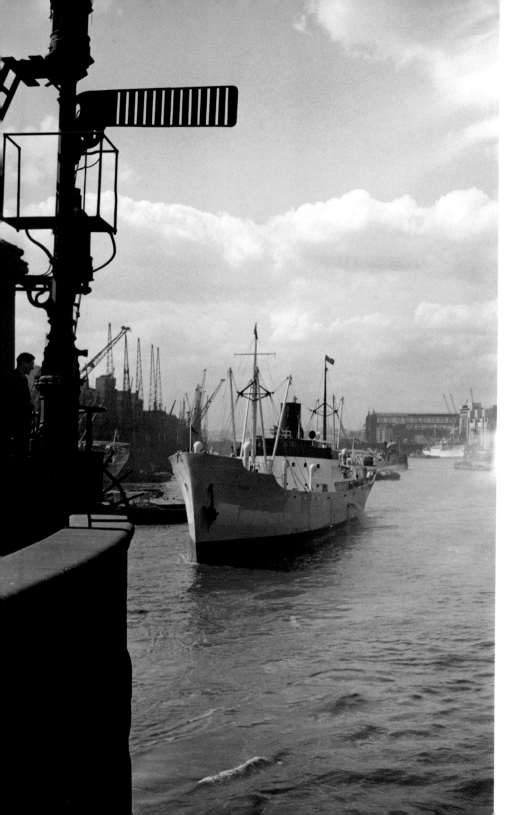

The bottleneck caused by the construction of Tower Bridge necessitated the introduction of strict traffic-control measures. Shipping into and out of the Pool of London was regulated from small cabins mounted on each pier of the bridge. During the day, signals were given by red-painted semaphore arms and at night two coloured lights were displayed – red for stop and green for go. The semaphore arm illustrated here is showing closed, when dipped at 45 degrees it indicated that passage was permitted. During foggy weather, a gong was sounded in addition to the other signals. A black ball suspended from the centre of each of the high-level footbridges during the day, or a red light at night, indicated that the bridge could not be opened. For ships approaching Tower Bridge from downstream, the relevant signal was also displayed at Cherry Garden Pier on the south bank. At this point vessels bound for the Pool had to hoist their own signals and sound their steam whistles to alert the Bridgemaster. Ships had to display a black ball, at least 2 feet (0.6 metres) in diameter, by day and two red lights at night, mounted high up to be visible. In fog, repeated blasts on the ships' whistles were required. Before the First World War, nearly 100 people were employed to operate and maintain Tower Bridge. They were under the command of the Bridgemaster and a superintendent engineer and included engineers and stokers working shifts as well as signalmen providing 24-hour cover. In addition there were teams of horses, stabled under the carriageway, available for problems on the bridge, and a paddle tug on standby for emergencies on the river.

TOWER BRIDGE

S. W. Rawlings, 1950s. A334

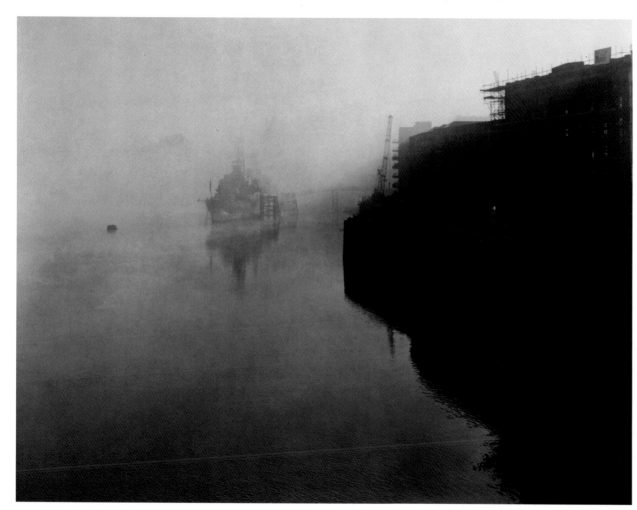

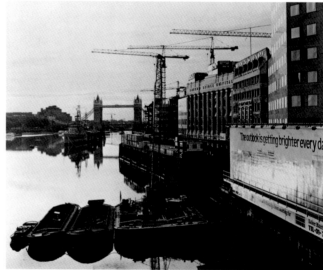

The Pool of London in the last quarter of the twentieth century was no longer the hive of activity it had been in previous decades. In Paul Barkshire's 1983 photograph, HMS *Belfast* is seen emerging from the mist, while the ghostly cranes to the right are engaged in construction, not unloading from ships or lighters on the river. The infamous London fogs were also a thing of the past. Even more cranes employed in building work on the south bank are apparent in the 1985 view. The complete redevelopment of this area, to become known as London Bridge City, began in 1982. Among the earlier buildings incorporated in this grandiose scheme was St Olave's House by H. S. Goodhart-Rendel, built in 1929–31 for the Hay's Wharf Company. Its stylish river front is seen displaying the company name. The pride the owners took in their new building – 'a milestone in the introduction of the Continental modern style into England' – was apparent from the series of gilded faience relief panels designed by Frank Dobson, which adorn this façade. There are three large reliefs symbolising Capital, Labour and Commerce. Thirty-six smaller panels, each with bales, crates, barrels, drums and boxes, linked together by a double chain motif of actual chains and of bricks symbolise 'The Chain of Distribution'. Next downstream is London Bridge Hospital. This private hospital was converted in 1985 by Llewelyn-Davies Weeks from former warehouses. It had been Chamberlain's Wharf, built immediately after the Tooley Street fire in 1861 and part of the Hay's Wharf Group, which provided cold stores for food stuffs.

POOL OF LONDON

Paul Barkshire, October 1983. 2595 (left)

Paul Barkshire, August 1985. 3427 (right)

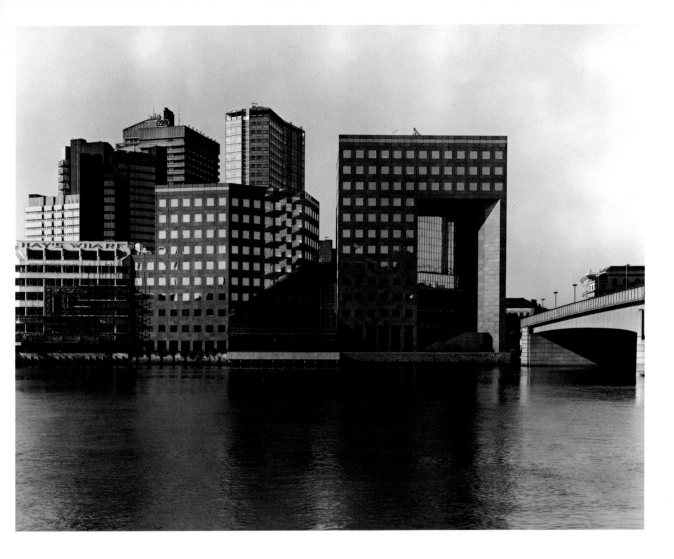

LONDON BRIDGE CITY

Paul Barkshire, May 1989. M35

This view from across the river shows part of the complete redevelopment of the waterfront from London Bridge (right) to Tower Bridge, dubbed London Bridge City. The huge block with the cut-away side towards the bridge is No. 1 London Bridge, designed in Postmodern style by the John S. Bonnington Partnership and completed in 1986. It was described perceptively by the *Buildings of England* (1998) as 'a typical boom building of minimum-cost, high-quality offices, related to the river but not to the historic approach to London Bridge'. The building stands on the site of Fennings Wharf, which incorporated a timber-built warehouse of 1836 by George Allen. The Hay's Wharf Company, which owned almost all of the wharves along this stretch of the river, ceased operations in 1969 and sought to redevelop the area. Their successors employed the architects Michael Twigg Brown & Partners to produce a masterplan in 1982. Lengthy planning enquiries ensued and there were many objectors who wished to see more of the traditional Thames waterfront retained. Among the most impressive features included in the new development was the Hay's Galleria, which has provided access to the riverside with splendid views of the City and the Tower of London. The second phase of the redevelopment up to Tower Bridge has recently taken place, with the highly distinctive building designed for the new London assembly by Sir Norman Foster, raised to the peerage in 1998 as Lord Foster of Thames Bank.

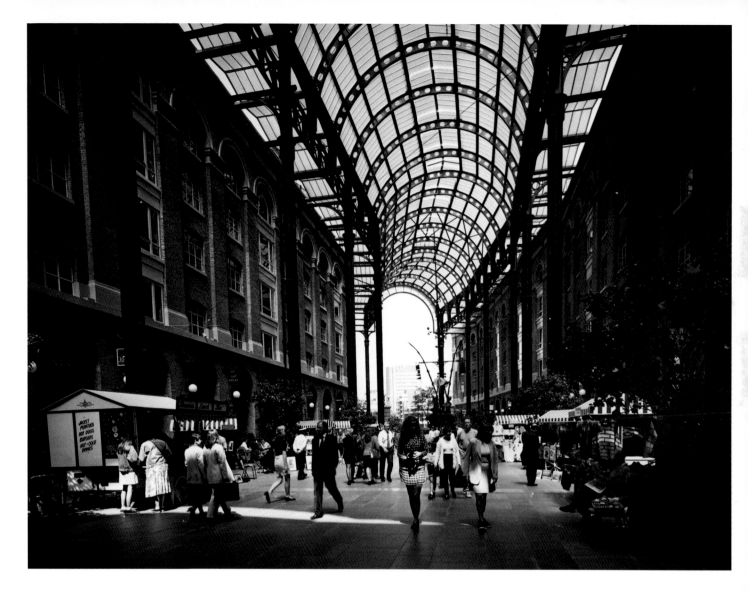

The change in the 1980s to residential and consumer developments on the Thames waterfront is exemplified at Hay's Galleria – even the name is suggestive. The imposing six-storey warehouses with vaults and lofts were designed by William Snooke and Henry Stock, and built in 1851–7 by William Cubitt for the Hay's Dock Company. Its trade was predominantly in foodstuffs and as early as 1867 the first New Zealand refrigerated butter and cheese arrived here, followed by frozen lamb in 1882. The west range of warehousing had to be rebuilt after the great Tooley Street fire of 1861 and the river ends were again rebuilt after bomb damage in the Second World War. Formerly, both ranges gave directly on to Hay's Dock, which could be closed with gates. This has been drained and now serves as an underground car park, while the street formed above it is an elegant shopping arcade. Above the shops in the converted warehouses are offices and flats. The curved street, which opens out on to the river, has been glazed over in nineteenth-century style to the designs of Michael Twigg Brown & Partners, 1982–6.

HAY'S GALLERIA

Derek Kendall, RCHME, May 1997. AA97/1106

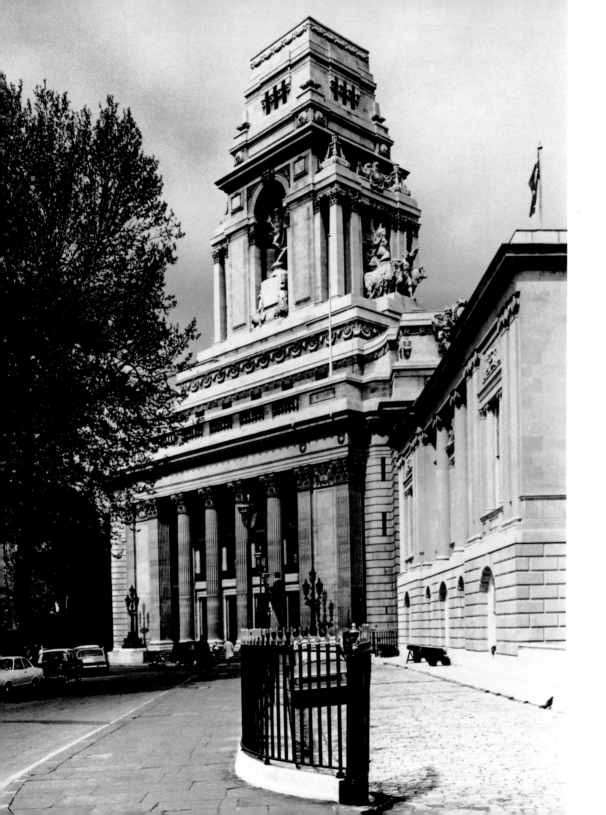

The Port of London Authority, successor to the Thames Conservancy, took charge of the tidal reaches of the Thames and the capital's docks on the last day of March, 1909. Somewhat romantically, the PLA's twenty-fifth anniversary publication maintained that 'As Aphrodite was born of the foam, the Authority was born of the agitated waters of the Thames'. Designed in Beaux-Arts style by Sir Edwin Cooper and built 1913–22, the Authority's impressive new headquarters were situated on Tower Hill looking down on the Pool of London. The building was opened officially on 27 October 1922 by the Prime Minister, David Lloyd George, appropriately, as it was he who when President of the Board of Trade had introduced the legislation to create the PLA. The sculpture decorating the exterior reinforced the message of the Authority's confidence and importance with allegorical figures of Produce, Exportation, Commerce and Navigation, surmounted by Father Thames. In a telling sign of the times, the Authority moved to Tilbury in 1970 and the building was sold for conversion to offices.

PORT OF LONDON AUTHORITY, TRINITY SQUARE

Nicholas Cooper, 1969. BB97/7

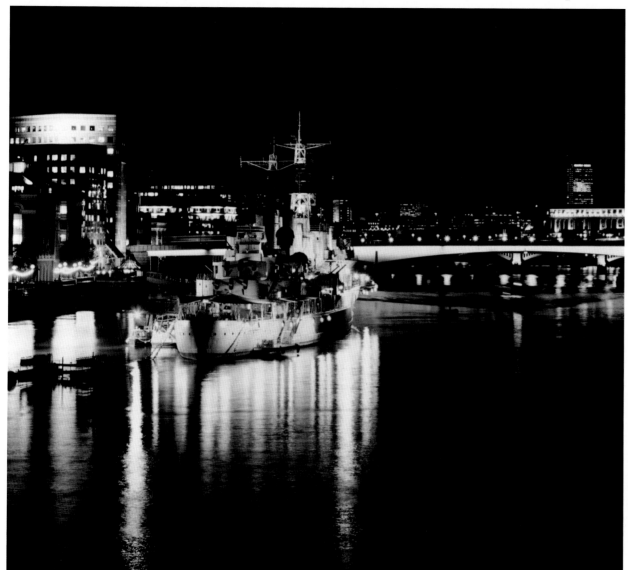

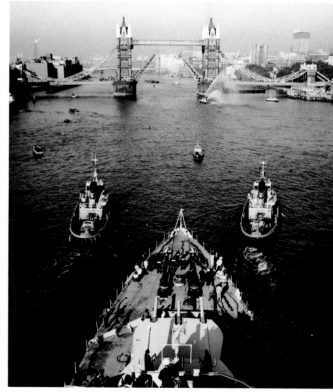

The cruiser HMS *Belfast* was built at Harland and Wolff's shipyard in Belfast. She was launched on St Patrick's Day, 17 March 1938, and fought in some notable actions of the Second World War, including the Battle of the North Cape, 26 December 1943, and she fired the first salvoes of the D-Day landings. Later she played a prominent part in the Korean War. After modernisation, *Belfast* continued to serve in the Far East and was not decommissioned until 24 August 1963. She remained in service at Devonport until the end of 1965, when she was retired to Portsmouth. When it was decided to retain her as a museum and a powerful reminder of Britain's naval heritage, HMS *Belfast* became the first Royal Navy ship to be preserved for the nation since Nelson's flagship HMS *Victory*. The photograph taken from the bridge of the *Belfast* shows her about to pass under Tower Bridge on 14 October 1971 for her permanent berth in the Pool of London. She was opened to the public exactly one week later on Trafalgar Day.

HMS BELFAST, UPPER POOL

Eric de Maré, 14 October 1971. AA98/5144 (right)

Derek Kendall, RCHME, 1995. (left)

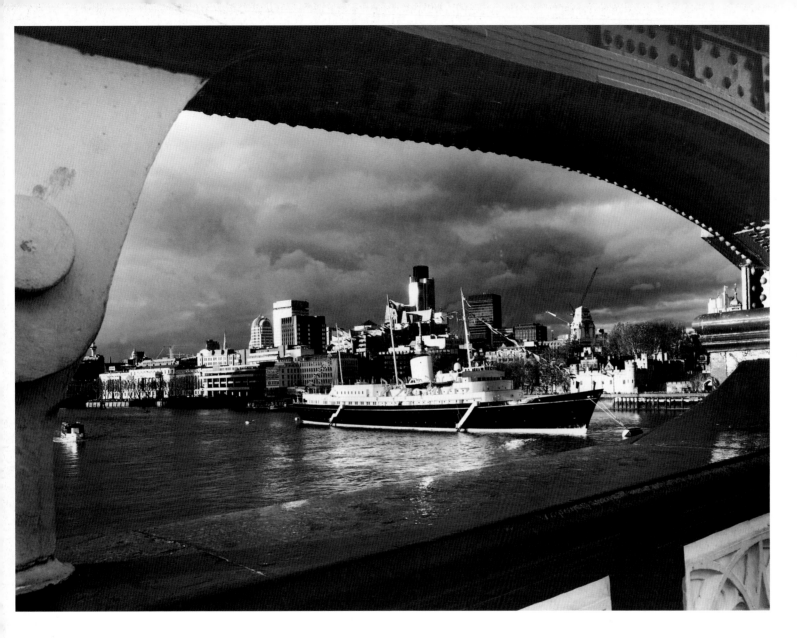

HMY BRITANNIA, UPPER POOL

Sid Barker, RCHME, November 1997. BB97/7563 (above)

Sid Barker, RCHME, 21 November 1997. AA97/6631 (right)

The royal yacht *Britannia* is seen here moored off Tower Pier on her farewell voyage around Britain in 1997. Built at John Brown's Shipyard on the Clyde, she was launched by Her Majesty The Queen on 16 April 1953. *Britannia* belonged to a long line of royal yachts – the second of that name – stretching back to the reign of Charles II. During her career, she sailed more than one million miles on nearly one thousand official visits throughout the world, and for a number of years she had been the oldest Royal Naval vessel in commission after HMS *Victory*. The second photograph shows the royal yacht leaving under Tower Bridge for the last time. *Britannia* was paid off at Portsmouth in a poignant ceremony in the presence of The Queen and other members of the royal family on 11 December 1997. The following year, the royal yacht was towed to Leith outside Edinburgh and opened to the public in 1999.

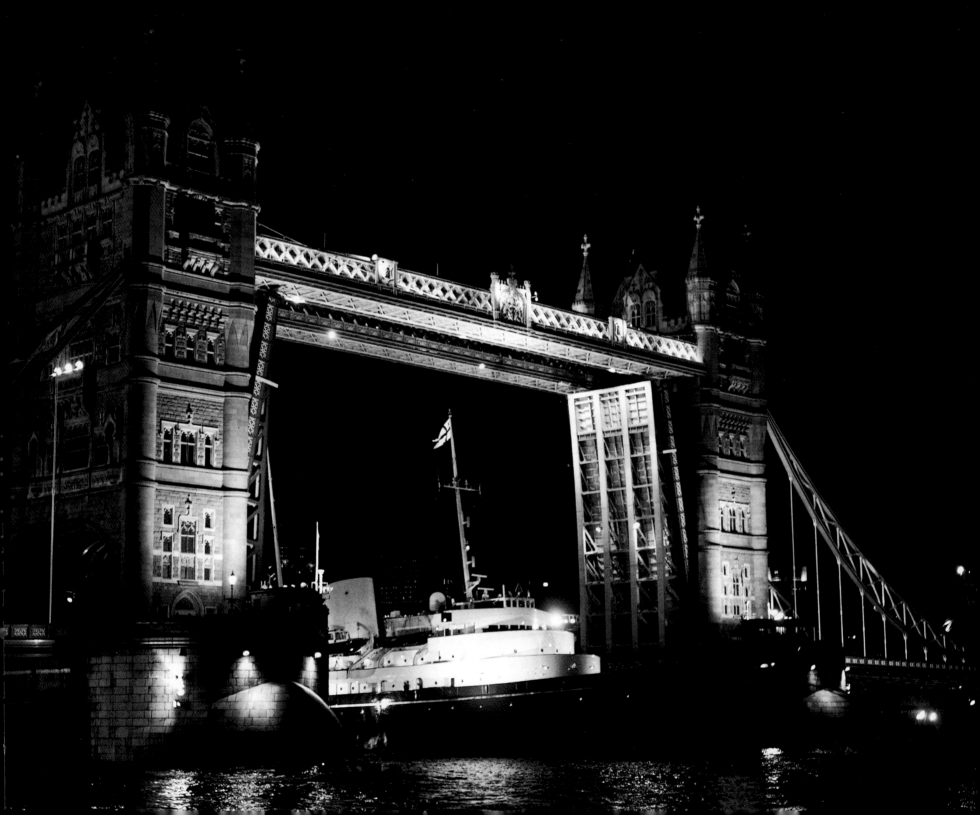

SHAD THAMES

Unknown photographer, c.1910. Butler's Wharf Collection, BB87/9668

The archetypal Victorian warehouse scene used for innumerable film locations recreating the London of Dickens or Sherlock Holmes, Shad Thames runs along the south bank of the river immediately east of Tower Bridge and continues along the west side of St Saviour's Dock, the tidal inlet formed from the mouth of the River Neckinger. Since at least the late seventeenth century, both sides of the street have been developed for commercial and industrial uses associated with the many wharves just downstream from the Pool of London. This group of warehouses on either side of Shad Thames was the largest wharf on the river when completed in 1871–4. The architects were James Tolley and Daniel Dale and the builders were John Aird & Son. From the late eighteenth century, a Mr Butler was associated with the firm, which became a public company in 1872 and was registered as Butler's Wharf Ltd in 1892. The high-level walkways were constructed to allow the movement of goods from the riverside for storage, sorting, packing and despatch in the capacious warehouses, which extended on the other side of Shad Thames. The inland blocks were progressively enlarged in the 1880s and 1890s. The wharf closed in 1972 and from 1983 the warehouses were converted into flats by Conran Roche.

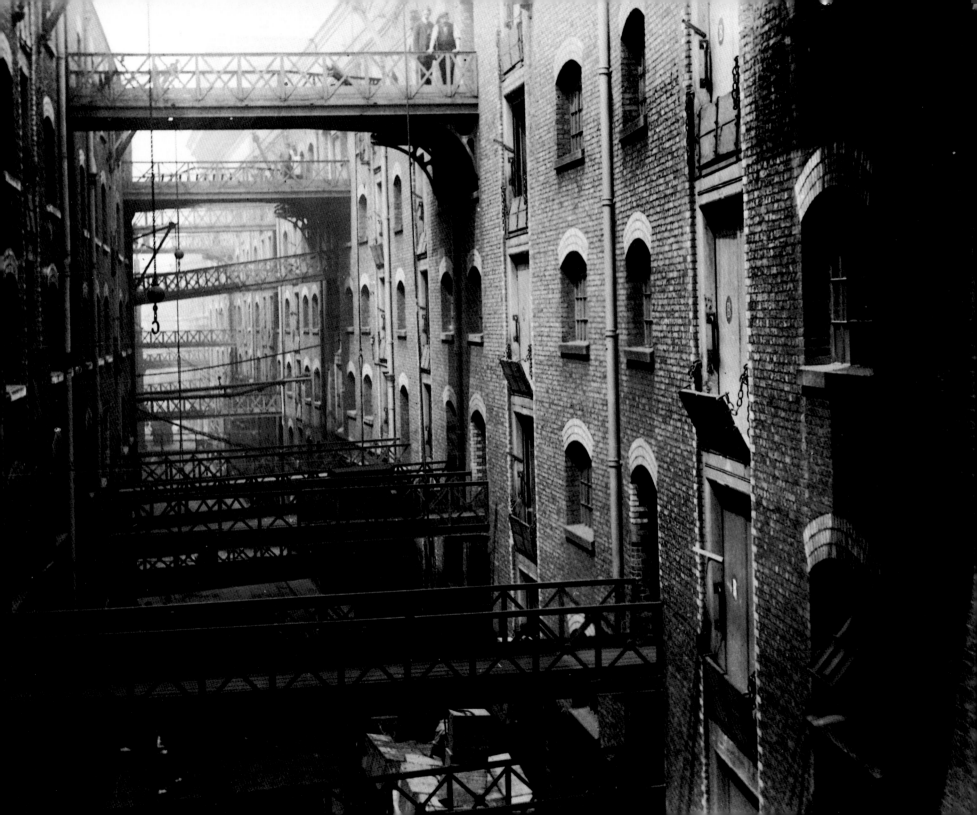

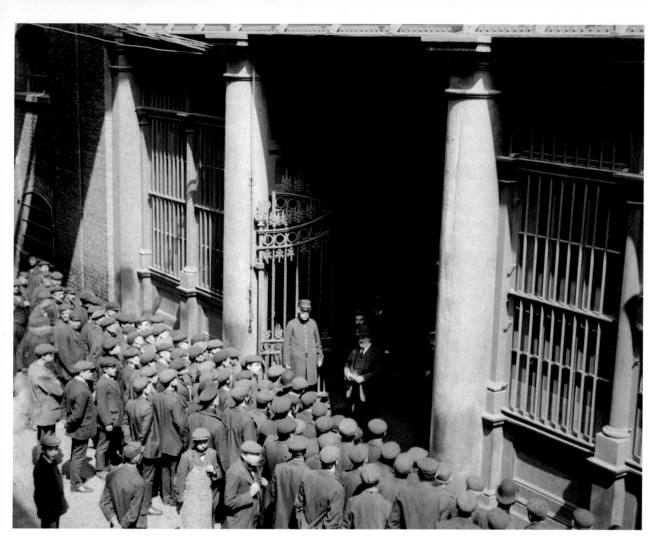

BUTLER'S WHARF

Unknown photographer, c.1910. Butler's Wharf Collection,
BB87/9665, BB87/9714, BB87/9709, BB87/9690 and BB87/9680
(clockwise from above)

Some time before 1910 the directors of Butler's Wharf Ltd commissioned a series of photographs recording in detail the various aspects of the work of the company. The whole process of handling a particular commodity was chronicled from unloading at the quay to despatch by van or tricycle. The breadth of their scope is interesting as it includes, among others, tea, tapioca, pepper, potatoes, tin and rubber. Apart from these, the photographer also documented the offices, kitchen and machine shops, and posed the cricket team and the company volunteers 'defending the flag'. A small selection of these photographs is illustrated here to give a flavour of the series, which numbers more than one hundred. In the first of the photographs, men are seen queuing to be taken on for a day's work. This system of casual employment became increasingly contentious, yet survived until 1967. The large numbers required when trade was brisk may be appreciated in the photograph of labourers lining up with their sack trucks ready for the barrels of Jersey potatoes being swung on to the quay. Apart from the cranes unloading from the freighters or lighters moored alongside, almost all the work was done by hand. The small group posed with a sack is unloading tapioca, while inside another group is picking up and weighing tea. The young boys under the watchful eye of the moustachioed foreman are labelling tins of tea to be sent out as samples.

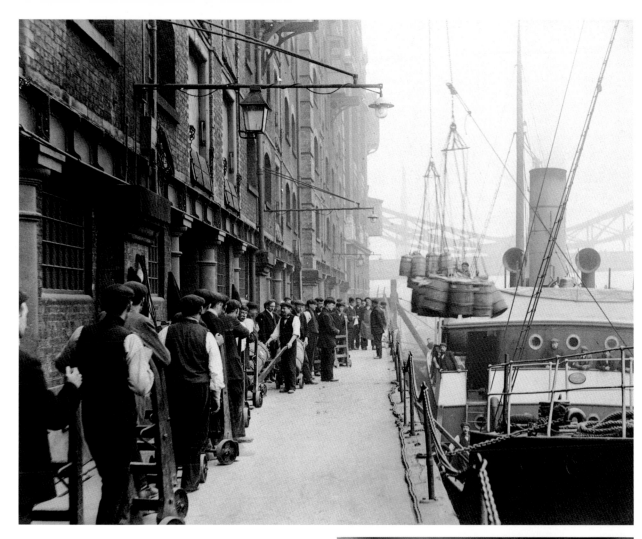
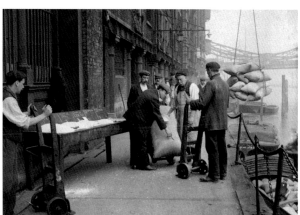
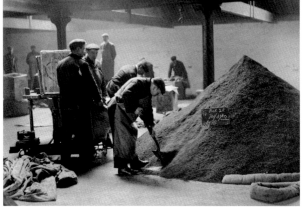
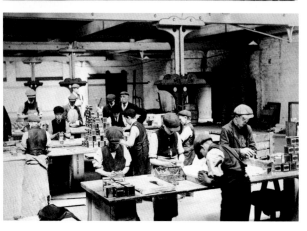

An Act of Parliament was passed in May 1800 to permit the construction of the London Dock at Wapping and clearance of the streets and houses on the site began soon afterwards. The London Dock Company incurred heavy expenses in buying up the various properties and the foundation stone for the new work was not laid until 26 June 1802. This was to be the second enclosed dock in London, coming only a year after the West India Dock. Daniel Asher Alexander, surveyor, and John Rennie, engineer, drew up the plans, and the new 20-acre (8-hectare) dock opened on 30 January 1805. Over the next 50 years the docks were extended westwards and were to comprise six basins and three entrance locks. Across the main entrance lock Rennie built the first cast-iron swing bridge in the world, 1803–4. The North Stack warehouses, designed by Alexander, 1805, were an imposing group (left). In the foreground of this photograph is the Wine Gauging Ground. An important feature of these docks was the range of vaults for wine and spirits, which covered 22 acres (9 hectares) beneath quay level. The transit sheds (centre), less secure than the warehouses, were designed to shelter goods in transit on the quays. They were perceived as a fire risk and from 1810 were built with iron roof-trusses. Another innovation was corrugated-iron roofing, developed at the London Docks in 1829 by Henry Palmer. Despite consider-

able investment by the PLA after the Second World War, the constricted site contributed to the early decline of these docks and they were closed in 1969. There was an outcry when the basins were filled in and subsequently some of the dock walls have been excavated and made a feature of the housing development that now covers the site. Alexander's magnificent warehouses and vaults were abandoned after the closure, suffered badly from vandalism and were demolished in 1979. A vivid description of the London Dock in its heyday was given by Henry Mayhew in 1851: 'the sight of the forest of masts in the distance, and the tall chimneys vomiting clouds of black smoke, and the many coloured flags flying in the air, has a most peculiar effect … Along the quay you see, now men with their faces blue with indigo, and now gaugers, with their long brass-tipped rule dripping with spirit from the cask they have been probing … As you pass along this quay the air is pungent with tobacco; on that it overpowers you with the fumes of rum; then you are nearly sickened with the stench of hides, and huge bins of horns; and shortly afterwards the atmosphere is fragrant with coffee and spice. Nearly every-where you meet stacks of cork, or else yellow bins of sulphur, or lead-coloured copper-ore … then the jumble of sounds as you pass along the dock blends in anything but sweet concord'.

LONDON DOCKS

York & Son, 1860s. DD97/583

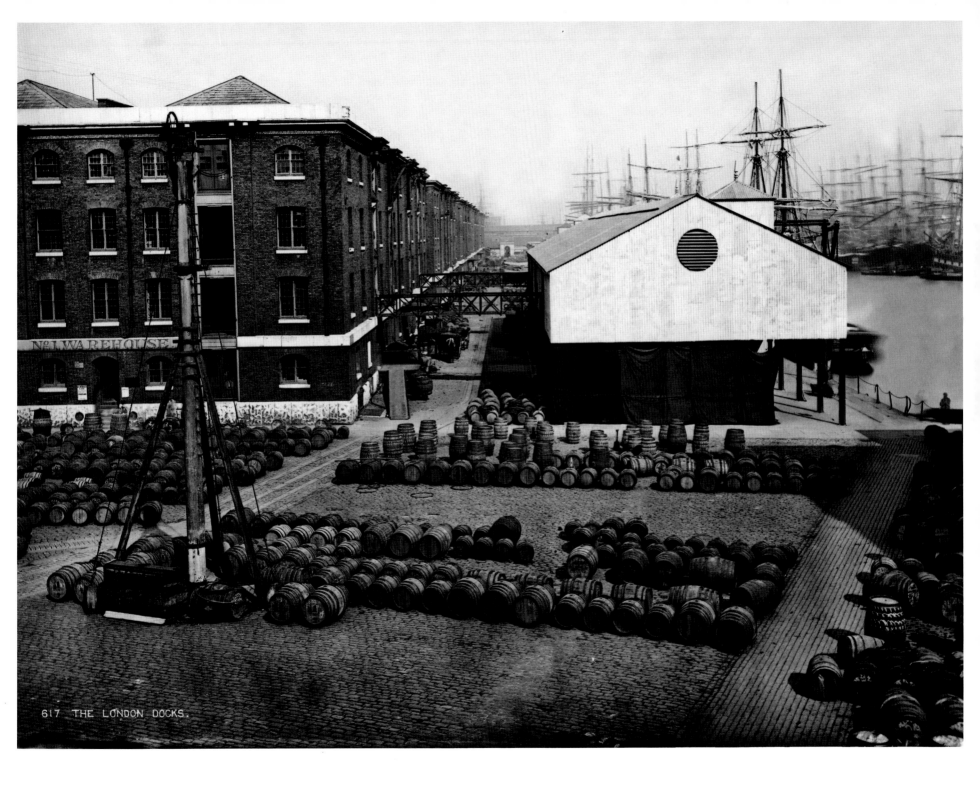

617 THE LONDON DOCKS.

THAMES TUNNEL, WAPPING TO ROTHERHITHE

Sid Barker, RCHME, May 1996. BB96/714

The Wapping to Rotherhithe tunnel has been described as perhaps the most significant nineteenth-century civil-engineering work in Britain. It was the first underwater tunnel in the world to be constructed through soft ground and hence is a structure of international importance. The engineer Sir Marc Isambard Brunel assisted by his more famous son, Isambard Kingdom Brunel, began work in 1825 following unsuccessful attempts by others in the first decade of the century. Brunel senior employed a revolutionary tunnelling shield made to his own designs, patented in 1818. The excavation was arduous and dangerous and there were five serious floods when the waters above broke through. On one occasion, the younger Brunel risked his life to save men trapped at the workface. After numerous technical and financial problems had been overcome, the tunnel – 1200 feet (366 metres) long and comprised of two parallel bores of horseshoe section – opened to pedestrians on 26 March 1843. It remained a foot tunnel until 1865, when it was sold for £200,000 to the East London Railway. It opened to traffic on 7 December 1869 and subsequently it has been used by electric underground trains on the East London Line. In 1995, proposals by London Underground to strengthen the tunnel by encasing the interior in concrete met with fierce opposition. As a result, the new lining reproduces the original features and part of the unaltered structure at the south end has been left exposed. The photograph shows the east bore from the north end after the removal of the track and ballast.

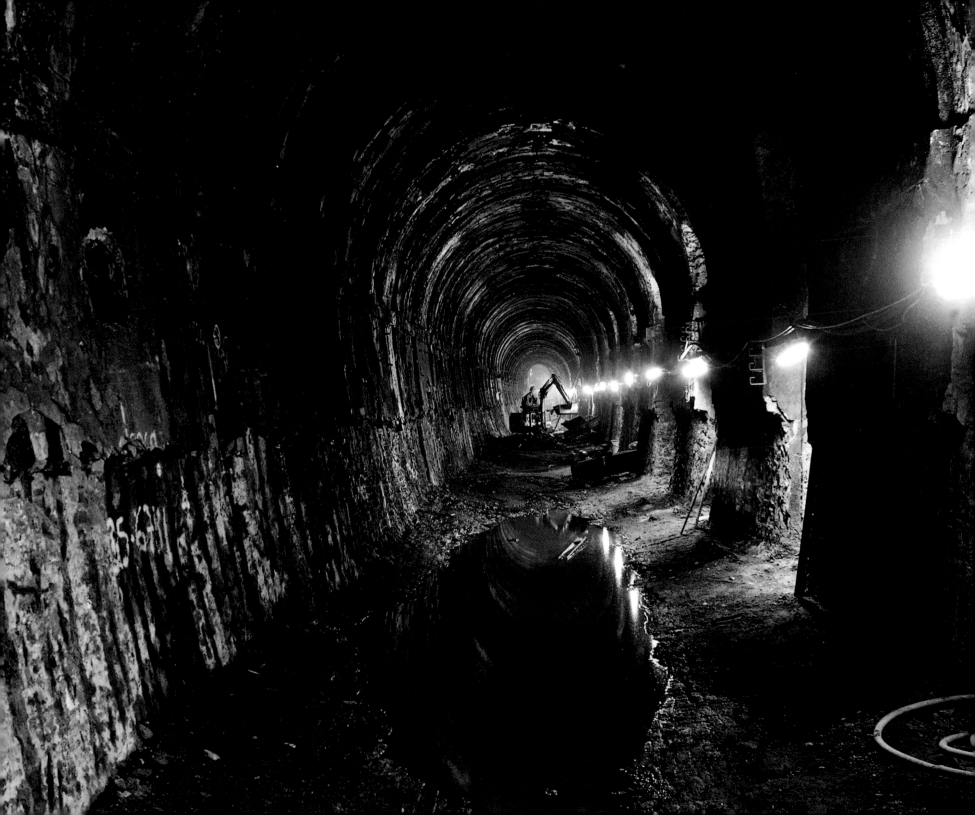

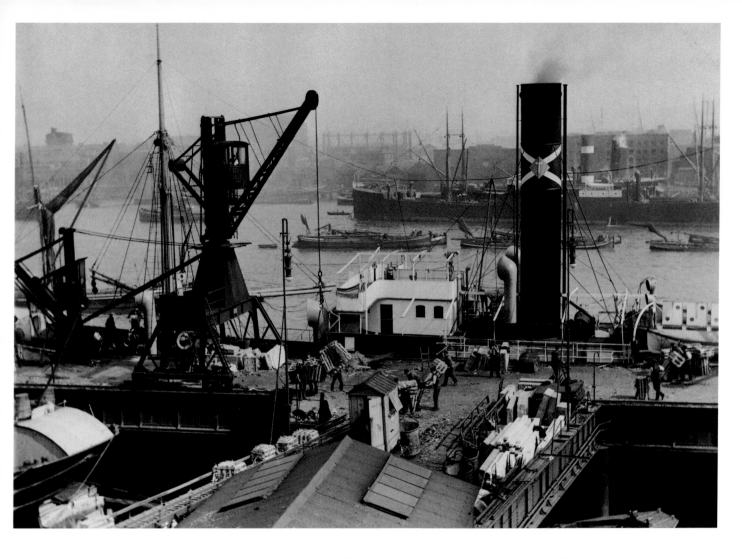

MIDDLETON'S & ST BRIDE'S
WHARF, WAPPING

Unknown photographer, c.1910. Butler's Wharf Collection, BB87/9741, BB87/9746, BB87/9745 and BB87/9752 (clockwise from above)

When these photographs were taken, Middleton's & St Bride's Wharf belonged to the Butler's Wharf Company. As at Butler's Wharf across the river, the company commissioned a series of photographs to record work in progress. In this selection crates of bananas are shown being unloaded and taken by mechanical conveyor into the warehouse. The popularity of bananas led to the development of a special type of ship. The banana carrier was of moderate size, but speedy and with special fittings. In order to ensure that the fruit reached market in just the right condition, the bananas were harvested long before they were ripe. The ships' holds were insulated and carefully ventilated. Air at a closely controlled temperature was pumped through the hands of bananas. These were packed in open-sided crates as seen here. From the warehouse the bananas were distributed by horse-drawn delivery waggon. The view on Wapping High Street shows a departing waggon whose driver halted his horses to pose for the photographer, while everyone else looked on and a policeman kept an eye on proceedings. These typical late-nineteenth-century warehouses were among the large wharves that spread east along the waterfront from St Katherine's Dock. The fourth photograph is from another group taken in these warehouses showing customs officers gauging rum – that is taking measurements to ensure that the levels of wastage from evaporation were within the limits set.

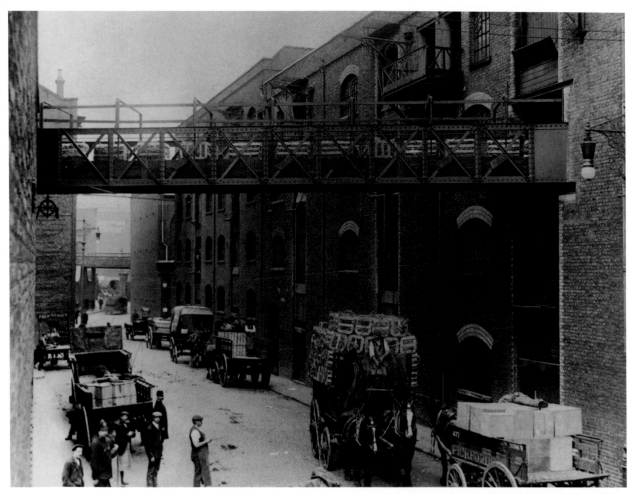

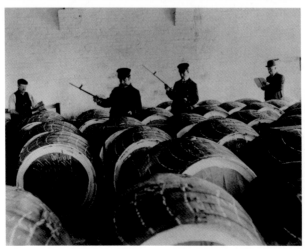

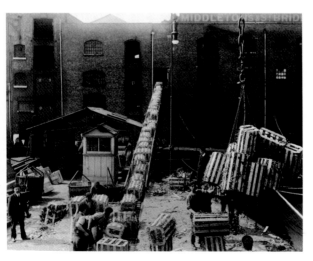

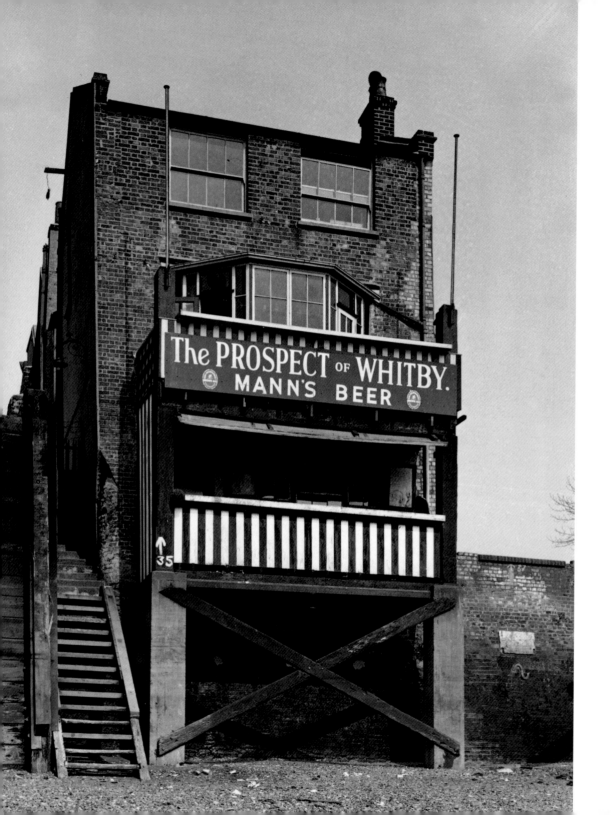

Reputed to date from c.1520, this riverside public house is certainly an early survival, occupying the original, narrow plot, which was created when the shore was drained and first developed in the sixteenth century. However, no part of the present structure appears to be older than the eighteenth century. Formerly known as the Devil's Tavern, supposedly because of its connection with smuggling, the present name derives from a ship, the *Prospect* registered at Whitby, which for a long time was moored nearby. This became a noted landmark and through association the name transferred to the pub. In the nineteenth century, the Prospect of Whitby became a haunt of artists. J. M. W. Turner was an habitué, perhaps making studies for one of his most famous paintings, 'The Fighting *Temeraire*'. He had seen this battleship, a veteran of the Battle of Trafalgar, being towed upstream in 1838 to be broken up at Rotherhithe. Later in the century, the pub featured in many of Whistler's watercolours and etchings. The Prospect of Whitby became a popular meeting place once again, this time for the young and trendy in the 'Swinging Sixties'. Paul Barkshire's photograph shows the pub standing alone amid working wharves, but since then the Prospect of Whitby has been dwarfed by blocks of flats built alongside.

THE PROSPECT OF WHITBY, SHADWELL

Herbert Felton, May 1955. BB92/2162 (left)

Paul Barkshire, September 1981. 1373 (right)

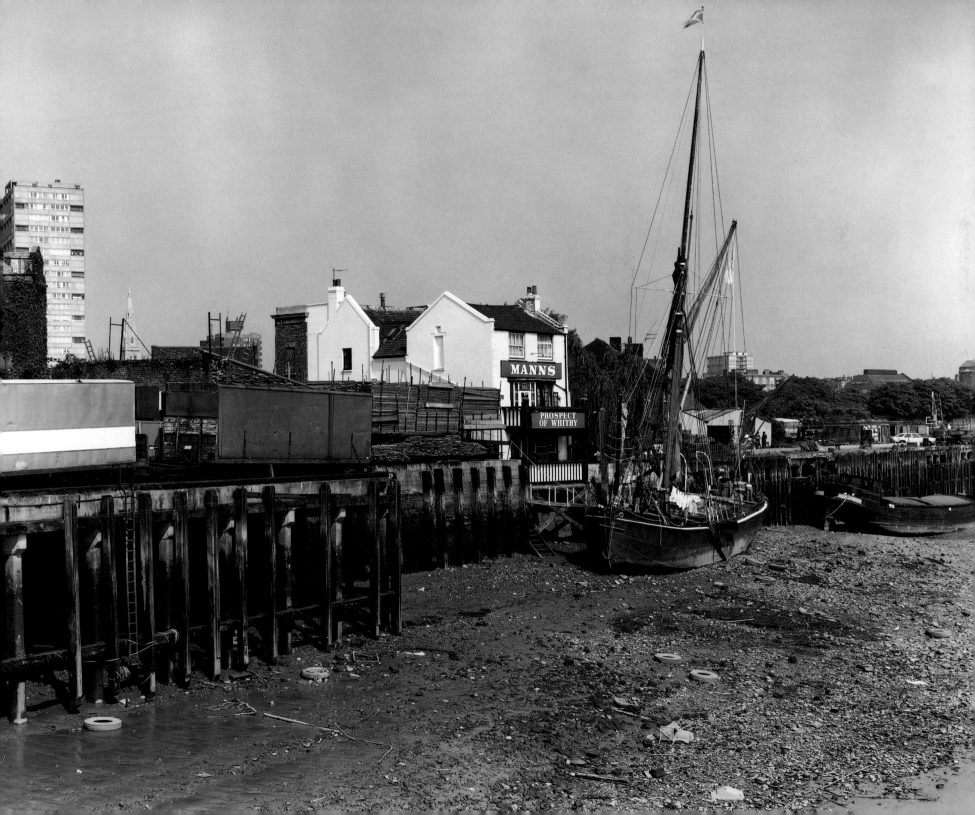

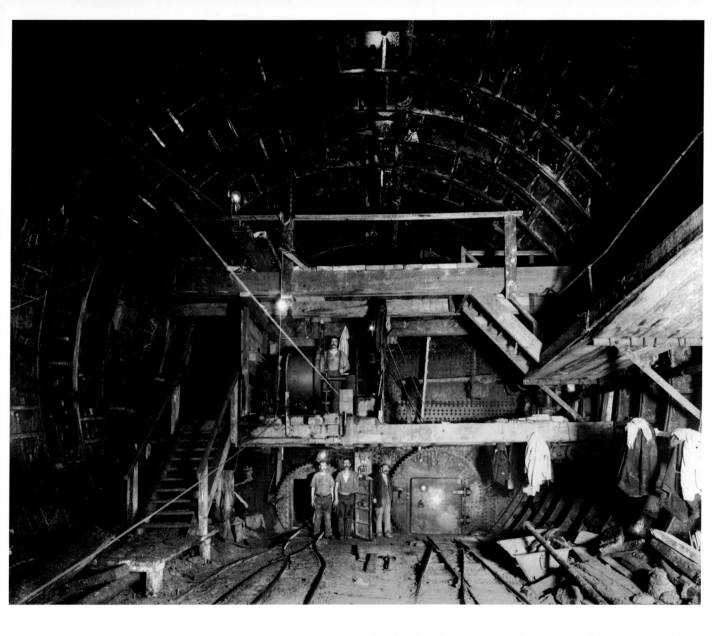

ROTHERHITHE TUNNEL

5 October 1906. BB99/6816 (above)
21 August 1907. BB99/6818 (right)
13 June 1908. BB99/6817 (far right)

The Shadwell to Rotherhithe road tunnel runs due north to south, but obliquely under the Thames. The provision of a tunnel here was suggested first in 1884, but the Metropolitan Board of Works gave preference to Blackwall. The intention was to improve communications between the London Docks to the north and the Surrey Docks on the south bank. Then in 1892 the LCC sought leave to operate a ferry, but the Thames Conservators objected. Eventually permission for a tunnel was granted in 1900. Work began in April 1904 under the direction of Sir Maurice Fitzmaurice, chief engineer to the LCC, who had assisted in the construction of the Blackwall Tunnel a decade earlier. This had been excavated using a similar method to that employed at Rotherhithe, where four vertical shafts were sunk, two on each side of the river. Two Greathead-Moir shields were assembled in the two northern shafts, one to

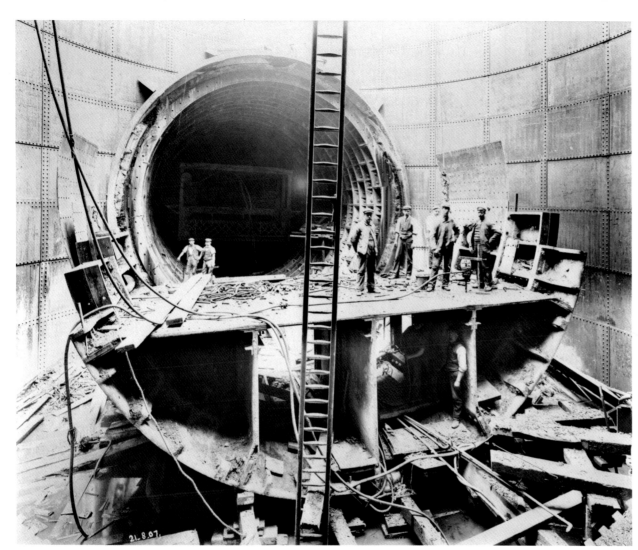

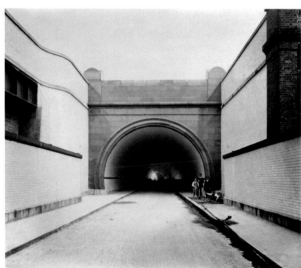

bore under the river and the other to excavate the approach tunnel. Each shield weighed 380 tons and was an enormous advance on the tunnelling shield patented in 1818 by Sir Marc Brunel for the first tunnel under the Thames. The other main technological advance was the construction of air-locks to enable the work to proceed under pressure. The photographs reproduced here come from a series taken as the work progressed. The first shows a pressurised bulkhead from the inside in October 1906. The second photograph shows the front of the shield in shaft number one being dismantled in August 1907 after the completion of the excavation. In the third photograph, the final touches were being made to the southern entrance on the day after the official opening on 12 June 1908 by the Duke and Duchess of York, the future King George V and Queen Mary.

REGENT'S CANAL DOCK

Campbell's Press Studio, 1905. CC73/2568

An Act of Parliament to authorise the construction of the Regent's Canal was passed in 1812. Plans to link the Grand Junction Canal with the Thames had been proposed since the 1790s, but only came to fruition after the intervention of John Nash. He foresaw the scenic potential for his developments around Marylebone (later Regent's) Park and he obtained permission from the Prince Regent for the new cut to be named after him. James Morgan was appointed engineer and work began at the Paddington end. The canal opened in stages until it reached the Thames at Limehouse. Finally on 1 August 1820 the Regent's Canal Dock or Limehouse Basin was opened for traffic via the canal to gain access to the waterways of central England. Trade increased rapidly and the dock was enlarged in 1819 and again in 1852–3. In 1869 the capacity of the river lock was increased to take larger vessels, especially colliers. The Limehouse Basin handled huge amounts of coal and timber as well as more specialised cargoes. From 1822 it was the centre for the ice trade with Norway, which lasted for just under 100 years. The ice was transported along the Regent's Canal to Carlo Gatti's stores at Battle Bridge, Kings Cross. This photograph gives a good impression of a Victorian dock crowded with ships and lighters.

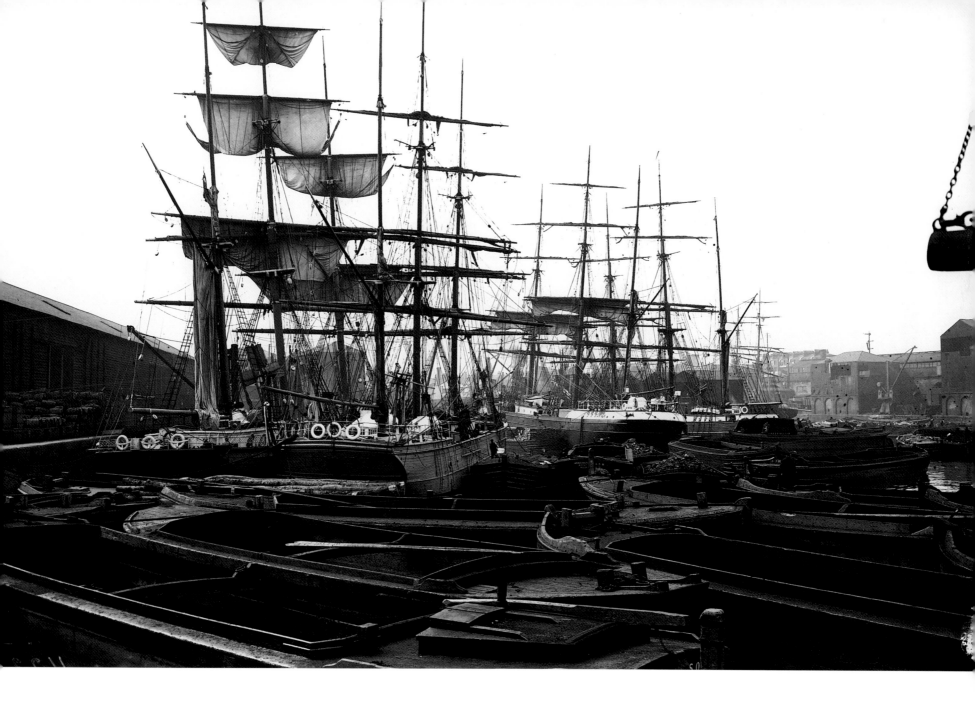

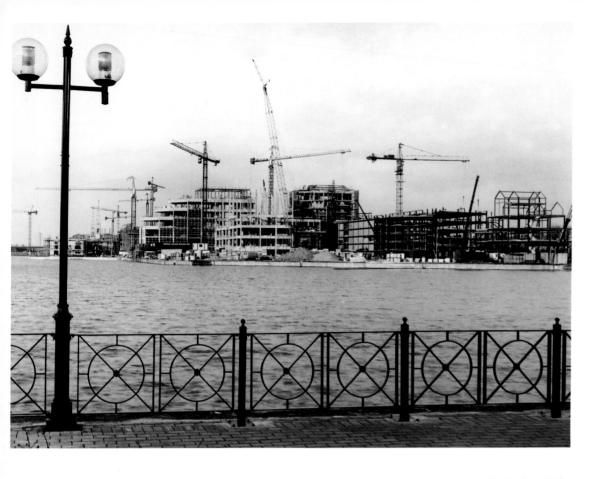

MILLWALL DOCKS

Derek Kendall, RCHME, January 1988. BB88/3594 (above)
Derek Kendall, RCHME, January 1995. BB95/10179 (right)

The Isle of Dogs peninsula – dubbed 'Docklands' – has become emblematic of the economic changes of the 1980s. The construction of enclosed wet docks dedicated to trade with the West Indies was proposed almost exactly 200 years earlier. Excavation in the undeveloped pasture land close to the City began in 1800 and the docks were completed in 1806. Development continued apace and ever more grandiose schemes were proposed. Alongside these, there was the haphazard and piecemeal growth of numerous riverside industries. The Millwall Docks, 1863–9, were completed by Sir John Fowler to an original scheme by William Wilson. They were intended for bulk trade and specialised in the handling of grain. The industrial and commercial pattern that had emerged by the mid nineteenth century remained largely intact until after the Second World War, with the exception of shipbuilding, which had declined steadily. However, with the increasing size of vessels in the post-war period, the Isle of Dogs was unable to compete and eventually the

Millwall and West India Docks closed in 1980. Various plans for the derelict areas had been put forward, but it was not until the creation of the London Docklands Development Corporation in 1981 that financial incentives and planning concessions became available to stimulate regeneration. The Enterprise Zone encouraged the building of offices and houses on a grand scale together with new roads and the overhead Docklands Light Railway. These two photographs, both taken from Clipper Quay on the south side of the Millwall Outer Dock looking north towards the entrance to the Inner Dock, show the completion of the major building programmes within ten years. The most famous building, which became an instant landmark, is No. 1 Canada Square – popularly known as Canary Wharf Tower – the tallest building in Britain and the second tallest in Europe. It was designed by Cesar Pelli as part of the much larger Canary Wharf development around the West India Docks. Construction began in spring 1988 and it was completed in August 1991.

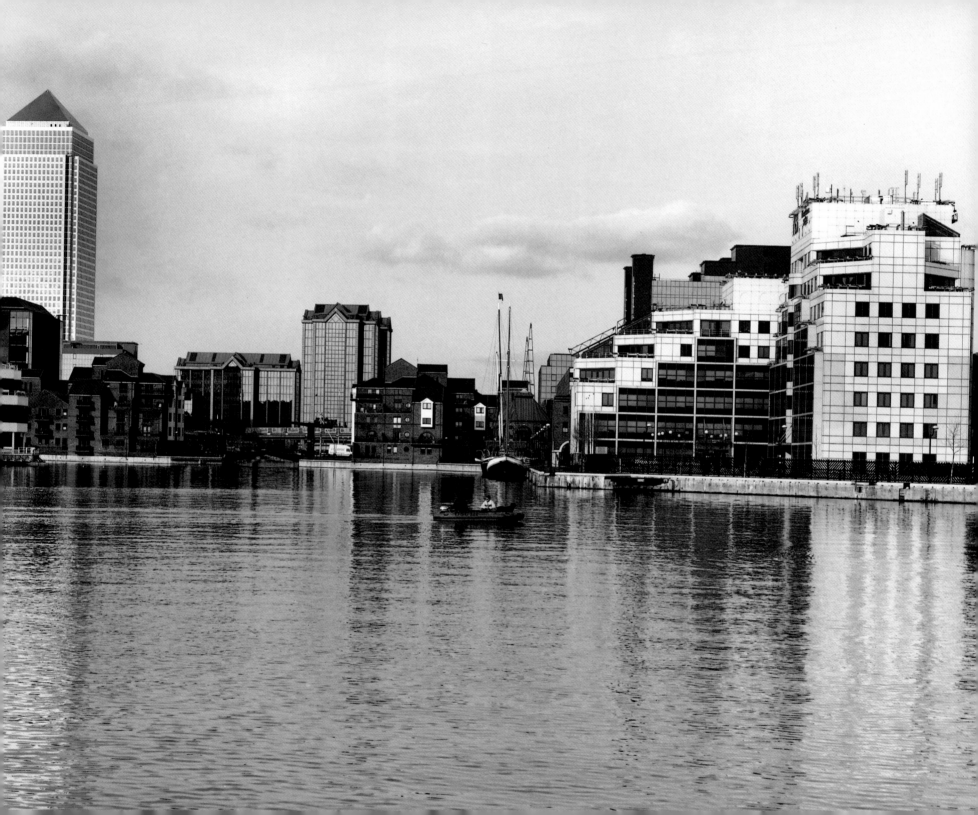

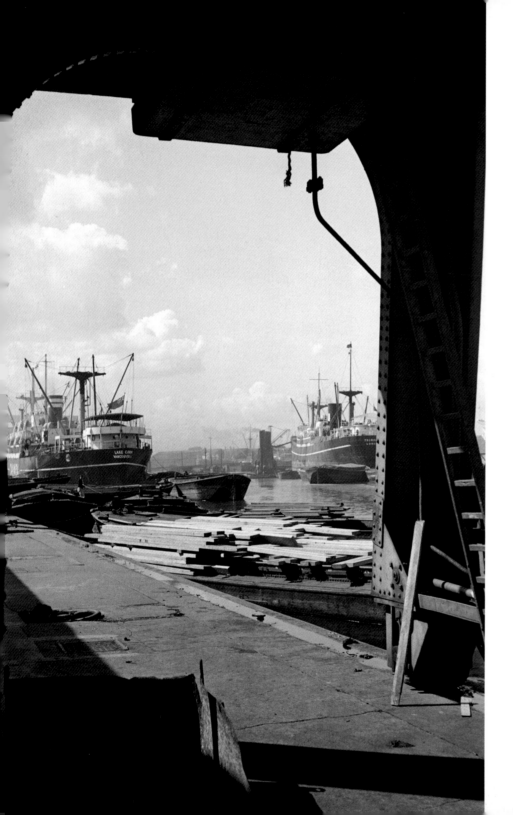

Greenland Dock occupies the site of Howland Great Wet Dock, which was allowed by Act of Parliament in 1696 and was London's first enclosed dock. It was completed in 1699 and from the 1720s became associated with the whaling trade. It was renamed the Greenland Dock when it was sold in 1763 and came to be used almost exclusively by whalers. Sold again in 1807, the entrance lock was enlarged and it was reopened as an import dock. Between 1893 and 1904 it was greatly enlarged for the Surrey Commercial Company in order to accommodate ships of up to 12,000 tons carrying grain from Canada. After the death of the original engineer, James A. McConnochie, the work was completed by Sir John Wolfe Barry. Once part of the vast Surrey Commercial Docks, Greenland Dock is now the only substantial expanse of water in Rotherhithe not filled in and built over. It was still a hive of activity when photographed by S. W. Rawlings and the contrast with Derek Kendall's photograph could not be more telling. The latter shows the housing on Finland Quay designed by Richard Reid, 1987–9, the whole area having been given over to residential and leisure use with landscaping by R. P. S. Clouston.

GREENLAND DOCK

S. W. Rawlings, 1950s. A461 (left)
Derek Kendall, RCHME, May 1997. BB97/1469 (right)

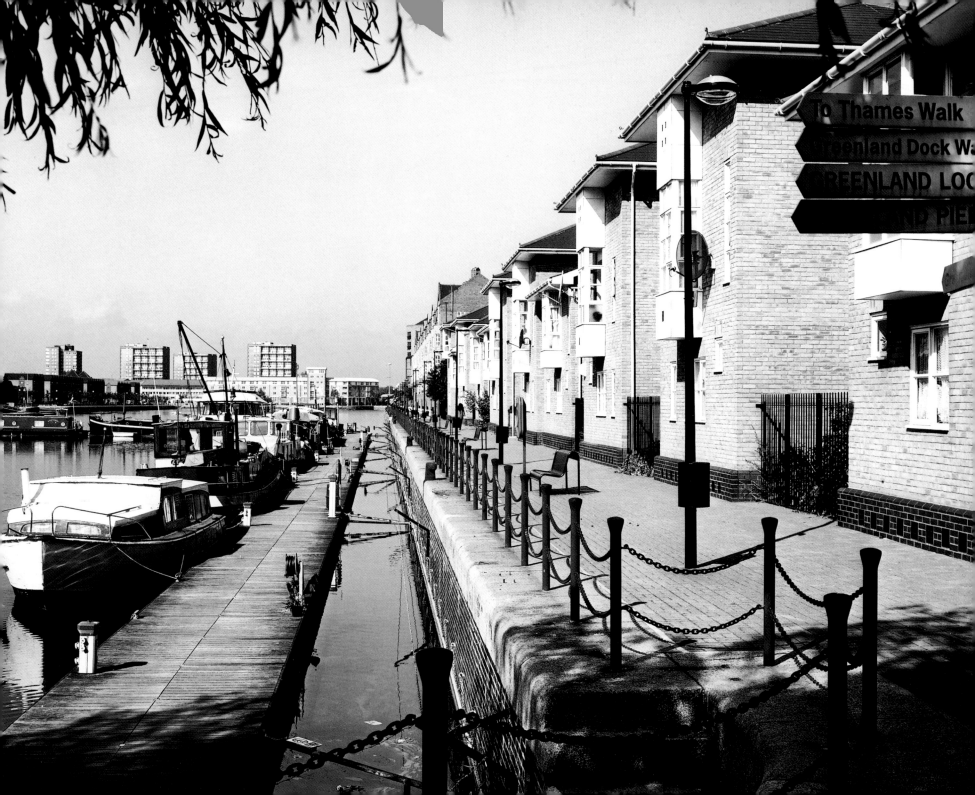

THE GREAT EASTERN, MILLWALL

Robert Howlett, November 1857. BB88/6275

The site at the southern end of the Isle of Dogs opposite Deptford had been acquired in 1837 by David Napier, a marine engineer, for development as a shipyard, known thereafter as Napier Yard. After a disastrous fire in 1853, the yard was leased to John Scott Russell as the building site for the *Great Eastern*. Work began on 1 May 1854 and for six years Napier Yard was dominated by the construction of this huge ship. Conceived and designed by Isambard Kingdom Brunel, the *Great Eastern* was vastly bigger than any existing vessel. Because of the size of the undertaking the keel was laid parallel to the shore with the intention of launching the ship sideways into the river. As ever, Brunel was at the forefront of innovation, whether in building tunnels, bridges, railways or ships. However, this ambitious project was very nearly the undoing of all concerned. In anticipation of the proposed launch on 3 November 1857, large crowds gathered, including Charles Dickens, who wrote that 'They delight in insecure platforms; they crowd on small, frail, house-tops; they come up in little cockle-boats, almost under the bows of the great ship ... Many in that dense floating mass on the river and the opposite shore would not be sorry to experience the excitement of a great disaster, even at the imminent risk of their own lives'. Sadly the attempt was disastrous, the ship ground to a halt and a workman was killed. More powerful hydraulic rams had to be installed. These inched the ship towards the water, but it was not until nearly three months later on 31 January that the *Great Eastern* finally took to the river. The enterprise bankrupted both Scott Russell and his company and brought about Brunel's early death. On 5 September 1859, he suffered a stroke while on deck two days before the ship's maiden voyage began and died ten days later at the age of 53. Although no larger ship was to be built anywhere in the world for another 40 years, Brunel's contention that bigger ships could be faster and more economical was soon proven and foretold the end of shipbuilding on the Thames.

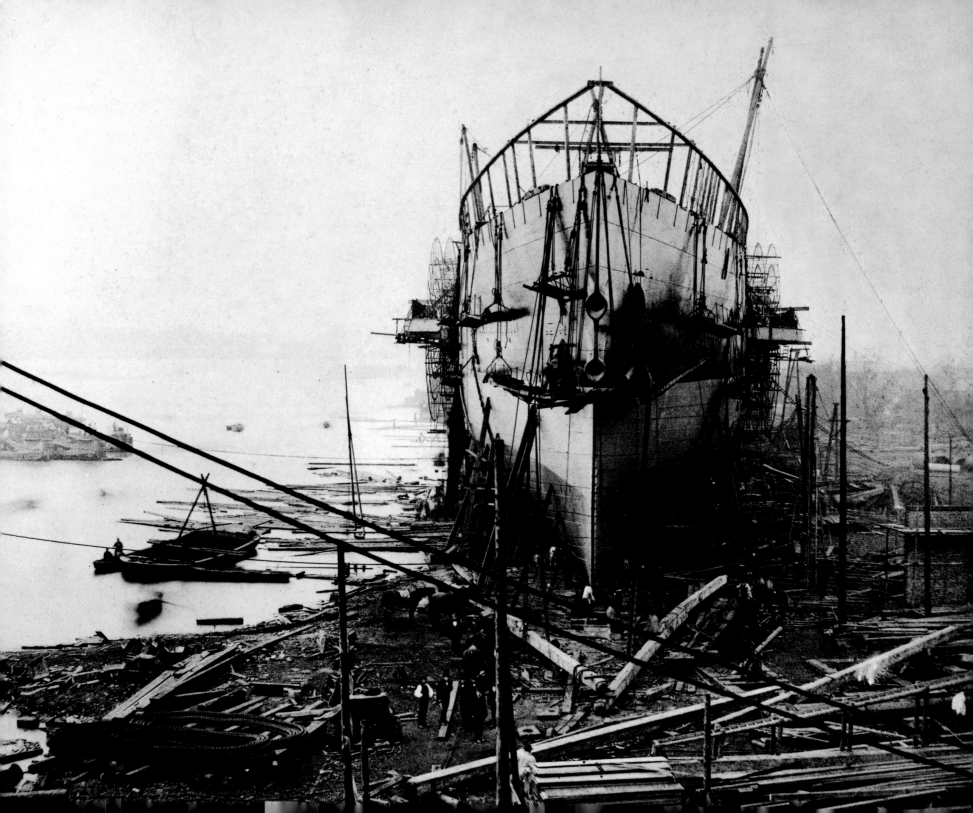

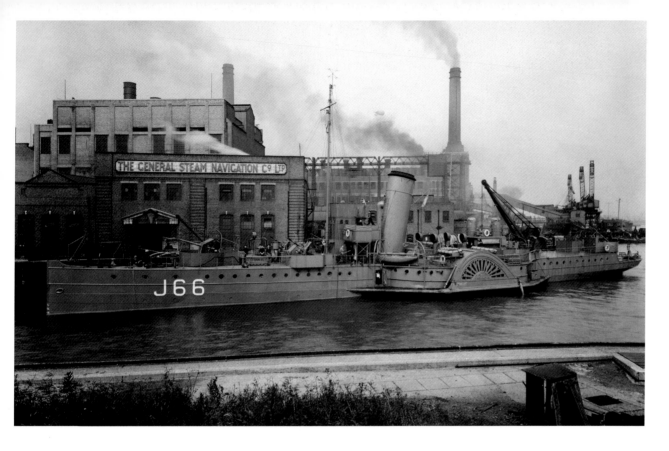

DEPTFORD CREEK

Larkin Brothers, c.1940. CC80/195

Roman and Saxon remains have been found near the ancient settlement at Deptford and the medieval village grew around the lowest bridging point and along the west side of the creek – the mouth of the Ravensbourne. Deptford grew apace when in 1513 Henry VIII established here the first Royal Naval Dockyard on the Thames. This continued to expand throughout the seventeenth century, but declined with the advent of larger ships and the restrictions of the site. It closed in October 1869. Numerous other industries were established along the banks of the Creek, including the General Steam Navigation Company, founded in 1820 by a local timber merchant, Thomas Brocklebank. He established a shipyard on the west side of the creek mouth in 1825, where the company's paddle steamers were built and maintained. The General Steam Navigation Company grew throughout the nineteenth century and ran services from London to the Continent and the Mediterranean as well as to West Country and East Coast and Scottish ports. Although it was one of the most successful steamship companies, it never attained the prominence of the great ocean lines. The company controlled the site seen here until 1968. In the foreground of this photograph is the paddle steamer *Plinlimmon*, formerly the *Cambria*, launched in 1895 and owned by P. & A. Campbell Ltd. She is seen here in war-time livery, having been hired by the Ministry of War Transport in 1939. In the background is Deptford Power Station. This was the first large-scale power generator in the world, built in 1887–9. The young electrical engineer Sebastian di Ferranti chose Creekside for his power station, planned to supply the whole of London, as land beyond the City was cheap and there was unlimited cooling water available from the Thames. In 1885 he had patented the high-voltage alternating-current transformer system that basically is still in use to this day. Also his scheme included all the elements of the national grid, which was not to come into being for another 40 years. Deptford Power Station was enlarged in 1929 and again in 1948–53, but was closed in the 1960s. The last part of the station was not demolished until 1990–1.

The repeal of the Navigation Acts in 1849 removed the monopoly on the carriage of tea and opened up the trade to competition. Huge prices were paid on the London market in the 1850s, which made it worthwhile to employ the fastest ships to transport this increasingly popular beverage from China. The highest prices were paid for the first tea of the season and it became a matter of pride and profit for ships' masters to race for the prize for being the first to arrive in London. The most famous race of all took place in 1866, when two ships left Foochow in China on the same tide. After 99 days at sea, they arrived in the London docks only 20 minutes apart. The *Cutty Sark* was commissioned by John Willis, who was ambitious to succeed in the first-of-the-season tea race. She was built on the Clyde in 1869 and began her maiden voyage out of London for Shanghai on 16 February 1870. Despite valiant efforts, *Cutty Sark* never won the tea race, but went on to greater glories in the Australian wool trade, which took over as the prestige run for clipper captains in the 1880s. *Cutty Sark* broke the wool record every year from 1885 to 1895. She was sold to Portuguese owners in 1895 and continued trading until 1922, when she was bought by Captain W. H. Dowman of Falmouth, who had her towed there for restoration. In 1938, Wilfred Dowman's widow presented her to the Thames Nautical Training College at Greenhithe, where she served as a tender to HMS *Worcester*. The College maintained her until 1952, when the *Cutty Sark* Preservation Society was formed by Frank Carr, Director of the National Maritime Museum, under the patronage of HRH The Duke of Edinburgh. She was put into dry dock at Greenwich in 1954 and after being restored and re-rigged she was opened to the public by Her Majesty The Queen on 25 June 1957.

THE CUTTY SARK, GREENWICH

Derek Kendall, RCHME, February 1996. AA96/2020

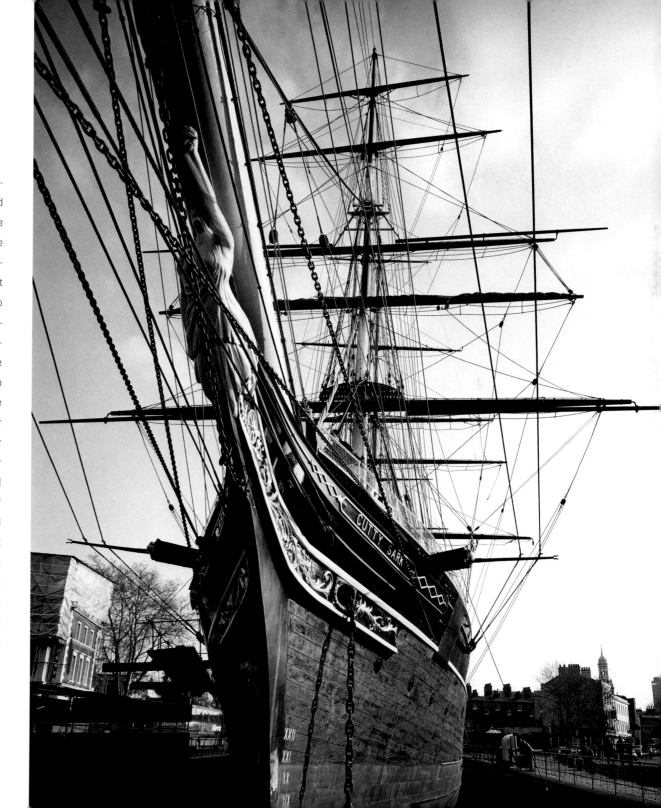

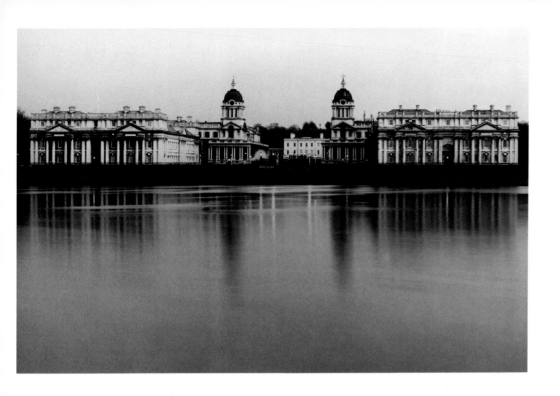

ROYAL NAVAL COLLEGE, GREENWICH

Derek Kendall, RCHME, February 1996. AA96/1185 (above)
York & Son, 1860s. CC97/1605 (right)

The town of Greenwich is of ancient origin; Roman and Saxon remains have been found. The first written reference dates from 964. Nearly a thousand years ago the settlement was attacked by the Danes and Greenwich acquired its own saint, Alfege, martyred in 1012. The parish church was founded in his memory and its eighteenth-century replacement still bears his name. The manor of Greenwich had been in royal hands since the early fifteenth century, but grew to prominence under the Tudors, whose palace of Placentia was the birthplace of the future Henry VIII. As king he spent huge sums of money on improving the palace of which nothing now remains. Greenwich's importance in maritime history began when Henry founded Trinity House and the naval dockyards nearby at Deptford and Woolwich. James I commissioned Inigo Jones to design the Queen's House – seen here between the domed ranges – begun in 1616 in what must have appeared as a startlingly new Italianate style. The park beyond includes on the hill the Royal Observatory, founded by Charles II and built by Sir Christopher Wren and Robert Hooke in 1675–6. The grand Baroque palace that stands today, seen here at twilight from across the river and in an earlier view from the park, was begun in 1664 to the designs of John Webb, Inigo Jones's pupil. However, only one range, the King Charles Block (right in the first photograph), was built. Following the accession of William III and Queen Mary, they commissioned Wren to build a naval hospital as a counterpart to the hospital for old soldiers up river at Chelsea. The diarist John Evelyn recorded that on 30 June 1696 'I went with a select Committee of Commissioners for Greenwich Hospital and with Sir Christopher Wren, where with him I laid the first stone of the intended foundation, precisely at five o'clock in the evening, after we had dined together. Mr Flamstead, the King's Astronomer Professor, observing the punctual time by instruments'. Wren's innovative design of two separate, symmetrical ranges was made necessary by the need to maintain a view of the river from the Queen's House. The completion of the whole scheme took more than 50 years and other architects, notably Vanbrugh and Hawksmoor, were involved. The first 42 pensioners had arrived in 1705 and numbers increased eventually to 3000. However, by 1850 there were few ex-sailors wishing to take advantage of the spartan conditions and the hospital closed in 1869. In 1873 it became the Royal Naval College. The Navy in its turn moved out in 1998 and the magnificent buildings, recognised as a World Heritage Site, now house the University of Greenwich and Trinity College of Music.

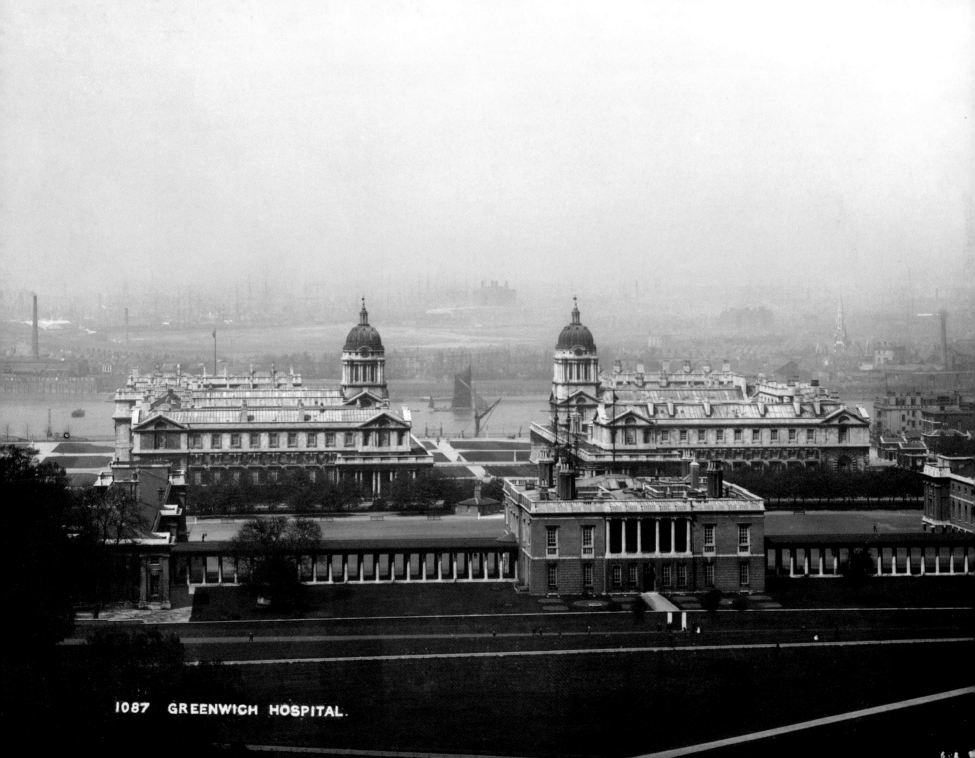

1087 GREENWICH HOSPITAL.

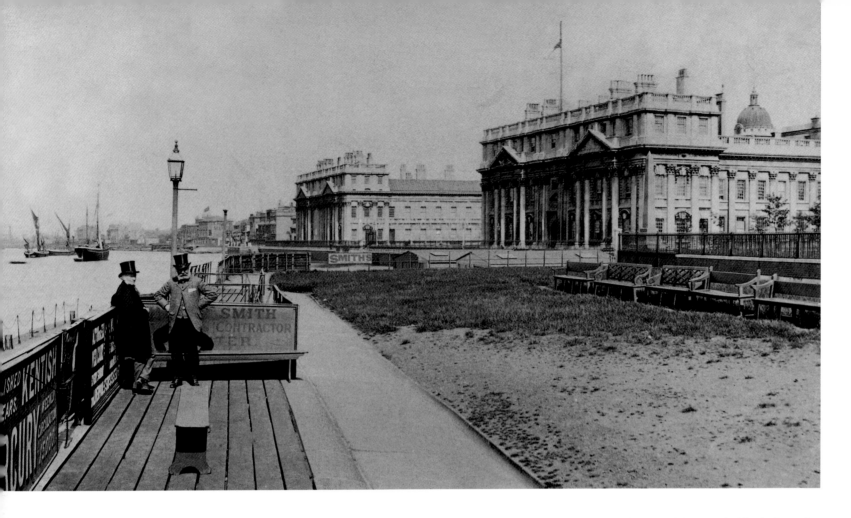

GREENWICH PIER

Unknown photographer, 1860s. Gerald Cobb Collection (above)
S. W. Rawlings, 1950s. A502 (right)

Regular steamboat services to Greenwich pier began in 1815 and the pier became a popular place from which to view the shipping on the river; hence the rows of seats shown in the photographs. Sadly, the identities of the two top-hatted gentlemen are not recorded, but they are posing in front of the steps to the jetty so might be the owners or have some other connection. With the pier otherwise deserted and the Royal Naval Hospital prominent in the background, they would appear to be the main subject of this particular photograph. Even as late as the 1950s, the promenade in front of the Royal Naval College was a popular vantage point from which to view shipping in Greenwich Reach. Frank C. Bowen, the prolific author on the subject of London river and its ships, writing in 1938, described the scene: 'Greenwich and its opposite shore are particularly popular and the former has the advantage of an un-usually long stretch of river in view, and so narrow that the ships are bound to come close. Thousands of people stand on the bank there for hours but many more pay their penny toll to go on the pier itself, a very long one, where several rows of seats are generally well-filled … The stream [of ships] has been greatly increased by the time Greenwich is reached; coasters and nearby Continental traders from the wharves and upper dock systems, timbermen and big transatlantic traders from the Surrey Commercial and many others'. In the background of this view are the two huge gas-holders on the Greenwich Peninsula. Each one in its turn was the largest in the world. The holder to the right was constructed in 1886 and still exists. The other was built in 1892 and having been reduced in size after the Silvertown explosion in 1917 was demolished in 1986.

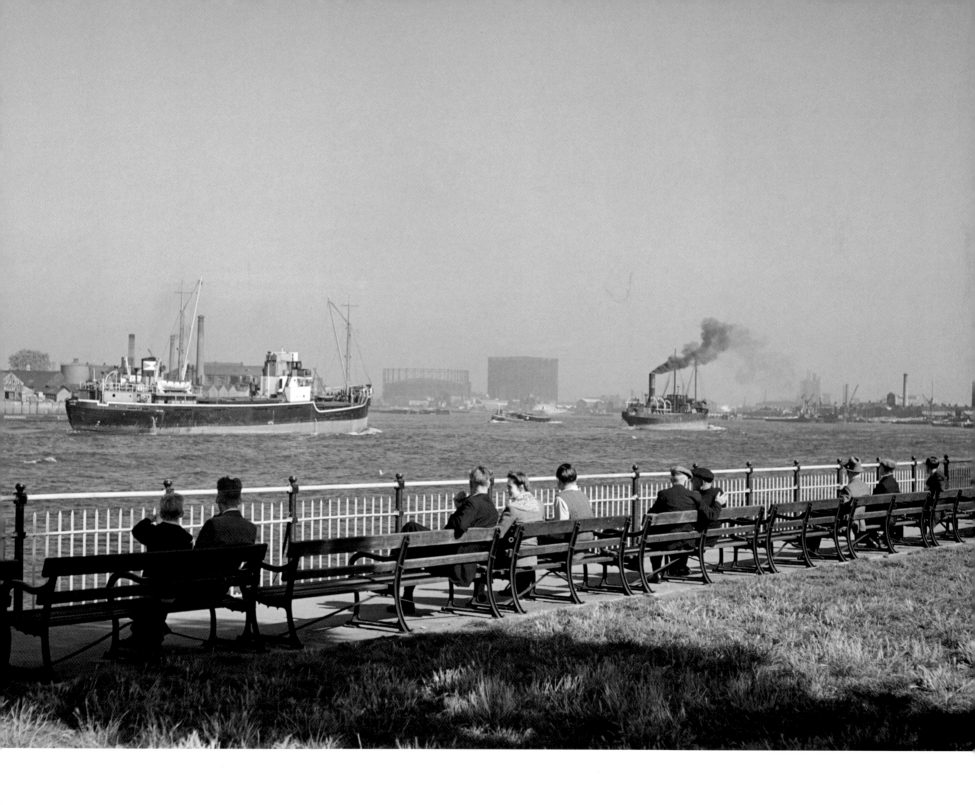

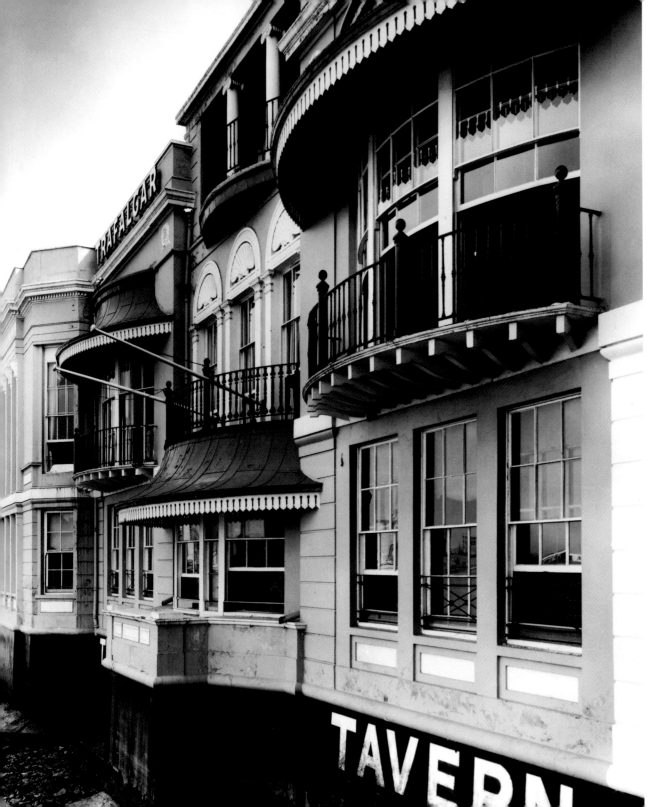

The elegant Regency-style façade of the Trafalgar Tavern looks out over the river immediately downstream from the Royal Naval Hospital. The inn was designed in 1837 by Joseph Kay, who was clerk of works to the Hospital. During the nineteenth century it became famous for its whitebait dinners. At one time, whitebait – the fry of herring and sprat – were caught in large numbers well up river, but pollution forced the fish further out into the Thames estuary. Throughout the season beginning in October each year, Greenwich became the fashionable rendezvous for those dining on this delicacy. The Trafalgar Tavern was the haunt of the literary establishment, notably Frederick Marryat, Wilkie Collins and Charles Dickens. Dickens used it as the setting for a scene in *Our Mutual Friend* (1864–5). The annual whitebait dinner also was popular with politicians. The Cabinet used to meet at Greenwich at the end of the parliamentary session: the Tories dined at The Ship and the Liberals at the Trafalgar. One of the last regular whitebait dinners was held in 1895, although there was a short-lived revival by Ramsay MacDonald in 1933. In the late 1990s, as water quality has improved, the whitebait have begun to return to the Thames. The Trafalgar Tavern was damaged in the Second World War and ceased to be an inn until an extensive restoration was undertaken by the architects Hendry & Smith in 1968. Since then it has become a popular resort once again.

TRAFALGAR TAVERN, GREENWICH

Paul Barkshire, September 1981. 1409

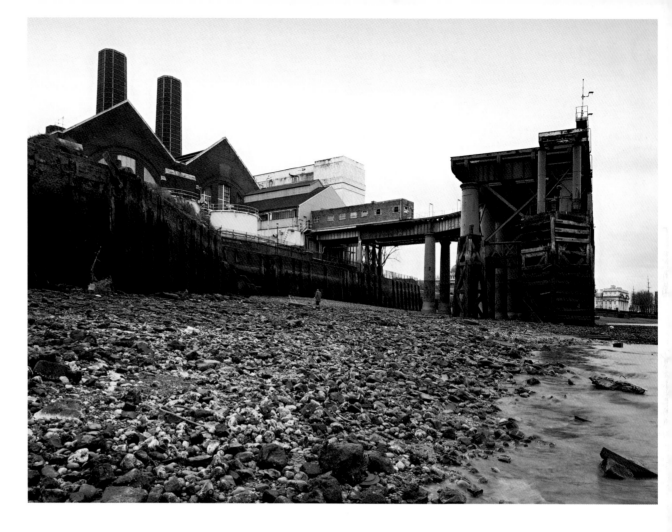

Not far downstream from the Royal Naval College is Greenwich Generating Station, built in 1902–10 for the London County Council. At that time, it was the largest single building erected by the new authority and as such was a powerful demonstration of LCC pride. It was designed to provide electric power for the capital's tramways and continues in use as a back-up source for London's underground railways – one of the few early power stations to remain in operation. Also it is noteworthy as an early example of a steel-framed building in Britain and, in its stock-brick skin with stone dressings, it has considerable architectural merit. The electrical engineer to the tramways, J. H. Rider, was responsible for the general layout, but the over-all appearance was probably due to the LCC architects' department under W. E. Riley. The station was originally coal-fired. The first section, opened in 1906, incorporated a late example of the use of reciprocating steam engines, but by 1922 these had been replaced by steam turbines. All the early plant has been removed and since 1972 the station has been equipped with eight gas-turbine alternators, formerly burning oil, but later converted to oil and gas dual-firing. One of the more notable ancillary structures to survive is the coaling pier, which stands on 16 huge cast-iron columns, designed by Sir Maurice Fitzmaurice, 1903–5. Originally, the coal was unloaded by crane into railway trucks that ran to the station's external coal bunkers, but this system was replaced by conveyors that ran directly into the boiler house.

GREENWICH GENERATING STATION

Derek Kendall, RCHME, January 1993. BB93/5512

This photograph of part of the Isle of Dogs, known as Cubitt Town, was taken from Greenwich Park by Roger Fenton. It is a detail from a larger view of the Royal Naval Hospital, one of a series of London landmarks he photographed. Cubitt Town took its name from William Cubitt, the developer, who laid out the principal streets and created the river embankment in the 1840s and 1850s. Christ Church, Manchester Road, seen here (left) not long after completion, was built in 1852–4 to the designs of Frederick Johnstone. The buildings on the riverside close by were the premises of the Cumberland Oil Mills, established in 1857. They were built by Cubitt & Company to the designs of one of their partners, William Rogers, for Nicholay, Graham & Armstrong, linseed oil and oilcake manufacturers. The mills continued in operation until 1949 and closed in 1964. The main buildings were demolished in 1972, but the chimney survived until the 1980s. Next downstream were a number of small wharves before William Cubitt & Company's own wharf established c.1843–4, seen here piled with timber and including a distinctive kiln. Their yard contained sawmills, timber wharves, a cement factory, a pottery and several brickfields, all producing materials for the building industry. William Cubitt retired in 1854 and ten years later the premises began to be divided into separate wharves. The large open space just inland was known as the Mudchute – the name perpetuated by one of the stations on the Dockland Light Railway – and was formerly grazing land but had become brickfields by the time this photograph was taken. Fenton's photograph gives an excellent illustration of the small-scale industries flourishing in the nineteenth century on the banks of Greenwich Reach and Blackwall Reach beyond.

CUBITT TOWN

Roger Fenton, c.1857. BB94/13975

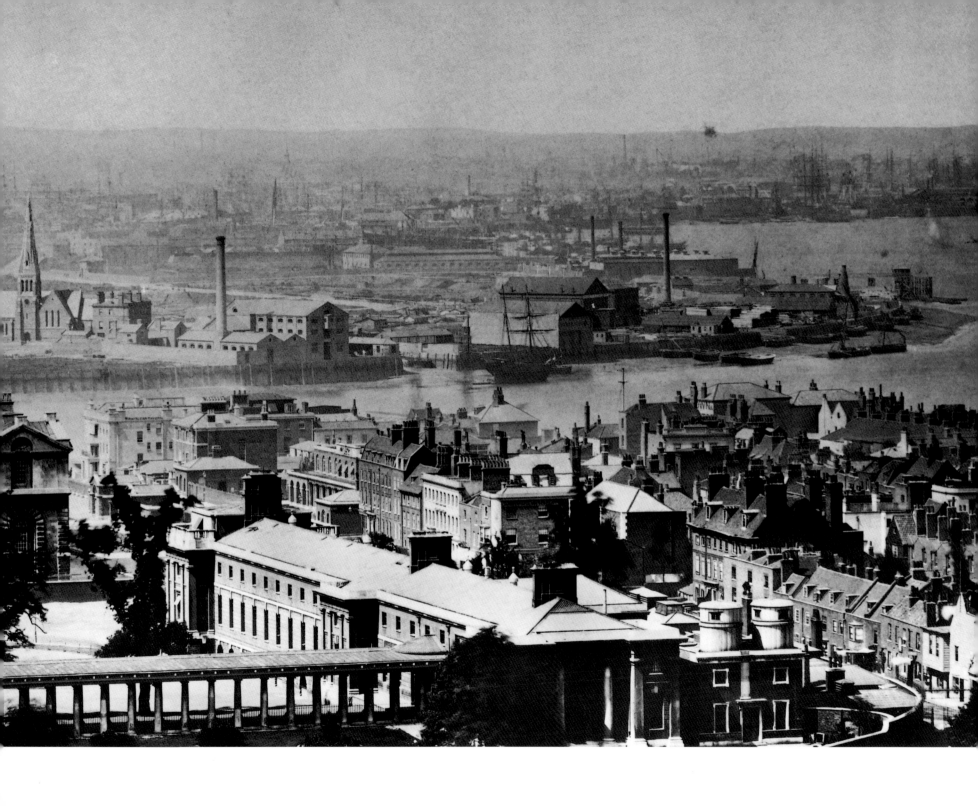

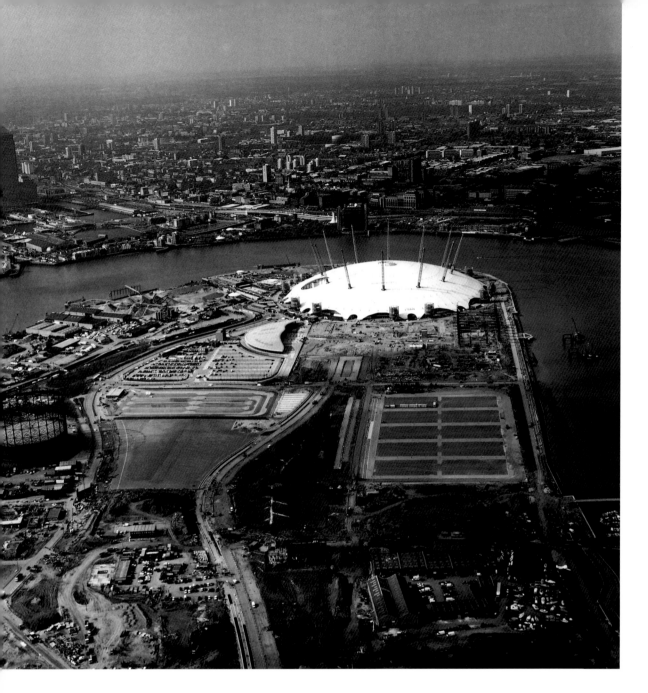

The history of the Greenwich Peninsula is typical of stretches of low-lying riverbank downstream from the City of London. Originally marshland with little agricultural value, industry developed slowly. The area attracted activities such as gunpowder manufacture as it was close to London with easy access by river yet remote from centres of population. From about 1800, a maze of wharves and small-scale industries began to grow up, but it was the manufacture of coal gas and its associated chemical industries that was to dominate the area for more than 100 years. George Livesey was the third generation of his family to manage the South Metropolitan Gas Company. Between 1883 and 1886, he built their showpiece works on a new site on Greenwich Marsh, which was to be an example to the world. He was knighted in 1902 for his achievements in the gas industry. The first gas holder, seen on the left in the general view from the south-east, was designed by Livesey and dates from 1886. At the time it was the largest in the world and the first four-lift holder. It survives in use for storage. Its companion, built in 1892, succeeded to the title of world's largest and was designed by George Livesey in collaboration with his brother Frank, then company engineer. This holder was severely damaged when on 19 January 1917 the Brunner Mond chemical works across the river at Silvertown, which had been manufacturing TNT for the War Office, blew up. The gas holder was repaired, but reduced in height, and demolished in 1986. The production of coal gas ceased in 1968 and most work came to an end in 1976 after the introduction of natural gas. The late twentieth century saw a steady slide into decline, with the result that the area was largely derelict when it was chosen as the site for the Millennium Dome.

GREENWICH PENINSULA

Damian Grady, RCHME, March 1999. 18318/11

One of the reasons that the industrial wasteland of the Greenwich Peninsula was chosen as the focus for the Millennium year celebrations was a decision taken in 1884. In that year an international conference held in Washington decided that the world's prime meridian should be at Greenwich. This was a consequence of Charles II's decision to build an observatory there in 1675. Hence, too, the recognition of Greenwich Mean Time as the world standard. The imaginary line of zero longitude passes along the west bank of the Peninsula. Initial designs for the Dome were prepared by Mike Davies, one of the founders of the Richard Rogers Partnership, in the summer of 1996 and planning permission was granted in January 1997. The deadline for opening was fixed for new year's eve 1999, with no possibility of delay. The huge white fabric dome is supported by a ring of 12 masts painted 'Van Gogh cornfield yellow'. The design was developed by Davies in conjunction with the engineers Buro Happold and Gary Withers of Imagination. Although universally known as the Dome, technically it is not a dome, but a cable-stayed grid shell. The roof is the biggest in the world, covering almost five hectares, and is the world's largest fabric structure – 93,000 square metres. Such superlatives have spawned a multitude of bizarre statistics. For example, if it were to be inverted under Niagara Falls, it would take more than ten minutes to fill with water. The Dome and the exhibition – the Millennium Experience – excited much criticism, as occurred, for example, when the Great Exhibition of 1851 or the Festival of Britain (see page 106) were proposed, but the result is a triumph of high-tech architecture.

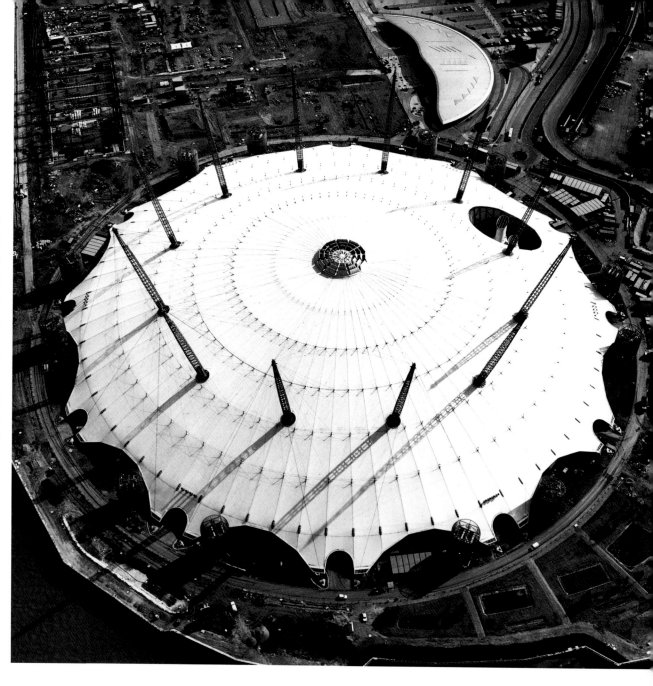

THE MILLENNIUM DOME

Damian Grady, RCHME, March 1999. 18318/19

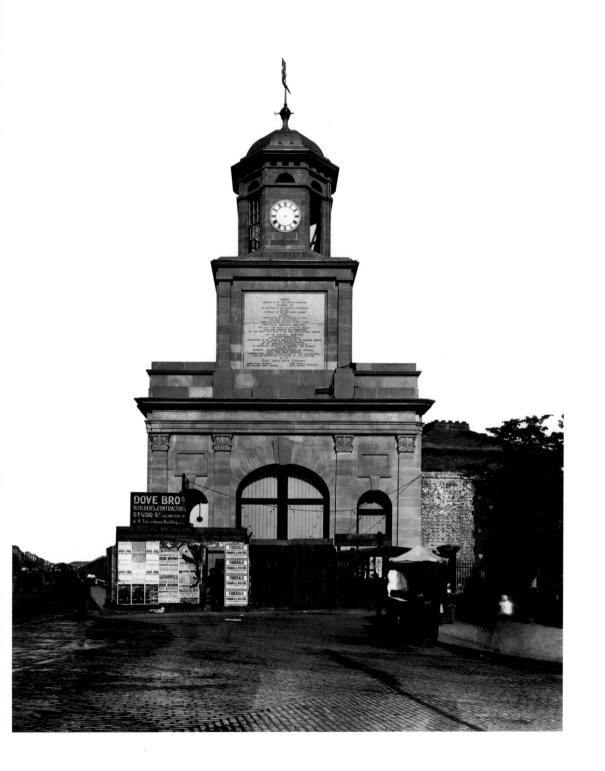

The East India Company obtained an Act of Parliament in 1803, four years after the West India Docks Act was passed, to authorise the building of docks at Blackwall. These were to accommodate the East Indiamen, which were then the largest vessels on the river, at 1200 tons. The engineers were John Rennie and Ralph Walker and the East India Docks opened on 4 August 1806. There were two docks, an inner Import Dock and a smaller Export Dock, both linked to the river by an entrance basin. The Export Dock incorporated William Perry's Brunswick Dock, which had been excavated in 1789–90. The main gate on East India Dock Road was built to impress in the form of a tri-umphal arch, designed by Ralph Walker, 1805–7. Following road widening, a replica was built in ferro-concrete in 1913–4. This is seen nearing completion in Bedford Lemere's photograph. The second photograph shows excavation well advanced for the construction in 1897 of a new entrance lock by the en-gineers H. B. & F. A. James. The new gates, not yet installed in this view, came from the nearby Thames Ironworks. The Export Dock was badly dam-aged by bombing and filled in after the war when the Brunswick Wharf Power Station was built on the site. The Import Dock was drained in 1943 and some of the concrete caissons for the 'Mulberry' invasion harbour were cast here in 1944. This dock was filled in when the East India Docks were eventually closed in 1967. The grand entrance arch had been demolished in 1958. Only the entrance basin survives.

EAST INDIA DOCKS

Bedford Lemere, May 1914. BL 22668 (left)

Unknown photographer, 5 April 1897. BB89/5072 (right)

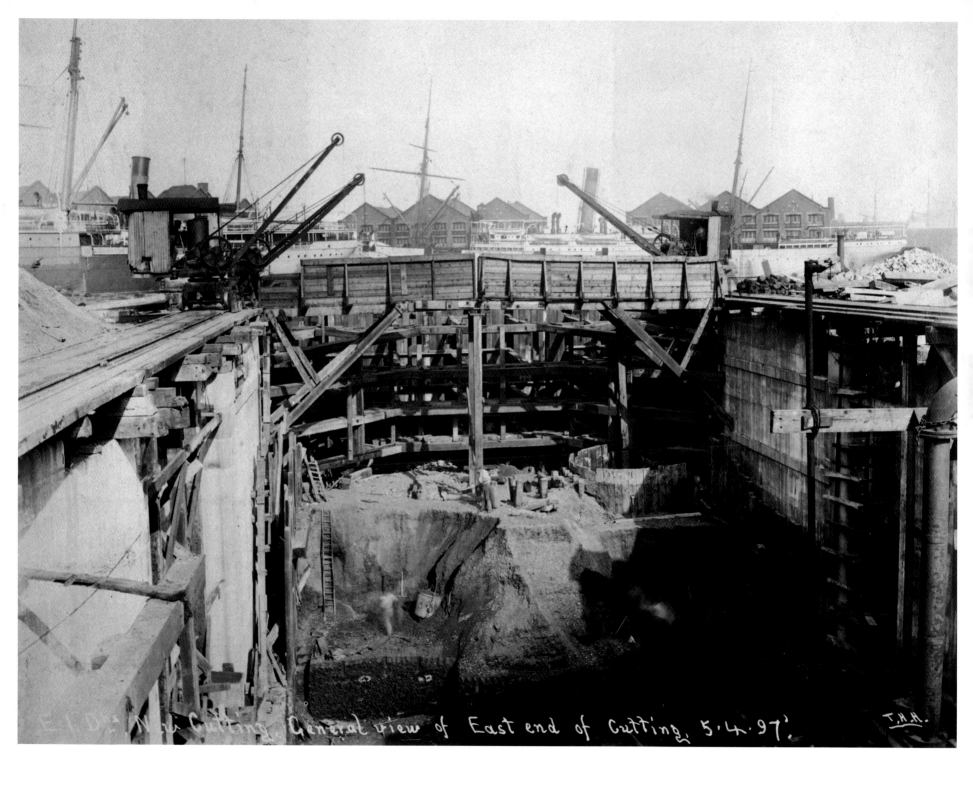

E.I.D. N.u Cutting. General view of East end of Cutting. 5.4.97.

T.H.H.

CROWN WHARF, BOW CREEK

Unknown photographer, 1946. Ministry of Works Collection, H1/6

Like the rest of the country, at the end of the Second World War London was woefully short of housing, an inevitable result of the blitz. As early as 1941 the LCC's plan for reconstruction had foreseen the problem and designs for fast, cheap homes were commissioned, including a full-size prototype displayed outside the Tate Gallery in 1944. Also inevitably there were enormous shortages of building materials, so the solution was the prefabricated bungalow, intended to have a life of no more than ten years. Quickly and affectionately known as the 'prefab', some of these houses still exist. In order to help overcome the shortage of materials, Britain imported 5000 prefabs from Sweden. The first of these was assembled in January 1946 at Abbots Langley in Hertfordshire. The Ministry of Works adapted the all-timber components from a standard Swedish design. Cargoes of flat sections arrived at docks all over the country between September 1945 and March 1946. The lighter being unloaded here was moored at Crown Wharf on the west bank of Bow Creek.

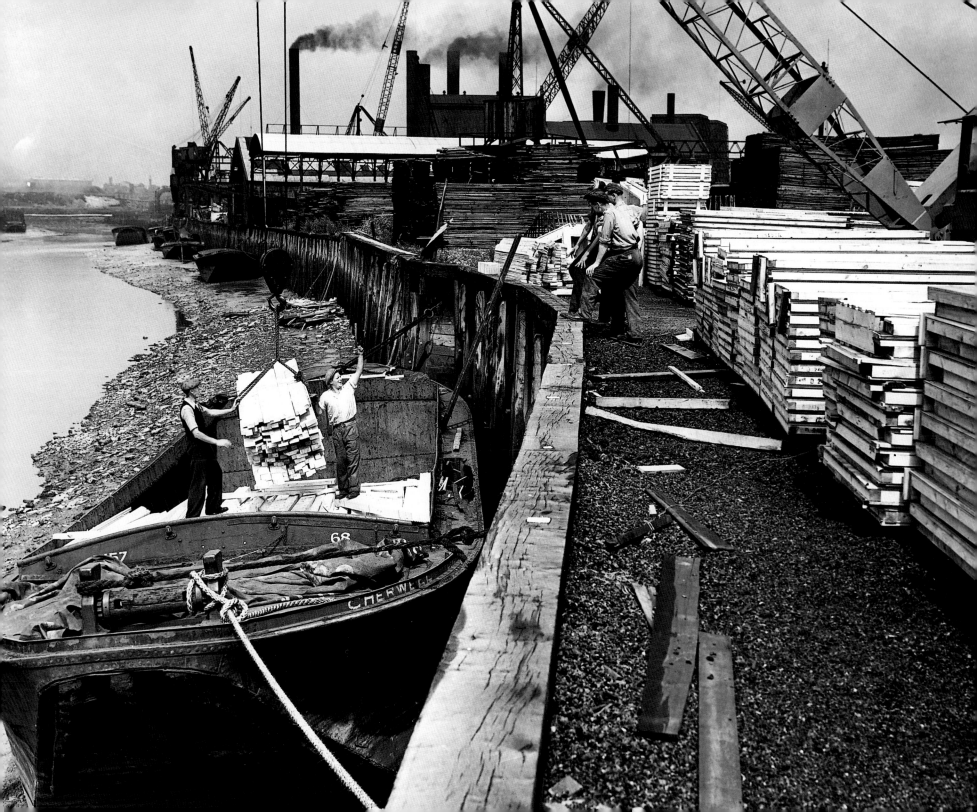

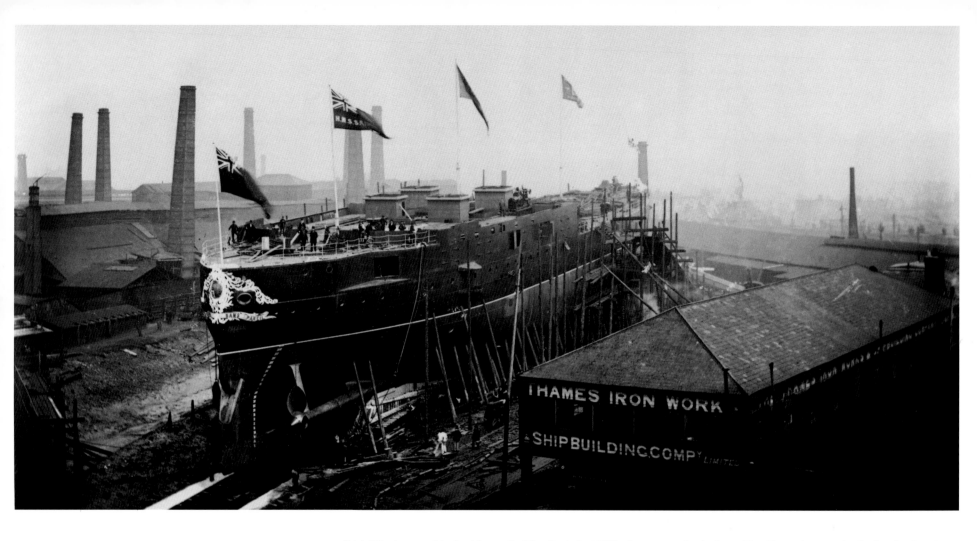

THAMES IRONWORKS, BOW CREEK

H. W. Taunt, 9 May 1887. CC56/1089 (above), CC56/1087 (right) and CC73/222 (below right)

Shipbuilding began on this site at the mouth of Bow Creek about 1838, when Ditchburn & Mare moved their business here from Deptford. Thomas Ditchburn retired in 1847 and Charles Mare continued as C. J. Mare & Company, which was to become the Thames Ironworks & Shipbuilding Company in 1857. This was the biggest and most important shipbuilder on the Thames. They specialised in building liners and warships. For example, the world's first iron battleship, HMS *Warrior* (now preserved at Portsmouth), was launched from here in December 1860. These photographs are from a series taken by Henry Taunt at the launch of HMS *Sans Pareil*, the second Victoria-class battleship laid down in April 1885. After service in the Mediterranean, she was put into reserve in 1904 and was eventually broken up in 1907. The

spectacle of a large ship taking to the water for the first time has always attracted crowds and this event on 9 May 1887 was no exception. Later in the nineteenth century, the Thames Ironworks diversified into building steam engines, electrical machinery and bridges. Components for the new Hammersmith Bridge were made here. The yard closed in 1912 after the completion of HMS *Thunderer* — the largest warship built on the river — and shipbuilding on the Thames essentially came to an end. However, an unlikely legacy continues to flourish in East London. When the Thames Ironworks closed, the works' football team changed its name to West Ham United. Their nickname — The Hammers — derived from the firm's emblem of crossed riveting hammers.

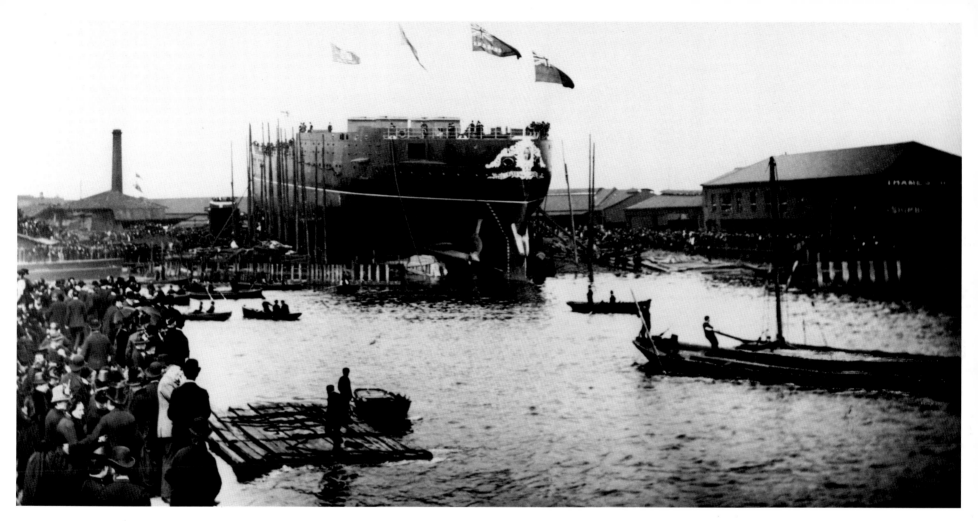
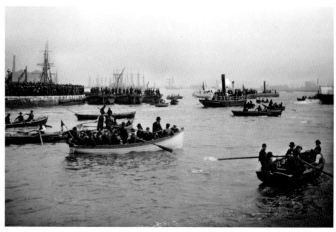

Plaistow Wharf was originally used for the storage of petrol, c.1860, but was acquired in 1881 by Abram Lyle, a shipowner from Greenock. He established Abram Lyle & Sons as sugar refiners in 1882 and began manufacturing at Plaistow Wharf in the following year, specialising soon after in the production of Golden Syrup. The amalgamation in 1921 of Lyle's company with Henry Tate & Sons created the largest sugar refiners in the world. Henry Tate had founded his company in Liverpool in 1869. Two years later, they established a base on the Thames at Silvertown, where they built a large refinery to begin the manufacture of sugar cubes in 1878. This continues as Thames Refinery, Tate & Lyle's major London site and London's last sugar-cane refinery. There was considerable expansion at Plaistow Wharf in the early part of the twentieth-century and the site was largely redeveloped in the late 1940s and early 1950s. The office block on North Woolwich Road was built in 1946–50 to a pre-war design. It displays the firm's trademark, familiar from the Golden Syrup tin. Refining here had ceased by 1970, but the site has continued in limited use for the production, packing and storage of Golden Syrup. The photograph shows tins awaiting recycling.

TATE & LYLE, PLAISTOW WHARF, SILVERTOWN

Derek Kendall, RCHME, 1994. BB94/18271

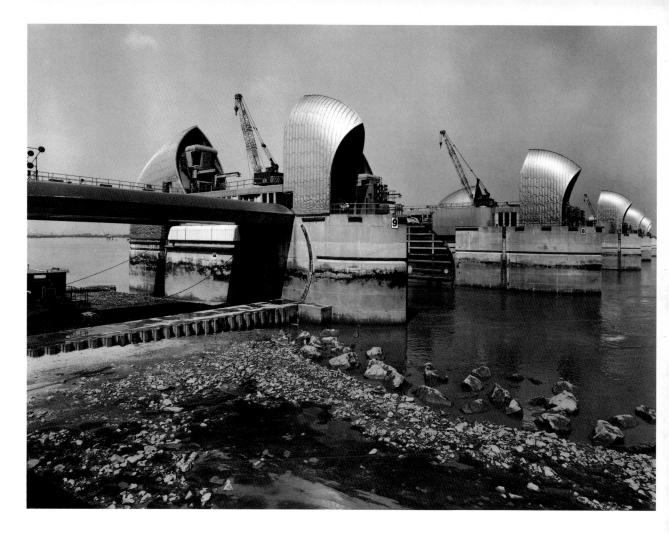

Following the last Ice Age, the south-east corner of England has been tilting downwards and London is settling on its bed of clay with the result that sea levels are rising. In 1928, 14 people drowned and 4500 were made homeless in floods in central London. The worst disaster was in January 1953 when 300 people died on the east coast and Thames estuary (2000 died in the Netherlands). An additional reason for this was that sea defences had fallen into disrepair during the war. A flood surge in 1965 saw the river reach the top of the embankments. Hence the barrier is of paramount importance in protecting the capital from flooding. It was constructed in 1974–82 as the key component of a massive flood-prevention scheme devised by the Greater London Council. The designs were by the engineers Rendel, Palmer & Tritton in col-laboration with the GLC Architects' Department, which was responsible for the Control Centre on the south bank. The stainless-steel hoods on the piers between the navigable openings house hydraulic machinery, which raises the 1300-ton gates off the river bed to form a solid wall in the event of a flood tide. Interestingly, the width of each of the four main gates is 200 feet (61 metres), the same as the opening at Tower Bridge. Notches cut in the concrete piers are at the same height as the top of the embankment walls upstream, thus giving a visual warning of the brimming river. It has been used more than 30 times since its official opening by Her Majesty The Queen on 8 May 1984. The barrier was designed to last for about 100 years, but the additional rise in sea level as a result of global warming may shorten its life span.

THE THAMES BARRIER, WOOLWICH REACH

Paul Barkshire, August 1988. 4234

WOOLWICH REACH

S. W. Rawlings, 1950s. A2

The stemheaded Thames sailing or spritsail barge is perhaps the best-known traditional sailing vessel. However, it is largely the product of nineteenth-century industrial expansion. Before the 1820s, when old London Bridge was taken down, cargoes coming up the Thames had to be offloaded in the Pool of London and transported around the obstruction caused by the bridge. The vessels that plied upstream were different from those operating in the Thames estuary and around the coastal waters of East Anglia and Kent. After the removal of the barrier, a new vessel was developed which could navigate the North Sea and Channel coasts as well as the tidal reaches of the Thames. Thus the Thames barge, which adopted the best features of several other types, came into being. In 1885, there were more than 2000 sailing barges registered and in 1930 there were still about 1000, but none was built after that date. Fewer than 200 survived into the 1950s. The last sailing barge to carry a commercial cargo was The Cambria in 1970 and she is now part of the Maritime Trust collection on display in St Katherine's Dock. Today preserved examples are sailed for pleasure and raced in order to keep alive the old skills.

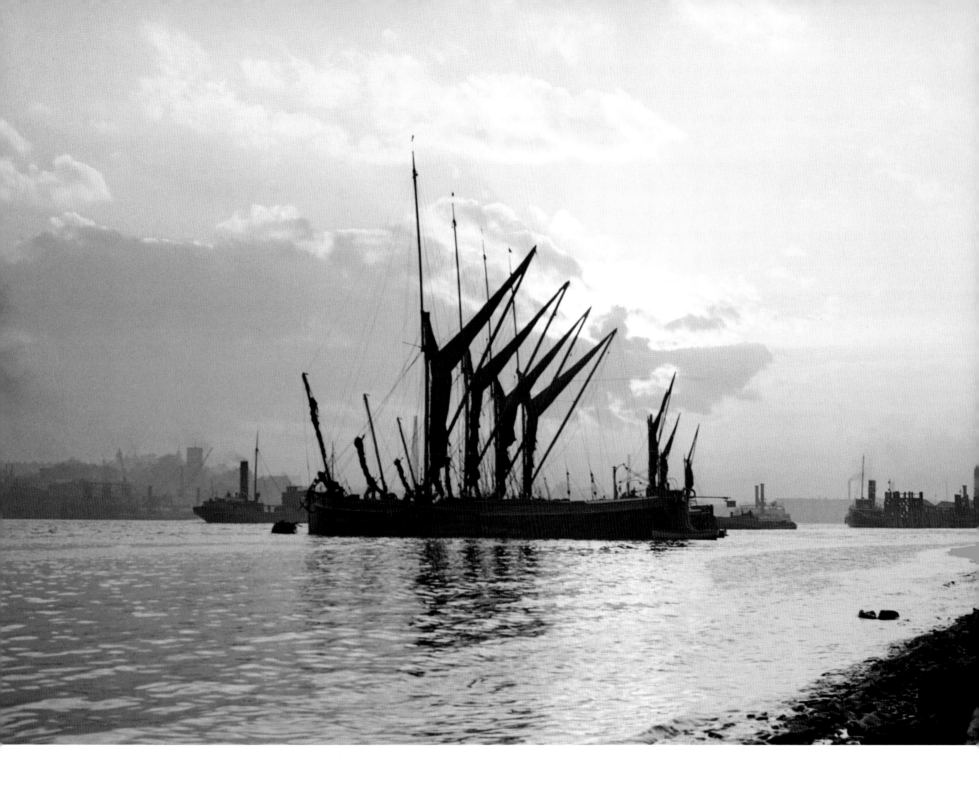

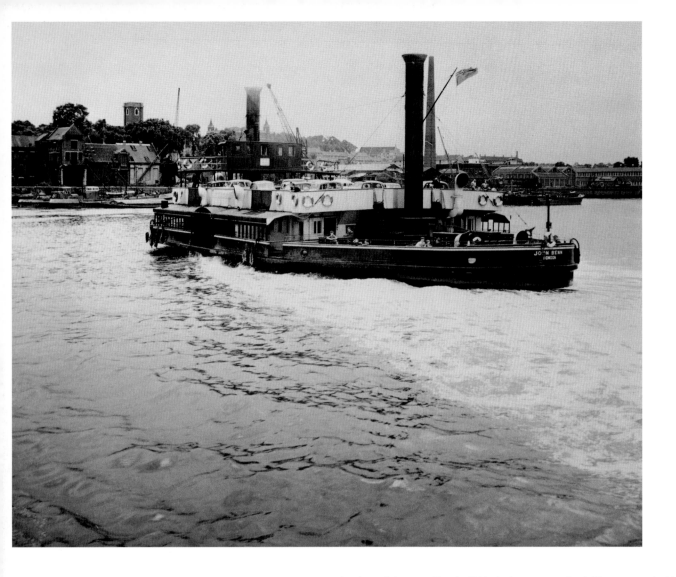

WOOLWICH FERRY

Unknown photographer, 1950s. BB99/10001

Londoners living east of London Bridge had no access to free bridges across the river, so an Act of 1885 empowered the Metropolitan Board of Works (forerunner of the London County Council) to operate a free ferry across the Thames at Woolwich. Two boats, the *Gordon* and the *Duncan*, provided the service when it was inaugurated on 23 March 1889 by the fifth Earl of Rosebery, Chairman of the LCC and later Prime Minister. A third boat, the *Hutton*, was added in 1893. These coke-fired paddle steamers maintained the service until 1922. In that year the *Squires* was added and a new *Gordon* arrived the following year. The last of the paddle boats, the *John Benn* (seen in this photograph) and the *Will Crooks*, were introduced in 1930. These four boats were built at Cowes on the Isle of Wight and served throughout the war. By the 1960s, greatly increased traffic waiting for the ferry was causing congestion on both banks. Three new diesel boats – the *Ernest Bevin*, the *John Burns* and the *James Newman* (all named after politicians with Woolwich or Thames connections) – built in Dundee came into service in 1963, when the four steam paddle-wheelers were sold to be broken up for scrap. The terminals were rebuilt in 1964–6 by Husband & Co. to accommodate larger lorries.

This was the first of the large Victorian docks, constructed in 1850–5. Its promoters were railway contractors and the engineer was G. P. Bidder, better known for railway construction. The dock was far larger than its predecessors with an entrance lock twice as long and wide as elsewhere in the London system. It was served by its own railway sidings connected to the main line and was provided with hydraulic power from the outset. The Victoria Dock was opened by Prince Albert in 1855 and the title 'Royal' was bestowed by Queen Victoria in 1880. From 1935 there was extensive reconstruction lasting until after the outbreak of war. The ship seen here unloading was the *Beaverglen*, the second of a class of four ships built for the Canadian Pacific line. She was launched on 10 December 1945 from Lithgows' yard at Port Glasgow. Together with her sister ships – *Beaverdell*, *Beaverlake* and *Beavercove* – she was designed for the route from the Royal Docks to Montreal. The *Beaverglen* was sold by Canadian Pacific in 1963 and after another change of ownership and a second change of name she ran aground off the Hook of Holland and was broken up where she lay.

ROYAL VICTORIA DOCK

S. W. Rawlings, 1950s. A100

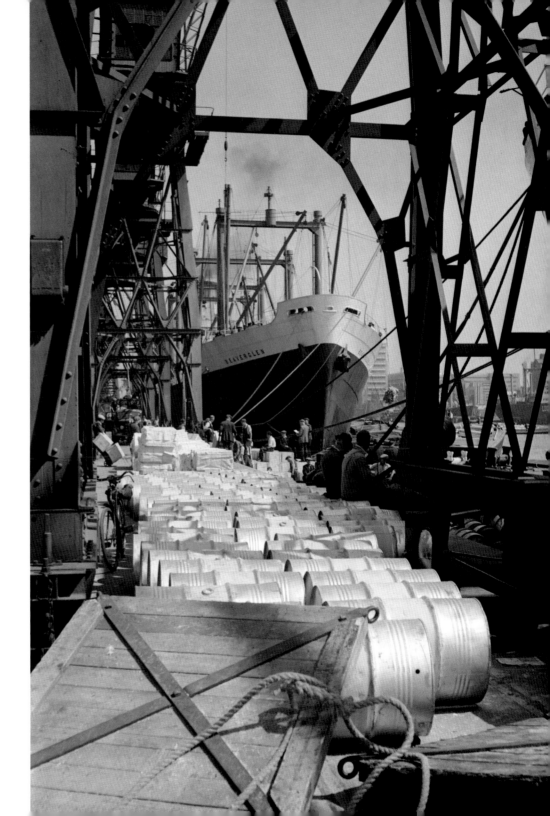

EMPIRE MILL, ROYAL VICTORIA DOCK

Derek Kendall, RCHME, May 1990. BB90/1536

Grain handling was an important part of the business of the Royal Victoria Dock from its opening in 1855 until it closed in 1981. Illustrated here is the Empire Mill, one of three huge flour mills that stood on the south quay, west of the Pontoon Dock (the original Victoria Graving Dock, part of G. P. Bidder's original design – see page 181). With the exception of Spillers' Millennium Mills, the others – Premier Mill and Empire Mills, both belonging to J. Rank Ltd – ceased operation in 1981, became increasingly derelict and were largely demolished in the early 1990s. Empire Mills were built by Associated London Flour Millers Ltd in the 1930s, replacing and perhaps incorporating parts of earlier mills dating from the 1900s. They were enlarged in 1957–8. To the left in this photograph, the pneumatic grain elevators constructed on a dolphin or floating jetty in the dock may be seen. Originally there were seven elevators, but only three survived in 1990 and these, too, have now gone. However, one of the large air pumps has been retained as a museum feature alongside some of the original cranes, which have been restored to ornament the quayside.

An Act to build a new dock was obtained in 1875. Originally it was designed to provide a much larger entrance to the Victoria Dock from the east and it was only during construction that the decision was taken to install wharves on both sides. It was the first dock in London to be lit by electricity. The engineer was Sir Alexander Rendel and the contractors were Lucas and Aird. On 24 June 1880, the opening ceremony was performed on behalf of Queen Victoria by the Duke of Connaught. Initially the Royal Albert Dock was used for transit and from the time of the First World War it became the centre for the frozen meat trade. In 1928, improved mechanical handling equipment, including the self-propelled floating crane (seen in this photograph), which was nicknamed 'The London Mammoth', began to be installed in the docks. The buildings flanking the Royal Albert Dock were swept away in the 1980s.

ROYAL ALBERT DOCK

S. W. Rawlings, 1950s. A547

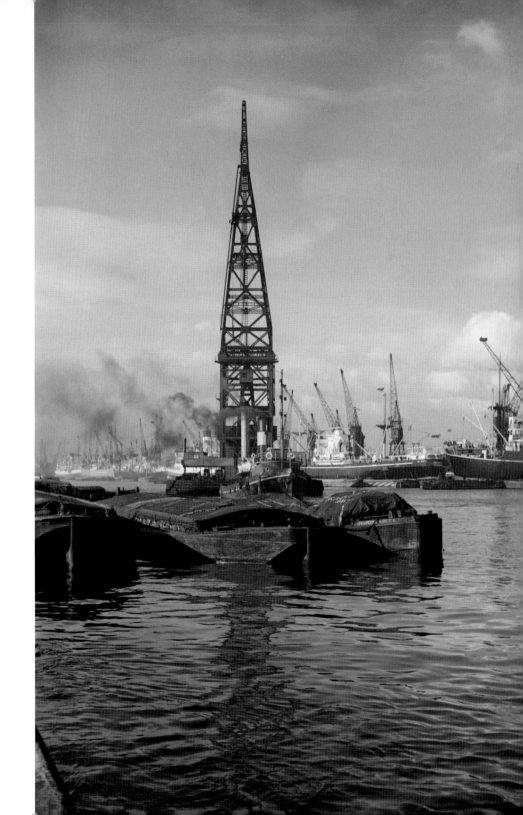

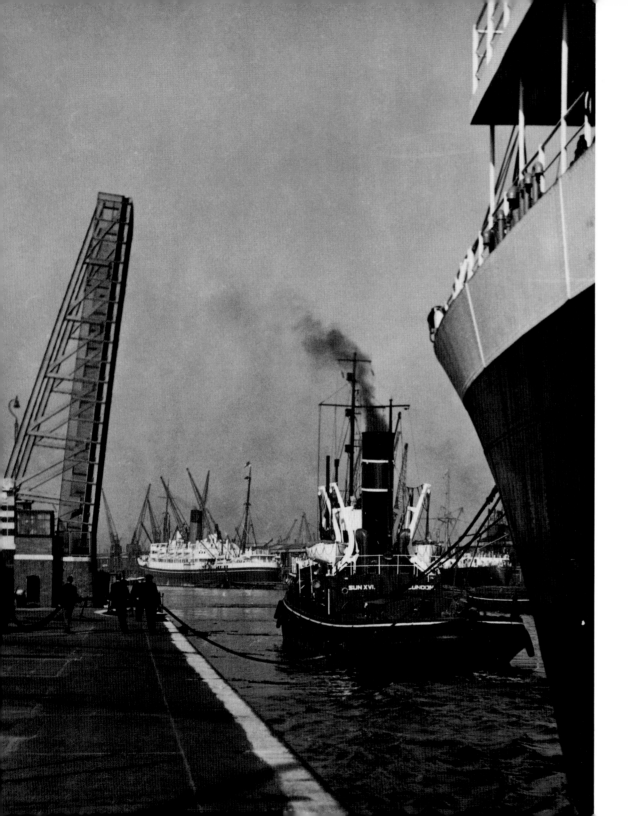

This was the third of the group of docks that became known collectively as the Royal Docks. In 1901 an Act of Parliament was passed to permit the construction of two docks, one on each side of the Royal Albert Dock. The Port of London Authority took over the scheme at its formation in 1909 and work began in 1912 on the first of the docks to the designs of Sir Frederick Palmer, the PLA's first chief engineer. It was completed by Sir Cyril Kirkpatrick, then chief engineer, and opened on 8 July 1921 by King George V. The King George V Dock was linked to the Royal Albert Dock, which lay to the north, and it was also provided with its own entrance lock on to Gallions Reach. This was sufficiently large to permit the passage into the dock in August 1939 of the Cunard liner *Mauretania*, an event that attracted huge crowds. In this photograph the steam tug *Sun XVI*, built in 1946, is seen taking a cargo vessel through the entrance lock. The planned second dock north of the Royal Albert Dock was never built and the land remained vacant, used mainly for allotments and sports fields, until the 1980s. Trade declined as larger container ships and bulk carriers came into use, which were unable to navigate the river or enter the locks, and eventually the Royal Docks closed in 1981.

KING GEORGE V DOCK

S. W. Rawlings, 1950s. A189

Perhaps the most telling illustration of changing times is this photograph of the control tower of the London City Airport, which looks out on the runway built over the site of the quays between the Royal Albert Dock and the King George V Dock. Plans for the airport, aimed at business travellers to Europe, were formulated in 1982 and permission was granted in 1986. Work began in April of that year to designs by the architects Seifert Ltd and the contractors were John Mowlem and Company. The original King George V Dock office by Sir Edwin Cooper, 1931, was incorporated as the airport transit office. The first commercial flights took place in October 1987 and in November the airport was opened officially by Her Majesty The Queen. In 1991–2 the runway was extended to permit the use of small jets and the extension was opened by Diana, Princess of Wales.

LONDON CITY AIRPORT

Sid Barker, RCHME, May 1998. BB98/12645

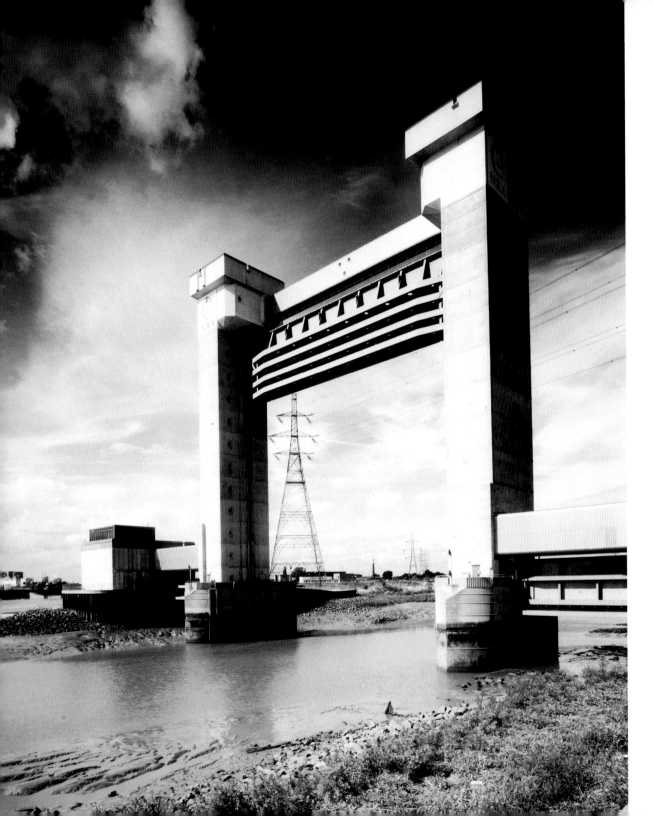

The huge and impressive Thames Barrier spanning Woolwich Reach was only part of the flood prevention programme brought to completion in the 1980s by the Greater London Council. In order for the main barrage to be effective, the coastal defences downstream had to be raised and the tributaries to the Thames each provided with a barrier like this imposing example spanning Barking Creek Mouth. The massive piers supporting drop gates were designed by the engineers Sir Bruce White, Wolfe Barry & Partners. Barking Creek is the name given to the tidal stretch of the river Roding, which flows into the Thames at the junction of Gallions Reach and Barking Reach. Flooding was commonplace in London's history, but the realisation that the Thames basin had been sinking steadily – estimated at some 15 feet (4.6 metres) since Roman times – led to schemes for the construction of flood gates straddling the river as early as the 1850s. In 1904 there was a proposal for gates at Gravesend, revived in 1934 with the addition of a road deck, which would have been by far the lowest bridging point on the river. The principal reason for the latest scheme was to protect the capital from inundation, but elsewhere the policy of building sea walls has been questioned. Such walls surrounding the Essex marshes were constructed to reclaim land rather than as flood protection and, when food production is high, there is less need for farm land. At the same time, salt marshes are cheaper and better for wildlife. This is not a popular view with farmers, as it is also true that more than 90 per cent of London's grazing marshes have been lost to development during the twentieth century.

FLOOD BARRIER, BARKING CREEK

Derek Kendall, RCHME, September 1994. BB94/18250

Thamesmead was planned in 1965–6 as a new town on the Plumstead Marshes between Woolwich and Erith. It was an enormously ambitious project devised by the Greater London Council Architects' Department under Hubert Bennett. The GLC broke with tradition and designed Thamesmead to be system-built for speed of construction and in 1968 opened a factory on site to produce concrete structural units. Local by-laws in force before the river defences were built required that all dwellings had to be raised off the ground. The result was that housing and shops, linked by footpaths and cycle routes, were laid out on a first-floor podium, with roads and car parks beneath. The problem of marsh drainage was solved by a network of lakes and canals, controlled by a pumping station at Thamesmere. These water features have given Thamesmead its distinctive character. As part of the flood defences programme, including the Barrier, the GLC raised the river-bank throughout the area. The high-level Thameside Walk, seen here, runs along the top of the bank overlooking Barking Reach. The shelters in this view are not boats cut in half, but ferro-cement replicas, known as 'heritage icons' – a term of dubious etymology.

THAMESMEAD
Derek Kendall, RCHME, November 1993. BB93/35092

FORD MOTOR WORKS, DAGENHAM

S. W. Rawlings, 1950s. A582

In 1911 the Ford Motor Company of America opened its first manufacturing base in England at Trafford Park in Manchester. In 1924 Ford purchased a large site in Dagenham. Here its main factory was constructed in 1929–31 to the designs of Charles Heathcote & Sons and work was transferred from Manchester in 1931. Originally, Ford had assembled Anglicised versions of American models, principally the 'T' and the 'A', but with its new plant Ford of Britain was able to produce models designed specifically for the British and Empire markets. The Dagenham estate covered 600 acres (240 hectares) and Ford leased land superfluous to its own needs to other companies attracted by the services and facilities it could provide. Among the attractions were a power station, blast furnace and railway sidings with access to the main line. The company also constructed a huge reinforced-concrete jetty, an early use of the material for this purpose, which provided berthing for ships up to 10,000 tons. After 70 years, car production at Dagenham came to an end when the last Fiesta rolled off the production line on 20 February 2002.

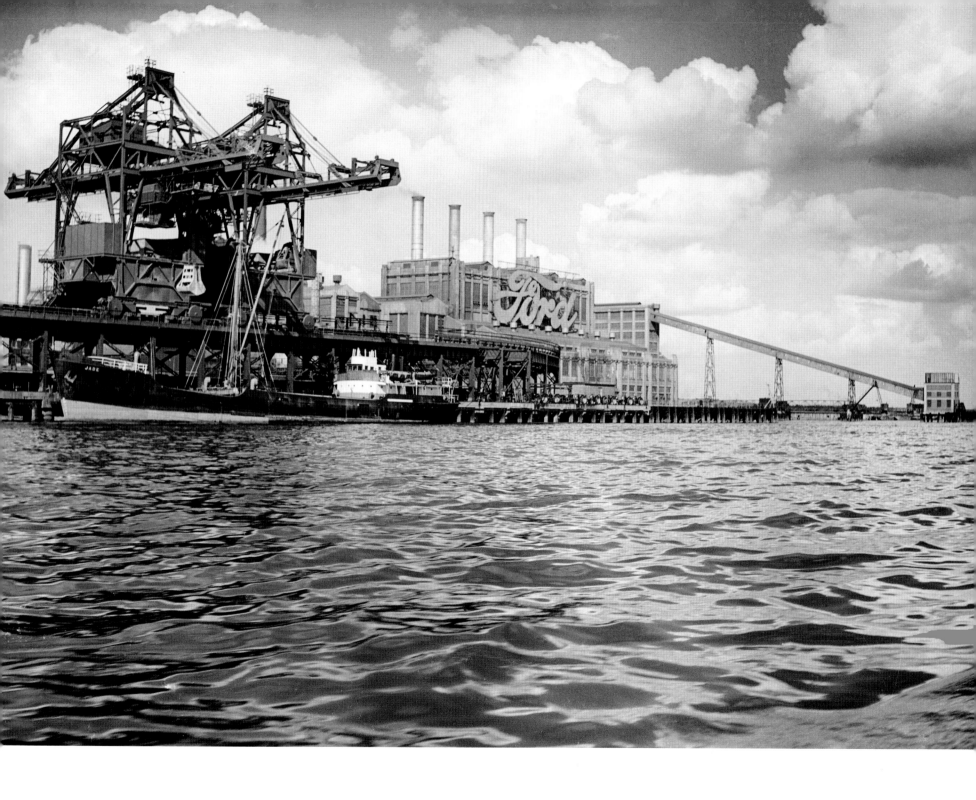

This view from the Essex bank at low water looking upstream to Halfway Reach shows the foreshore protection near Frog Island jetty. Inland (right) are the Hornchurch Marshes and in the distance may be seen the Ford Motor Works at Dagenham. The stretches of the Thames bear names that may refer to settlements along the river or are self-explanatory, such as Halfway Reach. This extends from Cross Ness at the end of Barking Reach to Jenningtree Point where Erith Reach begins. Both these markers are located on the southern shore. However, until the nineteenth century, Halfway Reach was known as the Guzzard — a name of unknown origin, although it has been suggested that it may have been a corruption of Buzards Bush. This reach name was recorded in the late seventeenth century, but its location is not known.

HALFWAY REACH

Derek Kendall, RCHME, September 1994. AA94/5326

Erith Reach is seen in this view taken from the Essex shore not far downstream from Frog Island jetty, looking south to Erith on the far bank. In the foreground are some lighters built of ferro-cement (reinforced concrete). Swim-headed lighters were constructed of concrete during the Second World War, owing to a shortage of more traditional materials such as timber or iron. However, they were particularly suitable for the transport of fuel and munitions. Many were abandoned on the estuary foreshore after the war. Alongside Erith Reach are the marshes of Rainham, Aveley and Wennington. In the mid nineteenth century they were described as 'low and uninviting and unhealthy', so providing ideal, secluded locations for army rifle ranges. The area was designated as a Site of Special Scientific Interest (SSSI) in 1986, as the marshes were attractive not only to flocks of wildfowl and waders but also to rare insects and surprisingly had become a refuge for water voles, which have declined in most parts of Britain. When the Ministry of Defence gave up their ranges in the late 1990s, the marshes came under threat of commercial development. However, in 2000 Rainham and Wennington Marshes were acquired by the Royal Society for the Protection of Birds as a permanent nature reserve. Aveley Marshes, currently a landfill site, are to be turned into a country park by their owners, the Port of London Authority. Therefore, this whole stretch of riverside is destined to become an attraction for visitors and a precious haven for wildlife within a dozen miles of the City of London.

ERITH REACH
Derek Kendall, RCHME, September 1994. AA94/5327

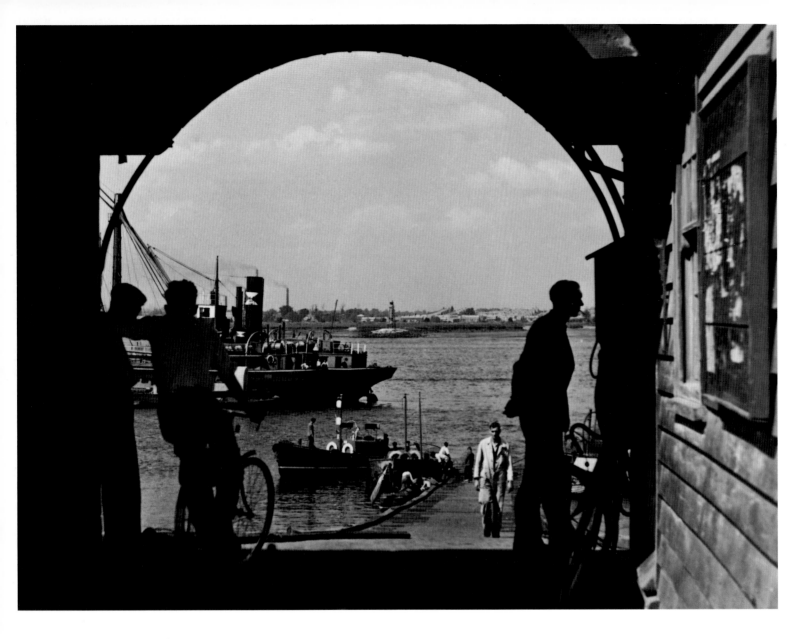

GREENHITHE

S. W. Rawlings, 1950s. A157

The word hithe is of ancient origin. It refers to a landing-place on a river and has given rise to numerous place names on the Thames (for example Queen-hithe). The medieval village at Greenhithe grew up alongside Ingress Abbey belonging to nearby Dartford Priory. In 1832–3 the house was rebuilt in neo-Tudor style by Charles Moreing and is supposed to have been constructed of stone from old London Bridge, which was being demolished at the time.

Ingress Abbey became part of the Thames Nautical Training College with grounds running down to the river where HMS *Worcester* was moored. As at Gravesend downstream, this area was exploited for chalk and the settlement at Greenhithe was overwhelmed by cement works in the nineteenth century. The cyclists seen here in Stanley Rawlings' photograph were waiting for the ferry from Thurrock on the Essex shore.

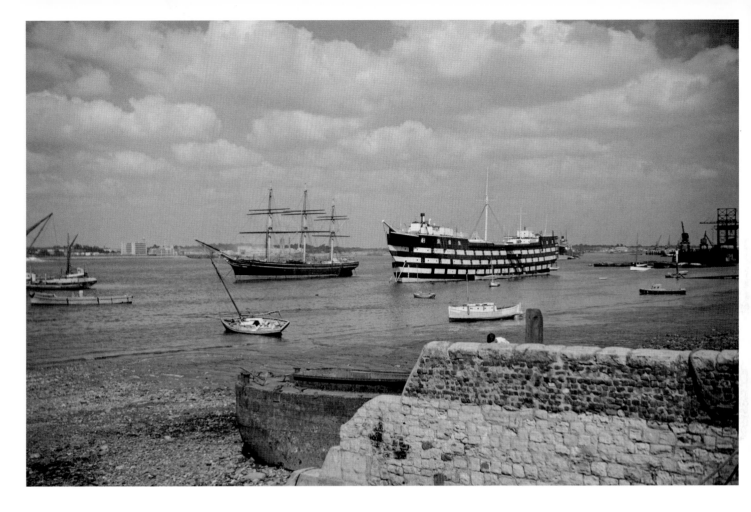

The *Cutty Sark* is seen here (left) off Greenhithe before being found a permanent berth at Greenwich. She is moored alongside HMS *Worcester*, the floating annexe of the Thames Nautical Training College, set up in 1862 to produce officers for the Merchant Navy. The Admiralty was prevailed upon to lend a frigate, HMS *Worcester*, which was converted at Blackwall. Inaugurated with just 14 cadets, the scheme proved extremely successful and the old frigate rapidly became inadequate for the numbers being attracted to the College. The Admiralty exchanged the *Worcester* for a battleship, the *Frederick William*, which took the frigate's name. The second HMS *Worcester* illustrated the great change in Royal Navy warships in the middle of the nineteenth century. She was laid down at Portsmouth in 1833 as a sailing battleship and was to have been called the *Royal Sovereign*. Six years later, her name was changed to the *Royal Frederick*, after one of the Hanoverian princes. She remained unfinished for 20 years, during which time she was altered to take auxiliary screw engines, and renamed *Frederick William*, in honour of the Crown Prince of Prussia on the day he married the Princess Royal, 25 January 1858. The ageing battleship was launched at last on 24 March 1860. However, in that same year HMS *Warrior* was launched, rendering redundant all wooden battleships. The *Frederick William* saw service as a guardship in the river Shannon, but was soon put into reserve at Portsmouth, where she stayed until 1876, when she was lent to the Thames Nautical Training College. There she remained until 1948, when she was sold. She foundered in the Thames on 30 August 1948, but was raised in May 1953 to be broken up at Grays on the Essex shore.

THE CUTTY SARK AND HMS WORCESTER, GREENHITHE

S. W. Rawlings, 1940s. A159

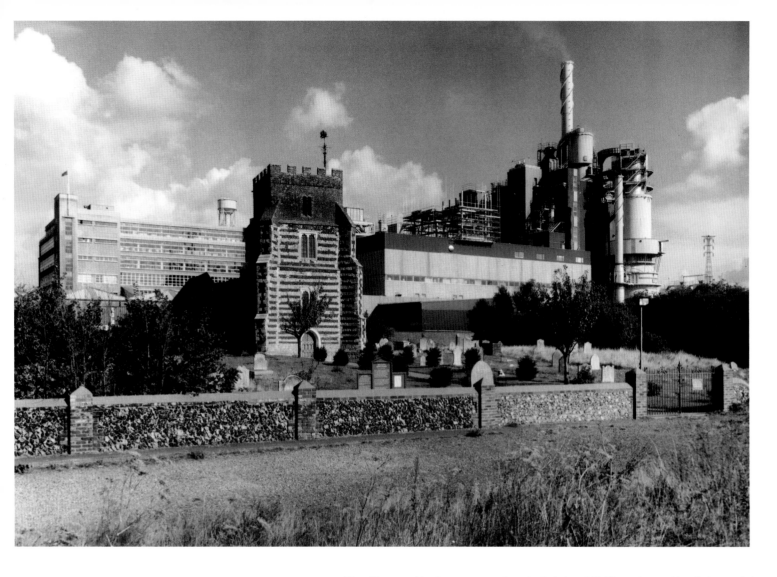

ST CLEMENT'S CHURCH, WEST THURROCK

Derek Kendall, RCHME, September 1994. BB94/18257

Many Thames guides have commented on the isolation of St Clement's church near the riverbank overlooking the reach to which it has given its name. In 1954 the *Buildings of England* entry began thus: 'The most remarkable thing about the church is its position, lovely and rather forlorn in the marshes'. A century earlier only the more archaic language differentiates this description: 'surrounded by trees, but no house is near it, and its isolation is very striking when approached over the dreary marsh land by which it is environed'. St Clement's church was built before the Conquest supposedly for the benefit of the fishermen of St Clement's Reach. Later it watched over a ferry used by pilgrims on their way to Canterbury. The foundations of an earlier church have been excavated beneath the present building, but the oldest features discernible above ground date from the twelfth century. The handsome west tower dates from the fifteenth century. Even more remarkable than its former isolation is its surreal position today, almost overwhelmed by the huge modern factory of Proctor & Gamble immediately adjacent downstream. The original Hedley's soap factory was built in 1939–40 to take advantage of readily available building land and a riverside site for the transport of raw materials and finished products.

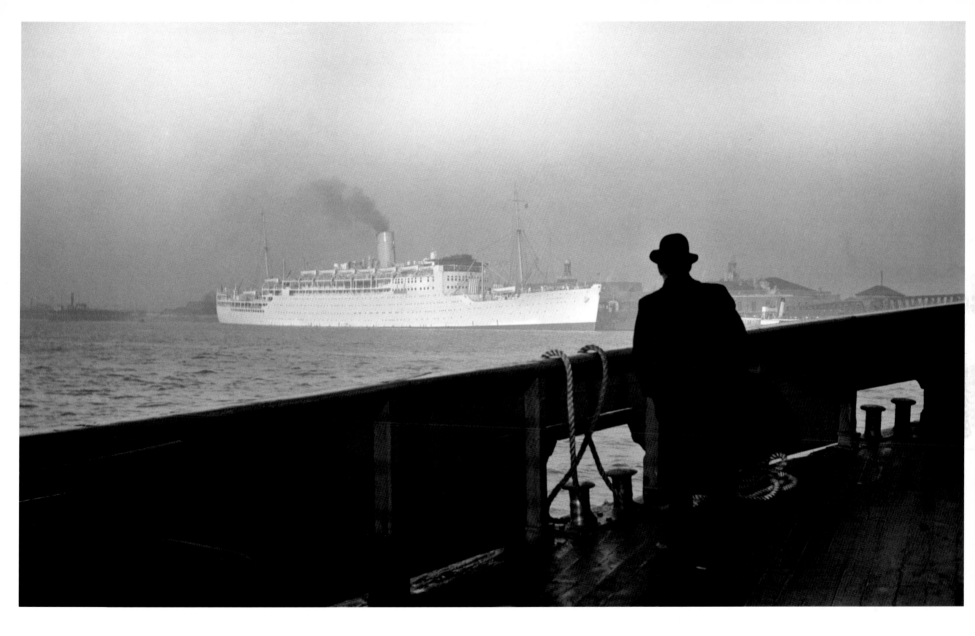

The photographer captioned this picture 'misty morning at Tilbury', which may not seem as romantic as Gibraltar, Cape Town or Hong Kong, but evokes something of the feeling for liner travel that was paramount in the 1930s and which soon faded in the post-war years. The P & O liner *Strathaird*, seen here, was built by Vickers-Armstrong at Barrow-in-Furness and launched on 18 July 1931. She was requisitioned as a troopship in 1939 and returned to her owners at the end of the war. In 1946–7, she was reconditioned by the original builders and re-entered commercial service with one funnel (formerly there had been three). Throughout the post-war period she was employed on the London to Australia run, although she was refitted as a one-class ship in 1954. The *Strathaird* was sold in 1961 to be broken up at Hong Kong.

TILBURY

S. W. Rawlings, 1950s. A548

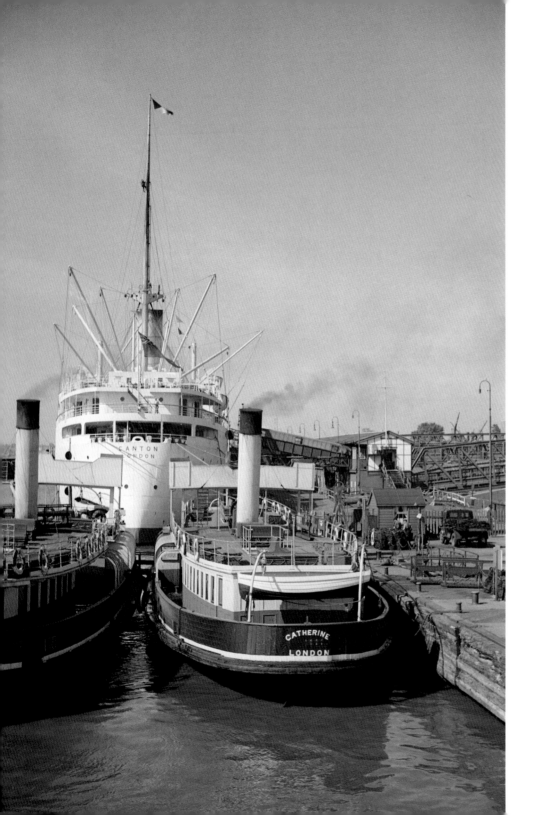

Tilbury was an ancient settlement on the Essex shore guarding the ferry to Gravesend. It is conceivable that it could have become a spa rather than a port, as in 1724 spring waters with supposed medicinal properties were discovered. 'Tilbury Water' became so popular that for a time from 1779 it was exported to the East and West Indies. The initial development of the port in the 1880s was slow as it was far from central London, but after the creation of the Port of London Authority there was greater investment and an improvement in rail links. The passenger landing-stage, seen here, was built in conjunction with the Riverside Station of the London, Midland & Scottish Railway and opened in 1930. In 1940 it was badly damaged by bombing. Both before and after the Second World War, the nearby Tilbury Hotel and its terrace with a commanding view of the river were popular vantage points from which to view the constant arrivals and departures of passenger liners from all over the world. The P & O liner *Canton*, seen here, was launched in 1938. With the huge increase in size of cargo vessels, the docks upstream have all closed, but following the opening of the first container berth in 1968 Tilbury has flourished and remains as the sole survivor of London's docks. In recognition of this new reality, the PLA transferred its headquarters from Tower Hill to Tilbury in 1970.

TILBURY FERRY

S. W. Rawlings, 1950s. A466

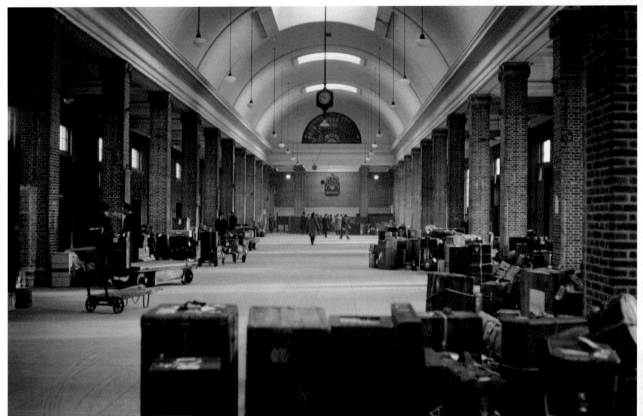

Tilbury Docks, 26 miles (42 kilometres) downstream from the Pool of London, were built by the East & West India Dock Company to the designs of their superintending engineer Augustus Manning. They opened on 17 April 1886 and were the last of the great private enterprise dock schemes. There was little further development until they were taken over by the Port of London Authority. A deep-water jetty opened in 1921 and a new entrance lock and dry dock followed in 1929. The passenger landing-stage and grand Neo-Classical baggage hall (seen here), designed by Sir Edwin Cooper, was opened by Ramsay MacDonald, then Prime Minister, on 16 May 1930. The new terminal was served by the LMS Riverside Station, built at the same time, and the passenger ferry to Gravesend also was operated by the LMS. In 1957 the PLA opened a new Ocean Cargo and Passenger Terminal. Traditionally Tilbury had handled London's ocean-going liners, but from a peak in the 1930s the number of ships visiting the port has declined with the advent of air travel. The emphasis today is on the inclusive package cruise, which brings sight-seeing passengers as close as possible to central London.

TILBURY PASSENGER TERMINAL

S. W. Rawlings, 1950s. A285 and A287

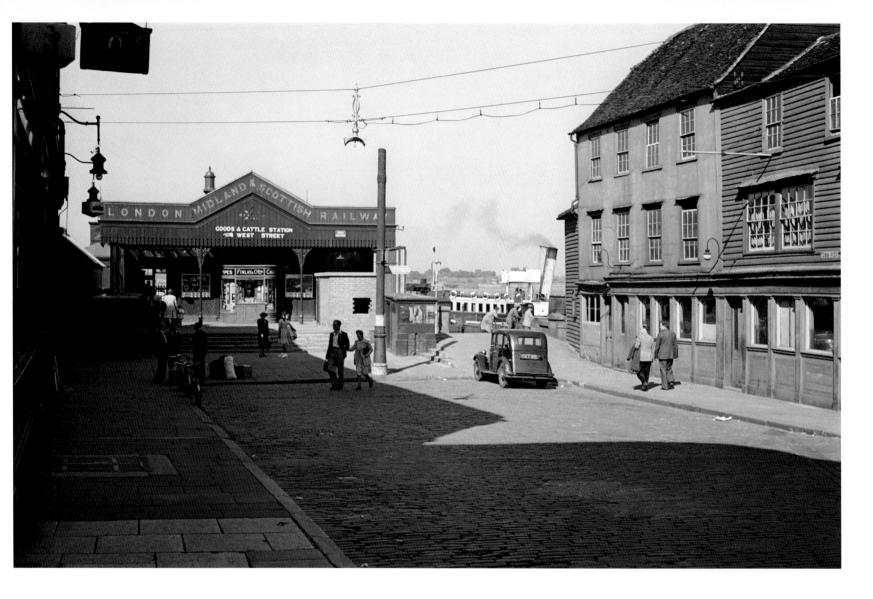

TOWN PIER, GRAVESEND

S. W. Rawlings, 1940s. A479

Gravesend occupies the first high ground upstream from the mouth of the Thames and as a result has been important as a landing place, port and fishing community. The settlement grew up around the time of the Conquest, although probably it was the site of a ferry as far back as Roman times. In 1727, a disastrous fire destroyed much of the town, including the parish church. This photograph shows the foot of High Street and the Tilbury ferry. To the right is the Three Daws inn: first licensed in the sixteenth century, the building seen here dates from after the fire. A fanciful local tale maintains that it was built by unemployed ships' carpenters. The Town Pier (left) was built to serve the ferries from London, 26 miles (42 kilometres) upstream, and Tilbury on the Essex shore. There was fierce opposition from local watermen and a riot, which took place on 22 June 1833, is depicted in a modern mural by the entrance to the pier. This is the earliest surviving iron pier in the world, built in 1833–4 to the designs of William Tierney Clark. The superstructure was added in 1854 by the London, Tilbury & Southend Railway Company. The Tilbury ferry no longer arrives here, but at a passenger pier just upstream.

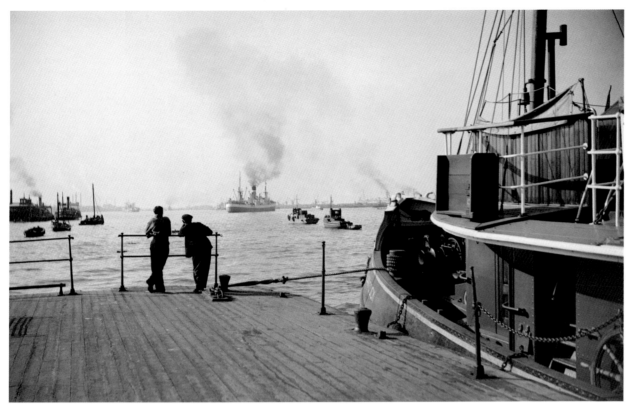

Gravesend prospered in the 1830s with the introduction of regular steamboat services to London and the opening of the railway. A new public garden was laid out by John Claudius Loudon downstream from the Town Pier and led to the construction of the Royal Terrace Pier. This was designed by John Baldry Redman and built in 1844 by Fox & Henderson, later the contractors for the Crystal Palace. Princess (later Queen) Alexandra landed here on 7 March 1863 on her arrival in England to marry the Prince of Wales. For a time, Gravesend was popular with visitors on excursions from London and a major attraction was Rosherville Gardens, the only serious Victorian rival to the eighteenth-century pleasure grounds. Jeremiah Rosher, a local chalk merchant, laid out the gardens in his worked-out chalk pits on the riverside to include a theatre, zoo, botanical garden and fun fair. However, the Royal Terrace Pier failed to prosper and in 1893 it was sold by the Official Receiver to Trinity House as the headquarters for the river pilot service. In 1894 the pier was restored by E. A. & H. Sandford. The first of S. W. Rawlings' photographs here was taken looking upstream from the Royal Terrace Pier and is a vivid illustration of shipping on Gravesend Reach. The other photograph was taken from the Town Pier and shows fishing boats around the Royal Terrace Pier.

ROYAL TERRACE PIER

S. W. Rawlings, 1950s. AA0001261 (above, left) and AZ19 (above)

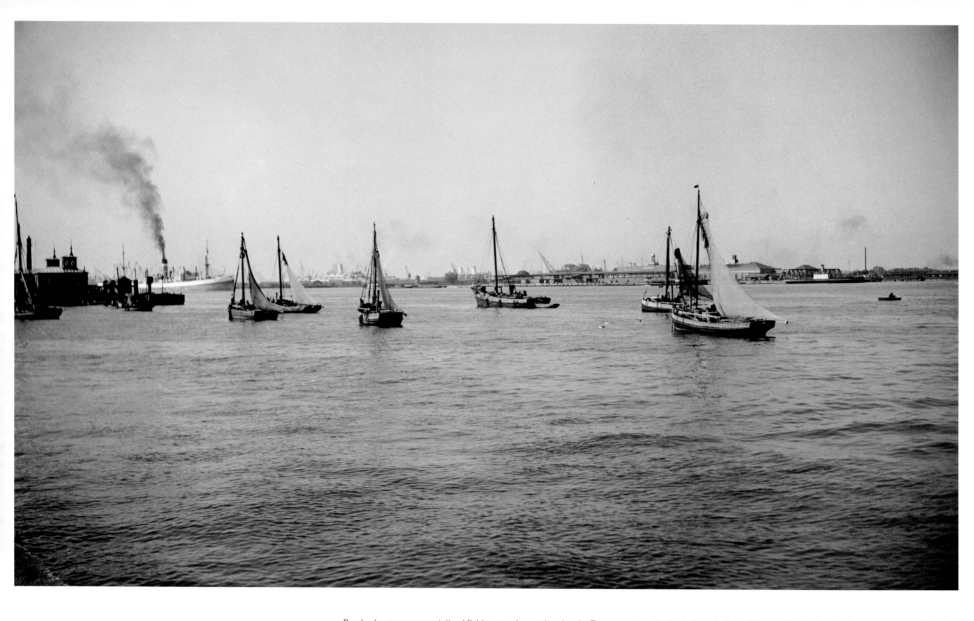

BAWLEY BOATS, GRAVESEND

S. W. Rawlings, 1950s. A200

Bawley boats were specialised fishing smacks restricted to the Thames estuary and the nearby coasts of Essex and Kent. They were employed shrimping in the summer and in the winter they went stow boating – using a stow net for stationary fishing as opposed to trawling. From about the 1860s the Gravesend builders were producing boats which did not work much below Lower Hope Reach, although increasing pollution in the Thames had driven the fishermen further out into the estuary. The Gravesend bawley had a rela-tively shallow draft for daily trawling in the shoal waters and a stable hull to minimise spillage from the copper. A notable feature of the boat, which had appeared first in the 1850s, was a boiler in which to cook the shrimps before landing. These boats were moored in an inlet known as Bawley Bay between the Town Pier and the Royal Terrace Pier. A small fleet of bawleys continued shrimping from Gravesend until the 1950s, when they were photographed by S. W. Rawlings.

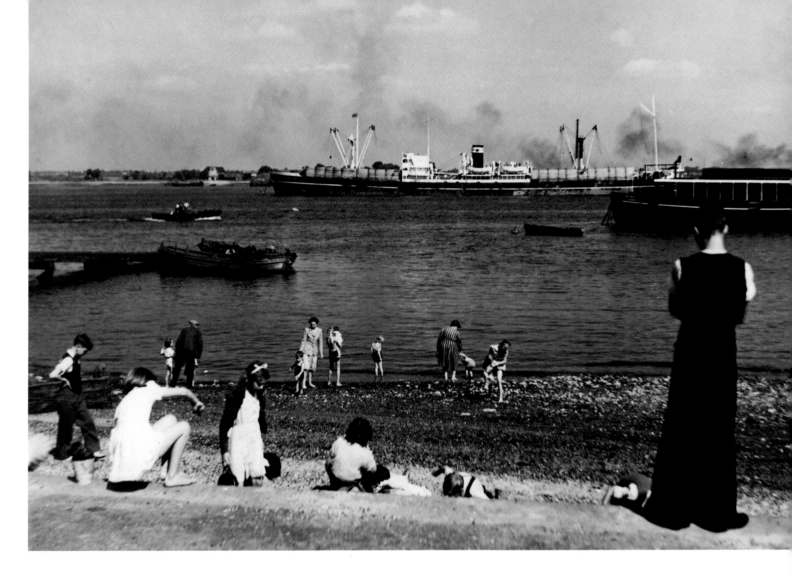

Gravesend's long association with the sea is commemorated by a number of local institutions. For example, the lad on the right in this photograph appears to be from the National Sea Training School. This was established in 1918 in the former Waterside Mission in Royal Pier Road adjacent to Bawley Bay. A new school east of the town was built in 1963–6 and the original building was demolished in 1975. However, St Andrew's church survives. This was built as the mission chapel in 1870–1 to designs by the eminent Victorian architect George Edmund Street. The chapel was dedicated to the memory of Rear-Admiral Sir Francis Beaufort (1774–1857), hydrographer to the Royal Navy for 26 years and inventor of the wind scale, which bears his name, as funds for the building were provided by his daughter. The church contains many memorials to mariners and commemorates the numerous emigrant ships that left from here for Australia. It closed in 1971, but has been restored as an arts centre. A curious maritime connection with the foreshore where the children are playing in this photograph was the result of an accident. In 1886 a schooner named *The Spring* ran ashore laden with sacks of cement. These solidified and formed a promenade, which remained visible until 1987 when the sea wall was rebuilt.

GRAVESEND REACH

S. W. Rawlings, 1950s. A149

201

S. W. Rawlings' photograph shows the transfer of a pilot off Gravesend. A launch from the pilot station on Royal Terrace Pier would meet vessels in Gravesend Reach and while still underway take off the sea pilot and put on board the river pilot. His job would be to guide the ship up the difficult meandering course of the Thames to her berth. For nearly five centuries, responsibility for training and licensing pilots rested with the Corporation of Trinity House. This venerable institution may even antedate the Conquest, but its records begin with its incorporation in 1514. At that time it was an association or guild of mariners of a semi-religious, charitable nature with a hall and almshouses at Deptford. On 20 May 1514 Henry VIII granted their royal charter with powers to regulate pilotage. Responsibility for sea-marks and lighthouses was conferred by Act of Parliament in 1566. In 1604 James I gave the Corporation rights concerning the compulsory pilotage of shipping and the exclusive right to license pilots on the Thames. Trinity House moved from Deptford to Stepney in 1670 and later had its hall off Lower Thames Street. Their present headquarters stand next to the former PLA building looking down on the Pool of London. This fine classical building was designed by Samuel Wyatt and dates from 1793–6. In 1959, the Port of London Authority established the Thames Navigation Service, with its operations room next to the pilot station on Royal Terrace Pier. As a result of the Pilotage Act of 1987, responsibility for Thames river pilots was transferred from Trinity House to the PLA with effect from 1 October 1988. Sadly, the ancient office of Ruler of Pilots disappeared at the same time, but Trinity House retains responsibility for deep-sea pilots.

TRINITY HOUSE PILOT

S. W. Rawlings, 1950s. AZ18

This view looking south across Allhallows Marshes shows the marsh drainage channel behind the sea wall alongside Yantlet Creek. Dickens wrote about the Kentish marshes in the opening chapters of *Great Expectations* (1861), but most authors have preferred the sunnier upstream locations. In their guide to the Thames, published in 1859, the Halls described the Hoo peninsula as 'a lonely primitive place'. Little has changed, as the bleak expanse of marsh remains truly remote with only scattered farms and small villages. The reclaimed land had been used for centuries for raising beef cattle, which required long periods of fattening. This was ideal for wildlife conservation as during the winter months the fields became important sites for wading birds. However, the advent of the cattle disease BSE has destroyed this long-established practice. Producing beef is no longer viable, so some farmers have given up, while in other areas the marshes have been drained for arable, with the result that winter feeding areas for birds have disappeared.

ALLHALLOWS MARSHES

Derek Kendall, RCHME, February 1994. AA94/2212

LONDON STONE, YANTLET CREEK

Derek Kendall, RCHME, February 1994. AA94/2210

The London Stone on the northern point of the Isle of Grain at the mouth of Yantlet Creek marked the easterly limit of the ancient jurisdiction of the City of London. Its counterpart is way upstream at Staines. This view shows the stone beyond the modern marker at the creek mouth. In Roman times Yantlet Creek was a navigable channel providing a shortcut for boats from the Medway to the Thames and separated the Isle of Grain from the Hoo peninsula. With the exception of Dickens, the only writer to appreciate the romance of the mudflats and shifting shoals of the Thames estuary was Joseph Conrad, who described the lower reaches of the river in *The Mirror of the Sea* (1906). He maintained that 'the estuaries of rivers appeal strongly to an adventurous imagination'. Appropriately, Conrad was a sea captain before becoming a novelist. Ships leaving the Port of London travelled along Lower Hope Reach beyond Gravesend and then Sea Reach as the Thames widened between the low-lying marshes of Essex and Kent. From the London Stone – 40 miles (64 kilometres) from London Bridge – they set sail for the Nore lightship and the open sea.

INDEX